COMPOSITION
IN LANDSCAPE AND STILL LIFE

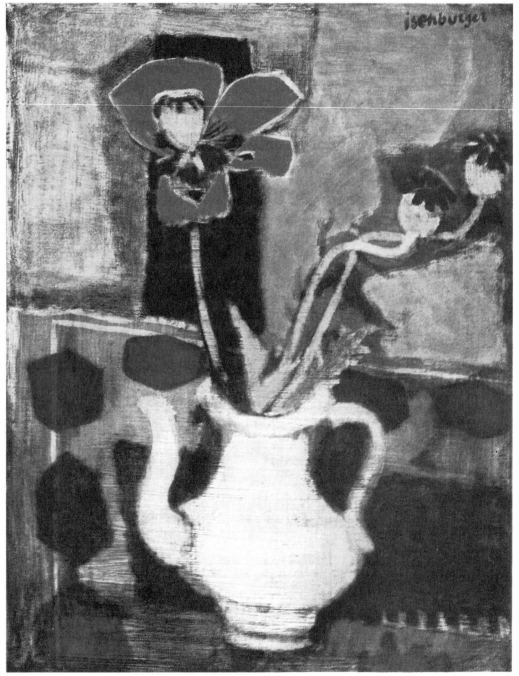

THE FADING POPPY OIL 26 X 20 ERIC ISENBURGER

Collection Mr. Vincent Connally

COMPOSITION
IN LANDSCAPE AND STILL LIFE

ERNEST W. WATSON

DOVER PUBLICATIONS, INC.
Mineola, New York

Acknowledgements

The author expresses his sincere appreciation to the painters who have made this book possible through permission to reproduce their work on its pages.

He acknowledges with gratitude the valuable editorial advice and assistance of his wife Eve Brian Watson.

Many thanks go to the following art museums and galleries for their efficient and friendly cooperation in supplying photographs of pictures in their Collections:

Art Institute of Chicago, Chicago, Illinois
Brooklyn Museum, Brooklyn, New York
City Art Museum of St. Louis, Missouri
The Louvre, Paris, France
The Metropolitan Museum of Art, New York
Museum of Fine Arts, Boston, Massachusetts
The Museum of Modern Art, New York
National Gallery of Art, Washington, D. C.
Nelson Gallery (William Rockhill), Kansas City, Mo.
New Britain Institute, Connecticut
Springfield Museum of Fine Arts, Massachusetts
Toledo Museum of Art, Ohio
Walker Art Center, Minneapolis, Minnesota
Whitney Museum of American Art, New York
Art Galleries in New York: Babcock Galleries;
Downtown Gallery; Kraushaar Galleries; Midtown
Galleries; Milch Galleries; Rehn Galleries;
Wildenstein & Co.
Others: Dartmouth College, Hanover, New Hampshire;
Smith College, Northampton, Massachusetts; Dreher
High School, Columbia, South Carolina.

Bibliographical Note

This Dover edition, first published in 2007, is an unabridged republication of the work originally published by Watson-Guptill Publications, Inc., New York, in 1959. The only significant alteration consists in reproducing the color plates in black and white in their original positions, as well as in a full-color insert facing page 160.

International Standard Book Number
ISBN-13: 978-0-486-45748-2
ISBN-10: 0-486-45748-6

Manufactured in the United States of America
Dover Publications, Inc., 31 East 2nd Street, Mineola, N.Y. 11501

Preface

This book is intended for all students of picture-making, regardless of age and experience. Since it is based upon the work of nearly one hundred masters of painting, past and present, I can voice its authority without an author's conceit.

My part has been to analyze the pictures and assemble them in chapters devoted to the consideration of various principles and creative procedures. My greatest problem has been to decide in just which chapter each painting would serve most effectively. That is because so many of them are almost as relevant to the instruction of one chapter as to another. It would not be surprising if some of the painters represented should consider that their pictures might indeed have been utilized in other ways, but I have done the best I could and I trust I have avoided criticism on that score by repeated references in my text to pictures other than those that appear in a particular chapter.

Studying these paintings has been a great personal experience for me and I can promise the same reward to any reader who searches them studiously with me. A good picture needs much searching because in it *more is hidden than is seen* by an untrained eye. I'll go further and declare that even the advanced student, if he will be as thorough in his analysis of pictures as I have tried to be, will find in them some pleasant and profitable surprises.

The hidden part, which of course is the picture's abstract design, is almost the *only* part that gives it any importance whatever. This surely is true of Eric Isenburger's *Still Life* on page 93. The objects themselves are such as might be found in the town dump. That is where the canvas itself might have wound up were it not for its non-objective design virtues in line, form, pattern and color. The way in which the painter has designed these abstract elements has made a fine work of art out of a collection of junk.

So in our study of pictures we have to start with *design*. And design is pure abstraction; it has nothing whatever to do with the subject matter of the work. This is true whether the subject in its finished state be realistically treated or painted in an abstract manner. This abstract structure of a picture is its *theme;* the thing represented is its *idea*. Regardless of the idea, the painting must have a theme.

Without theme the utmost facility in simulating the factual beauty of a rose, a head or a tree will result only in a "pretty" picture — as damning a compliment as could be paid any work of art.

This is not to disparage an artist's ability, or his desire, to paint realistically. That skill is important too! But it will not stand alone. Such contemporary masters as Andrew Wyeth and Walter Murch, to mention but two among many, delight us with their penetrating search for realism that is infinitely more revealing than the most perfect photograph; yet their work would not be noteworthy unless painted within the framework of creative design.

Simulation of natural appearance is, of course, the beginner's first concern: the ability to represent graphically the facts of nature and all objects that surround us. There are few professional painters who have not had that kind of training, even those who are now preoccupied with an experimental art that *seems* to have no relation to nature.

And all students must first of all learn how to use the painter's tools and materials, how to mix paints and get them on canvas or paper in an agreeable manner. This, and the ability to represent graphically the appearances of our objective world, constitute the *craft* of painting.

The *craft* of painting and the *art* of painting are two different things, but each becomes dependent upon the other as soon as the young painter attempts to do creative work. The sooner he does begin thinking creatively, the better. While still in the early formative stages he should begin to groom himself for professional painting by serious study of the esthetics of picture-making. Chief among these is what is known as composition. The purpose of this book is to invite and direct that kind of study. The technical or craft aspects of painting will have to be sought in other books dedicated to that aspect of his education and, when possible, in personal instruction. No book can successfully attempt to cover every facet of the painter's art.

Composition is what we have been talking about when we have used the term *design*. Composition and design are approximately synonomous but composition refers particularly to the application of design in picture-making. Most people are likely to associate design with furniture, wall and floor covering, fabrics, tableware and automobiles. In art circles the word design is more generally used in reference to pictures than composition. That is because design is

8

a "bigger" word, it has a structural connotation and it seems to imply a more fundamental and deeper attitude. And so in this book on composition the author will be found speaking more often of design in pictures than of their composition. Yet the word design could not have been substituted for composition in the book's title. I trust that with this explanation the reader will not be confused by the various uses of both words.

Creative study of pictures involves critical analysis. In the preparation of this book I have made analyses of many of the paintings reproduced and many more than have been included. This is what has given me the great personal pleasure which I referred to earlier, because analysis is the process of reaching into the painter's creative intention and discovering how he has realized it. The analysis of a picture proceeds along the lines of the chapter headings. Some pictures will be especially interesting in line, others in color, pattern, drawing, balance, etc. The simplest method of analysis is through tracing from photographs of the original paintings or from halftone pictures like those in this book. Sometimes your tracings will involve lines only; sometimes you will isolate the light areas or the dark areas. But in all such study you will be acquiring an intimacy with the painter's manner of speaking. Intelligent, thoughtful tracing is a creative process inasmuch as it gives something of the *feeling* that the painter must have had. And when you are *doing* something about the understanding of a picture you are getting more than you would by just looking: *tactical* experience is added to visual experience.

We even find copying in the professional work of many old masters. Rembrandt occasionally "lifted" a figure direct from other artists' paintings. We know how often Van Gogh copied Japanese prints and was strongly influenced by them in the process.

For the student who follows the suggestions for analytical study implied in my own diagrams this book becomes a stimulating *work-book* which will keep him actively learning about composition.

One way to crystallize the instruction here offered is to make a scrap album of such paintings (reproductions) as may be available from time to time in any printed sources. Alongside these pictures make as complete analytical studies of them as possible. And as museum galleries are visited, study the paintings in the same way except that your diagrams necessarily will have to be rather sketchy.

In most art schools considerable time is spent on the study of

pure abstraction or non-objective design. One who is studying by himself can work this way too and it is profitable to do so — whatever the direction he expects his work to take in the future. A good method is to take the identical motive seen in some non-objective painting, say the Rolph Scarlett canvas on page 21, and re-design it, using the same elements but changing their size, value, color and arrangement. This is a fascinating and instructive exercise for developing one's design sense.

While this is an instruction book, a *workbook*, it is not a series of sequential lessons nor are the chapters presented in an order calculated to fit the needs of any particular reader. The needs and interest of each person are different; one may be led first to the chapter on trees, another to pattern, etc. Thus each artist makes up his own course of study from material that the author has brought together.

A survey of the history of painting impresses us with the fact that art has been a continuous exploration of ways and means of perfecting the language of visual expression. All languages change to some extent with changing times — none more radically than the language of art. Each period has its own philosophy, its own means of expression; each is related to the atmosphere of the time in which it flourishes. It is molded by current social, political and ethical ideas. The road signs, to mention some, read: Realism, Romanticism, Impressionism, Post-Impressionism, Expressionism, Surrealism, Cubism, Abstraction. The study of these diverse phenomena is both fascinating and profitable for the painting student, but since this is not a history book we shall not intrude upon that field.

As a matter of fact, all of these different kinds of art have a common design basis even though, superficially, they may seem completely isolated from each other. Theoretically, at least, a person who is adequately educated — that means keenly sensitive to design — is able to read the language of all art of all times and of divergent philosophies. That is because some aspects of design are eternally immutable; *balance*, for example, is one of the absolutes of our universe as we know it, therefore esthetically indispensable.

March 1959 *ERNEST W. WATSON*

Contents

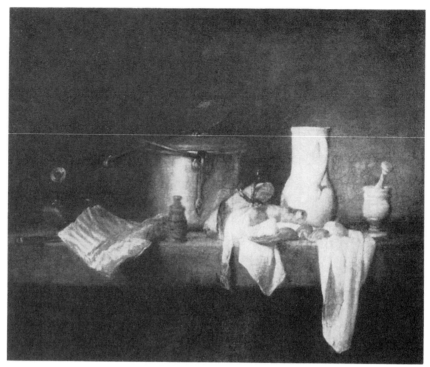

KITCHEN STILL LIFE CHARDIN

Courtesy Museum of Fine Arts, Boston

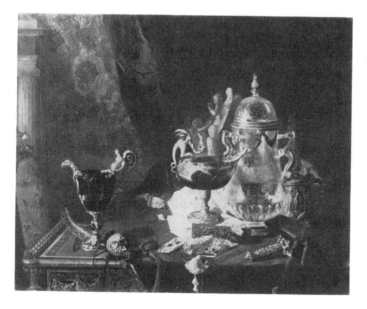

12

The Purpose

"It is beauty I seek, not beautiful things." Plato

These eight words, written more than two thousand years ago, are printed here as the text, not merely for the first chapter but for the entire book. If indelibly etched upon the painter's mind as *purpose*, they will direct his thinking into practical, creative channels. Indeed it is not too much to say that the acceptance of Plato's concept — seeking beauty rather than beautiful things — is essential to any real progress because it is the very cornerstone of all art.

Now just what is the significance of this idea for the student of painting? It means that the artist's function is to *create* beauty instead of trying to find it ready-made either in nature or in things. Not that the artist necessarily shuns subjects which are commonly accepted as beautiful; but he recognizes the danger in them. He may be tempted, as many are, to do little more than make an artistic inventory of things or places instead of creating something original and expressive of his own perceptive response to an exciting world. His canvas in such case is equivalent to a show window for the display of pretty merchandise. The painter may, to be sure, do a superb window dresser's job, as did Desgoffe in his still life *Objects of Art* on the facing page, but none the less he is asking us merely to admire the elegance of his carefully selected and artfully arranged bric-a-brac.

By way of contrast consider the Chardin still life, a collection of simple kitchen utensils. They were made primarily for utilitarian rather than decorative purposes. If they do have a humble, intrinsic beauty they are not showpieces; in the painting they become elements of shape, form, color and texture with which the painter has organized a work of art. The picture delights us because it offers a satisfying esthetic experience.

Chardin was not always so "pure" in his intention and in his achievement. He could and did descend to the sentimental and anecdotal, as in *The Raid* (not reproduced) which pictures a cat crouching among luscious comestibles on a well-stocked buffet.

I think Eric Isenburger's canvas *The Fading Poppy* (page 4) is an excellent example of Plato's ideal. Certainly whatever beauty we see here does not reside in the old pitcher or in the drooping flowers. These merely serve as objects around which the painter has woven a colorful abstract pattern.

Or take Charles Burchfield's *February Thaw*, reproduced on page 80. One could scarcely find a more dreary and commonplace subject to paint anywhere. Burchfield never seeks out picturesque subjects for his watercolor brush. On the contrary, he has seemed often to revel in muddy streets, melting snow and other varieties of bleakness. He can make and has made beauty of a bare, plaster-cracked room of a deserted house. On occasion, to be sure, he will paint a beautiful tree in its spring or summer glory.

Some years ago in a book entitled *Apples and Madonnas*, by C. J. Bulliet, the author declared that "an apple by Paul Cézanne is of more consequence artistically than a head of the Madonna by Raphael." This startling manifesto, certainly a sensational declaration of the basic truth that we are discussing here, did serve to dramatize it, and the book was a contribution to the revolt against sentimental, illustrative painting. Although it was an assertion of Cézanne's superiority as a painter, the author's real purpose was to emphasize the esthetic qualities of a picture regardless of its subject matter. It was an arresting way of saying that a painting of the most ordinary subjects *can* be greater than one which is dedicated to the noblest of sentiments. Well, then, if the artist's function is to create his own beauty instead of copying it from a carefully selected subject having an obvious beauty, we must ask how he is to go about it. What are the ingredients of the kind of beauty we are talking about?

They are *abstractions* rather than things; they are line, form, values, pattern, color and textures. These are what the painter has to work with. Just how he makes use of them in creating his picture is the measure of its beauty. With these abstract elements he composes his canvas. The result may range from pleasant decoration to deeply moving drama, depending upon his imagination and his skill in picture organization. It may be a pure abstraction, a semi-abstraction or it may be realistic. In one canvas the emphasis may be on pattern, in another, line; others may be dependent principally on texture or color. Some rely in various degrees upon the subtle or-

14

chestration of all abstract elements. Thus the analysis of one picture reveals quite a different structural approach from others. Some are so complex that they defy simple analysis. In others of course the design structure is obvious.

From what has been said it could be inferred that a realistic painting is necessarily less creative than one in which the abstract elements are dominant. If by realism we mean only the meticulous reproduction of the subject, the mere painting of *facts*, the inference is justified; but we must realize that many great canvases which to any untrained eye may seem to be quite literal transcripts of nature have actually been most creatively organized and have in them something which an observer, viewing the same subject, would never have seen — the product of *mind sight* rather than eye sight.

Thus it would be a mistake to assume that a picture which prominently displays its abstract structural basis, especially a non-objective or abstract picture, is necessarily more creative than one which embroiders it with realism and in which its structure may not be so obvious to the uninitiated. However, as Erle Loran has put it, "The one certainty is that no painting, ancient or modern, has achieved significance that does not contain in its internal structure the elements of abstract order."

Matisse has stated the same truth in other words: "There is inherent truth," he said, "which must be disengaged from outward appearance of the object to be represented. This is the only truth that matters. Exactitude is not truth."

To the perceptive eye of the artist, nature itself is basically abstract, and simplicity is the key to its realization. Simplification is the process of eliminating meaningless detail and of reorganizing the disparate elements into a well-conceived plan in which colors of parts and their shapes fall into a prearranged design. Simplification thus is understatement of details rather than overstatement; the greater the simplification — that is, the understatement — the more the painter is likely to draw upon his own creative powers and give us expression rather than illustration. Look for example at Albert Pinkham Ryder's *Forest of Arden*. This is not the picture of a real landscape; it is the image of a mood inspired by landscape — not *a* landscape. It is ethereal rather than earthly. It is more a stage setting in a dream world in which we ourselves become the actors. It could not have been painted on the spot. Ryder, as a matter of fact, did

15

not paint out-of-doors. A painfully slow worker, he is said to have spent years on a single canvas. So his thoughts did not focus upon leaves and branches or on any natural phenomenon that would interest a naturalist. He was not concerned with nature's minutiae but with her dramatic aspects. These could only be expressed through *design*, design which deals with abstractions rather than with facts.

Like Ryder, the Chinese never painted from nature. They went out into the country to meditate for days at a time in the half-light simplicity of early morning or evening. Away from the reality of the scene, in the quiet of their workrooms, they painted their conceptions. Detail always took a subordinate place in the grand pattern; often there was scarcely any detail.

Although Corot worked directly from nature, when he went out to paint he carried with him much more than brushes and paint: an inner vision that served as a pattern for all that nature had to give. He was master of simplification; he reduced the manifold complexities of nature to broad effects and simple compositions that reflected his particular response to her quiet moods.

In striking contrast is the canvas by Thomas Doughty. He was one of many 19th century Americans in the Hudson River School who, by painting the glories of nature objectively, tried to give us in their canvases the same delight we might have experienced had we accompanied them to the places where they painted. We can see that the canvas was painted directly from the scene, so meticulously are all details observed and rendered. It is really nature itself that speaks to us. This is not to deny that such a dedicated artist, enthralled by the beauties of the American landscape, did put into his work a degree of individual vision and a personal manner of expression, but essentially his focus was upon facts.

Now let us turn to a painter of a later generation, Marsden Hartley, who died in 1943. Of course he is not acceptable to people who prefer Thomas Doughty's mirrorlike reflections of nature. One has to be very sensitive to design to appreciate his pictures. But his was a creative influence in pictorial art because he encouraged the trend toward creative, abstract painting. He has said that he had "no interest in the *subject*, not the slightest." He added, "I am clearing my mind of all art nonsense, trying to accomplish simplicity and purity of vision for life itself, for that is more important to me than anything else in my life. I am trying to take out of experience as

16

THE FOREST OF ARDEN
ALBERT PINKHAM RYDER

Courtesy Stephen C. Clark Collection

This famous landscape sprang from the imagination of one of America's greatest painters. Unlike Corot, Ryder was seldom if ever seen painting in the fields. His was a meditative art; he spent years working on his canvases. Whatever he took from nature was transformed by his creative processes into something felt rather than seen.

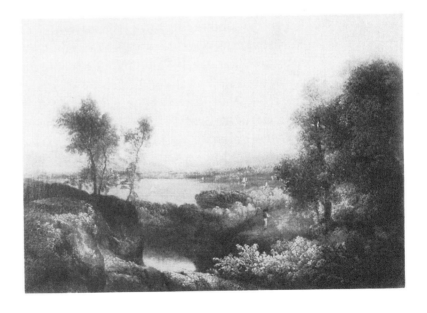

ON THE HUDSON
THOMAS DOUGHTY

Courtesy
The Metropolitan Museum of Art
Gift of Samuel P. Avery

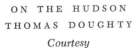

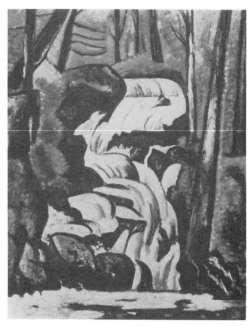

TWO MEN IN A SKIFF COROT
Courtesy The Metropolitan Museum of Art
The Mr. & Mrs. Isaac D. Fletcher Collection

SMELTBROOK FALLS
MARSDEN HARTLEY
Courtesy City Art Museum of St. Louis

it has come to me in the intervening years that which has enriched it and make something of it more than just intellectual diversion. It can be done with proper attention and that is to be my mental and spiritual occupation from now on. In other words, it is the equivalent of what the religious-minded do when they enter a monastery or a convent."

Now that doesn't sound like a man who would go out painting with Doughty! How different the outlook and the purpose of the two men. Regardless of the degree of Hartley's success in what he tried to do, he did — in the words of Plato — seek beauty, not beautiful things. In his *Smeltbrook Falls* his preoccupation with design is so conspicuous as to be readily analysed even by a beginner.

The probability is that Russell Cowles' canvas *The Brook* (painted in 1943), of an almost identical subject, will satisfy more people because while by no means an objective painting it is not so rigidly divorced from natural appearance. Yet its beauty resides in its abstract structure rather than in verisimilitude.

18

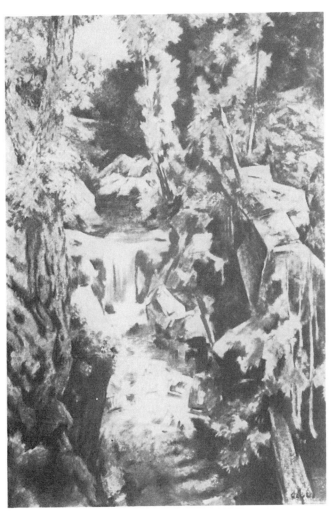

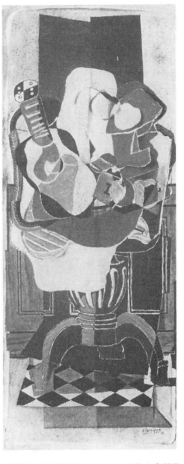

THE TABLE BRAQUE
Courtesy
The Museum of Modern Art
Lillie P. Bliss Bequest

THE BROOK RUSSELL COWLES
OIL PAINTED IN 1943
Courtesy Kraushaar Galleries

While abstract design structure underlies all great art of all time, it remained for the modernists to exploit it as pure abstraction, a trend that continues to dominate the contemporary art world. Georges Braque, one of the foremost exemplars of this school of painting, used subject matter only as a point of departure for his extremely abstract designs. Much non-objective painting obviously is inspired by geometry rather than nature or objects of any kind, but many non-objective painters do start with nature and lose it

19

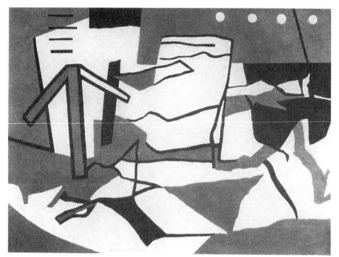

U.S.S. NEVADA RALSTON CRAWFORD
Collection Mr. John J. Carney

entirely or partly as Ralston Crawford has done in his *U.S.S. Nevada*, a pictorial report (for *Fortune* magazine) of what he saw and felt as an eye-witness to the detonation of the atomic bomb at Bikini in 1946. About Crawford's work James Reston of *The New York Times* wrote "He takes off with a subject, strips it of its superficial identity and performs clever variations on its component parts. Alternating these, each clothed in contrasting cool color, light or dark, he arrives at flexible compositions that look as if they could be taken apart and reassembled otherwise."

Now it is certain that Ryder, Corot, Hartley and all the other painters, even the abstractionists, studied the facts of appearance at the beginning of their careers. Obviously a painter needs an extensive knowledge of nature and skill in factual representation, regardless of the direction his later work will take. Picasso, the god of modernism, was a realistic painter in the early years of his career. And, quoting Matisse once more — Matisse whose work may seem very far indeed removed from nature — "An artist must *possess* nature. He must identify himself with her rhythm by efforts that will prepare the mastery which will later enable him to express himself in his own language."

This advice comes from a letter which Matisse wrote to the Curator of Painting of the Philadelphia Museum of Art in 1948 at

20

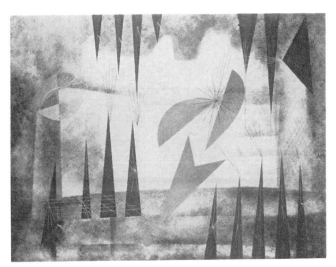

the time of his retrospective exhibition there. Being fearful that his work might, as he said, "have a more or less unfortunate influence on 'young painters,'" he asked, "How are they going to interpret the impression of apparent facility that they will get from a rapid or even a superficial over-all view of my paintings and drawings?"

The student may indeed be beguiled by the apparent superficiality of much modern painting and be lured by the experimental urge to neglect the basic training that comes from a dedicated study of nature and natural appearance. Indeed some contemporary art schools encourage this neglect of traditional training in the fundamentals of representation, in their too fanatical devotion to the current preoccupation with abstraction.

Yet while counseling the student to "possess nature" as Matisse advises, we should urge him to keep his thinking on a creative plane. The study of abstract and non-objective art is recommended as an accompaniment to work from nature and objects; abstraction is indeed the very cornerstone of composition.

Composition refers to what can logically be called the "machinery" of picture-making. Machinery might seem an odd term to apply in the field of esthetics, since machinery immediately suggests science and industry; but the dictionary informs us that machinery is "the means and appliances by which *anything* is kept *in*

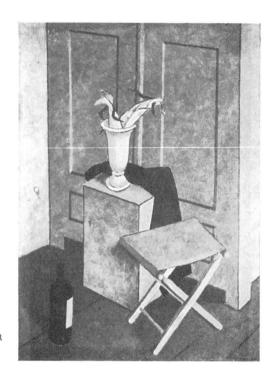

CAMP CHAIR NILES SPENCER
Courtesy Downtown Gallery

action or a desired result obtained" (our italics). I like to use the word machinery because it stresses action. Certainly there is action in every good picture — not the physical action of moving parts, but action in the interplay of line, value, volume and color, and in the way in which the eye is led from one area to another in the composition. In future chapters we shall discover many ways in which pictures, like machines, are made to "work."

To one who is without sensitivity and a trained eye, the workings of a fine painting are as mysterious as are those of an intricate machine to the average man who might stand before a modern automatic machine, bewildered by the complication of its moving parts, understanding nothing of its operations except that the rods of brass that are fed into the machine at one end come out at the other, completely manufactured products. While to most of us the design of such a machine might be completely mysterious, we do know that all of its parts, even the tiniest revolving gears, have to be perfectly interrelated and interdependent or the machine will not work.

The demonstration on these pages is a simple analysis of the working of a picture; in our studies of much more complicated compositions

22

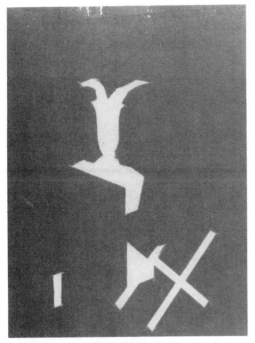

FIGURE 1

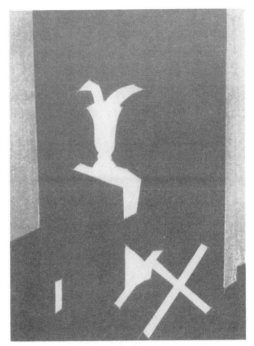

FIGURE 2

ANALYSIS OF

NILES SPENCER'S PAINTING

CAMP CHAIR

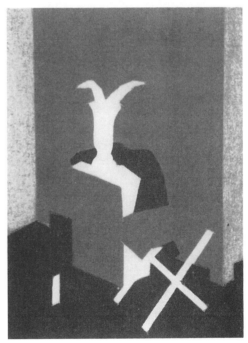

FIGURE 3

we shall discover that the machinery of picture-making often is a very involved business indeed. The Niles Spencer canvas has been analyzed in three diagrams in order to demonstrate the part played by the different elements. In fig. 1 we concentrate upon the nearly white elements of the vase, the box on which it rests, the legs of the campstool and the bottle's white label. These white shapes represent in themselves an extremely varied and interesting design. They are the nucleus of the composition. When, in fig. 2, the gray, vertical elements are added, the white elements are related to the picture format.* Fig. 3 does not really complete the analysis because in the painting, the gradation of tones on the cabinet doors and on the floor are important factors in the design. In fig. 2, for example, we feel the need of the darker note at the top to balance the darker floor; and the dark of the floor is a counterpoise for the drapery.

Nor can a study of the canvas be complete without color. But although we have taken liberties in reducing the tonal elements to three flat tones that do not exactly match those of the canvas, the analysis does serve to point up the possibilities in arrangements of simple abstract shapes and values of light and dark.

It is difficult for the layman to believe that the organization of a picture can, like that of a machine, be such a sensitive, complicated and responsibly integrated arrangement of elements that the alteration or removal of one small shape, color or value at any point or even a slight change in the direction of a line can seriously interfere with its action. Yet the student of art soon learns that this is no exaggeration. In Spencer's *Camp Chair* note how essential to the whole picture is the white label on the bottle. When it is covered by a scrap of gray paper the picture is wholly out of balance. That little white spot and the dark of the bottle, which is a counterpoise for the black drapery, are as essential to the action of this picture as is the small gear to an intricate machine. Every element in a picture must be exactly the right size, the right value, the right color and in the right spot in the design to achieve the desired esthetic effect. The flagpole in Robert Vickrey's *Autumn Landscape* on page 157 has a function in that picture somewhat similar to the bottle label.

*Format. This term is a convenient one to describe the picture's shape, size and proportion.

Phenomenon Of Seeing

Anyone about to venture into the art of picture-making ought to take note of an optical limitation in the functioning of the human eye: its inability to focus upon more than a very small point at one time. We do not actually "take in" a picture at a single glance. This will come as a surprise to many people who have never had occasion to be aware of it. And certainly we are not at all conscious of it, because the focal beam moves over the area under observation so quickly and flits so unconsciously from point to point that the phenomenon is seldom noticed. Yet it is an important factor in creative art; it has to be reckoned with by painters.

To demonstrate the point hold a hand, with fingers spread, at arm's length. When you look at the thumb you cannot "see" the little finger. To do so you have to shift the eyes perceptibly. Notice your eye movement as you read this line of type.

Now it is obvious that awareness of this optical phenomenon is important to the painter when he is composing a picture. Knowing that the observer's eye will have to move about in it, he naturally will want to direct our seeing, taking us from one point of interest to another in an orderly, meaningful and restful way. Unless he does control us that way his picture will not express his intention or contribute satisfactorily to our pleasure: it will lack unity and thus fail as a creative entity. The eye, put to the trouble of finding its own way, will, of course, see everything in the picture but it will not get the intended impact any more than it would from a poorly composed piece of writing. There are exceptions to this generality which will be discussed later on.

This is not a practical factor in such simple pictures as a vase of flowers, a rather static composition which involves slight eye-movement, nor in the painting of a single tree. But as soon as the picture's range is extended ever so little, the problem is presented. Indeed we might say that the composing of any picture is primarily

EXPERIMENTS
IN EYE CONTROL
IN COMPOSING A PICTURE

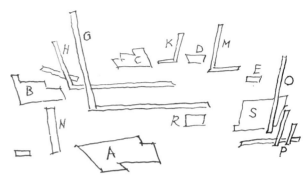

*Key Sketch for accompanying diagrams
1 through 8. See text on page 28.*

1

2

3

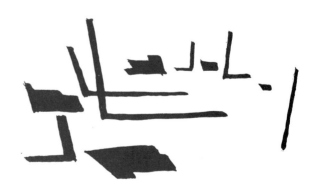

4

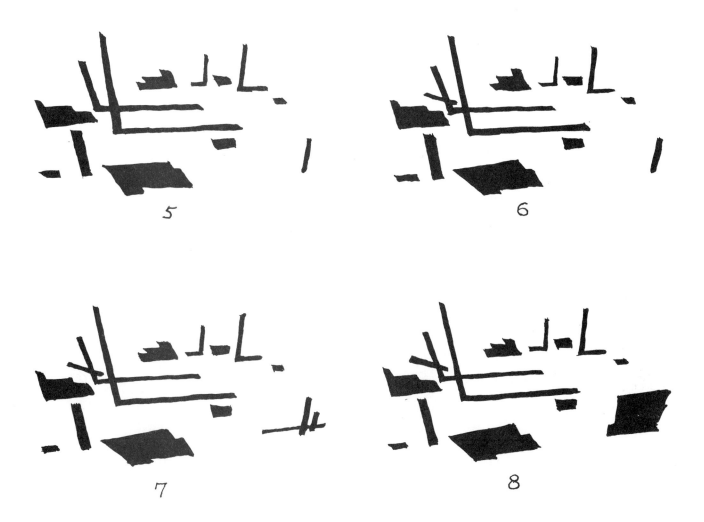

5

6

7

8

a matter of controlling the seeing process.

The painter has many devices to lead us in, around and out of his picture. At times he will rely principally on line, at another time on mass, contrast, spatial arrangement, value or color. He may use one or many of these abstract structural means; the way they are designed and coordinated creates the "hidden part" of the picture which I referred to in my preface. The spectator is not conscious of being on a conducted tour and he has the satisfaction of imagining that he is seeing the picture with his own perception. Indeed he is, too, because after the way has been shown him there still remains the degree of his receptivity to subtleties inherent in every good painting.

In many canvases, probably in most, the student can readily discover the painter's compositional strategy; in others it is so subtle as to elude detection for all but the experts. Let us consider one of the more obvious devices, one that will be found in a great many canvases. Refer to the diagrams on pages 26 and 27.

In fig. 1 we have a series of five masses, gradually diminishing in size, so placed as to establish an elliptical path created by the movement of the eye from larger to smaller masses in the group. This primary attraction of the eye to the largest mass or object is another phenomenon of seeing.

2 In this composition, "posts" have been erected to arrest, slow down, too-swift a sweep along the elliptical path. Although it is desirable to point the way, it is not desirable to make it a "thruway." The post N, however, does urge the eye onward from A to B. Turn to page 33 and note how in Sol Wilson's *Sailboats in Harbor* the slanting sail at the left serves to check an otherwise too-violent perspective thrust to the right.

3 Here we have still further delayed the elliptical sweep of the eye with the horizontal shadow lines, but these only represent interesting diversions along the way. They give more content to the design. If the shadow lines do tempt us to step straight back through the composition instead of following the original path, the greater pull of N, H and G resists that tendency.

4 The composition has seemed incomplete, one-sided, up to this point so the post O has been inserted here. This not only gives a better balance to the arrangement, it serves to stop the elliptical journey which previously seemed to be wandering nowhere at the right, and brings us back to the foreground and out of the picture.

5 Although the changes here seem minor, they are designed to make the design more interesting. Substitution of a shorter post at the right seems to be a pleasanter link in the elliptical action.

6 Note here the enhancement of interest at H by the insertion of the cross-beam. This is compelling, not so much by added weight

The posts here have been isolated from Julian Levi's "Cape Cod Morning" to demonstrate how these elements alone constitute a varied and interesting pattern of vertical lines.

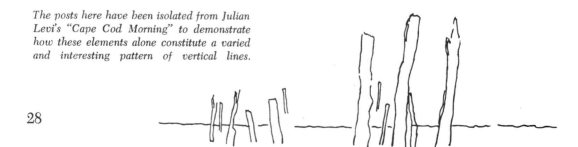

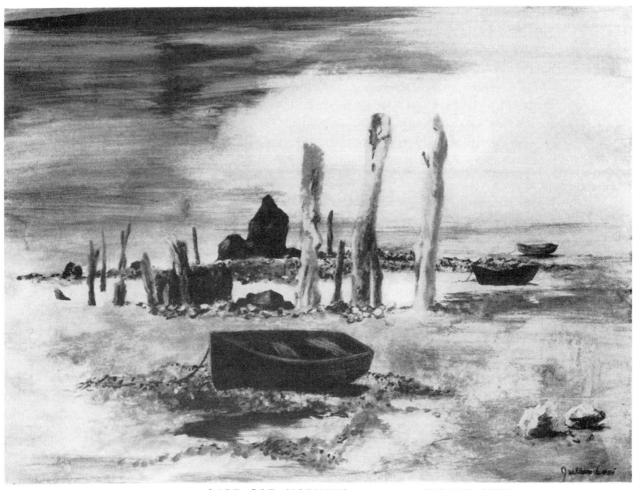

CAPE COD MORNING JULIAN LEVI

Courtesy Whitney Museum of American Art

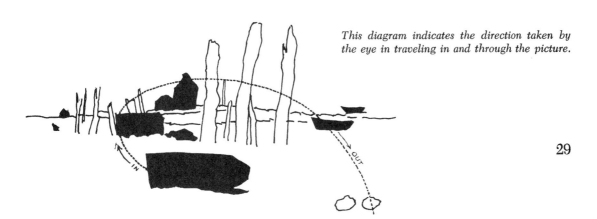

This diagram indicates the direction taken by the eye in traveling in and through the picture.

29

of mass as by *interest*, an element which, as we shall see in future studies, competes powerfully with mass. We are intrigued by that cross-beam; we begin to think of it as having an illustrative as much as an abstract function.

7 Here we are thinking it might be advisable to counter that attraction at H by a similar one at P, though this may seem not really necessary, possibly not advisable.

8 In all of the arrangements up to this point the path of interest has been reasonably well maintained in spite of various diversions along the way. Here, with the substitution of the large mass S, we create some confusion: we are uncertain, as we first approach the design, as to how to get into it. The eye travels between A and S before finally taking the elliptical path beginning with A.

Now I admit that in this demonstration we have oversimplified a compositional situation. Suppose value relations were to enter in, as they usually do, some of the masses being lighter or darker than others, or suppose color were introduced. If, for example, B were to be a very light value, or perhaps S, the situation would be radically changed. However, I believe that the principle here dramatized is useful and that it will be discovered to apply in the composition of many pictures: as in Julian Levi's *Cape Cod Morning* which reveals much the same kind of design strategy.

Upon my first appraisal of this canvas I was a bit puzzled by those two stones in the lower-right corner. Then it became clear that their purpose was something more than the mere filling of what otherwise would be an empty area.

Of course a more comprehensive analysis of that fine canvas would reveal many other factors that are essential to its intention. The tonal subtleties of the painting, and its color, are of course major contributions to its calm and somber mood. We could go much further even in a line analysis that would include the part played by the clouds and other less obvious line relationships.

On page 28, I have isolated the posts to demonstrate how interesting and how beautifully designed these elements are even when standing alone — their relative sizes, their slant, their spacing.

In Erle Loran's *Mexican Port* we have another interesting example of the route automatically taken by the eye as it enters and travels throughout the picture. There can scarcely be a difference of opinion about this: that huge rock at the left compels our attention

30

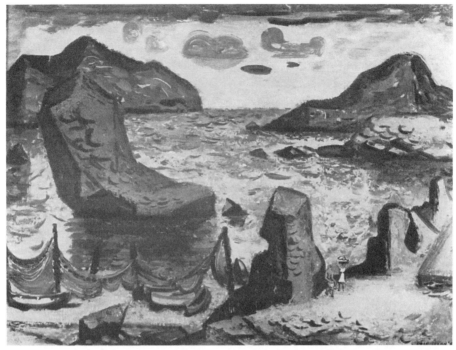

MEXICAN PORT GOUACHE ERLE LORAN

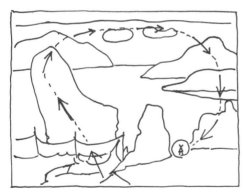

Author's diagram to chart the eye's natural path of interest into and through the picture.

and starts the movement upward where it is turned by the mountain to the center and right. We find ourselves at last in the lower-right corner where the figures invite a final focus of attention.

It has been my observation that this is the usual direction of

31

eye-control — left to right — in pictures. Can it be unconsciously directed by our left-to-right mode of writing?

Of course there are many other methods of eye-control. Among the most obvious is *perspective*. Converging lines funnel the interest deep into distance if the painter so wishes, as in Louis Bouché's *Ten Cents a Ride*, Robert Watson's *The Lighthouse* and William Lamb Picknell's *On the Borders of the Loing*. In such compositions the painters may seem to have a more pictorial, even illustrative, intention than concern with the design of the format. But that depends upon how the other (than) line elements are treated. In Watson's canvas there is a strong competition of format interest with depth interest which our diagram suggests. This is enhanced by the relative

This diagram by the author was made to demonstrate the importance in Sol Wilson's painting of the tall sail and wall at the left (omitted in this sketch). The perspective thrust of the wharf line needs these compensating elements seen in Wilson's own preliminary sketch below.

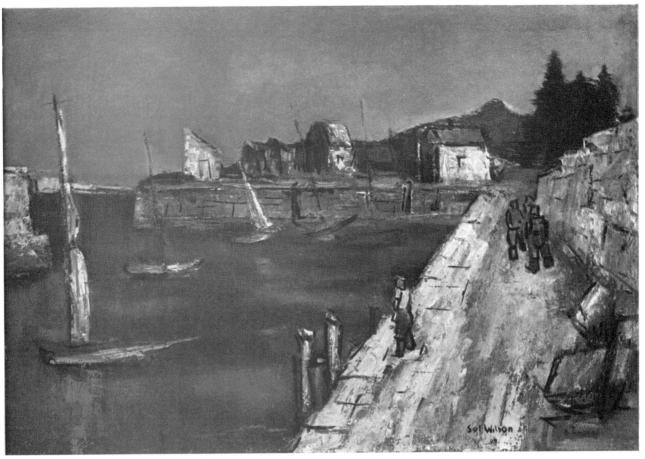

SAILBOATS IN HARBOR OIL 20 X 30 SOL WILSON

Courtesy Babcock Galleries

This is a black-and-white wash drawing made by Wilson as a preliminary study for his painting.

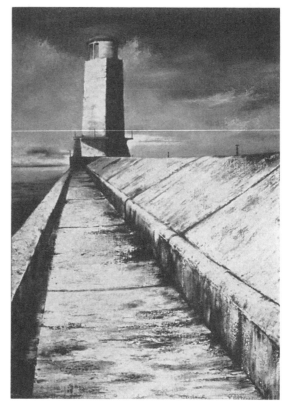

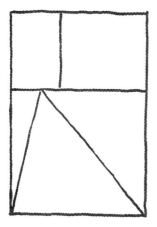

THE LIGHTHOUSE ROBERT WATSON

The diagram charts the painting's basic design structure. Emphasis is on format design.

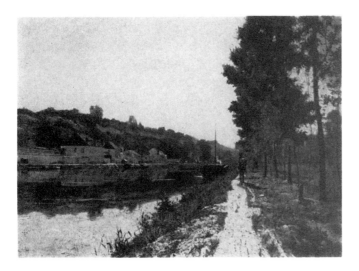

ON THE BORDERS OF
THE LOING
WILLIAM LAMB PICKNELL

Courtesy
The Metropolitan Museum of Art
Bequest of Mrs. Gertrude Flagg
Emphasis is on perspective depth.

34

THE HAUNTED HOUSE
L. M. EILSHEMIUS

A picture with a strong perspective thrust into a distance that is not worth going to. There is a house in the picture.

TEN CENTS A RIDE LOUIS BOUCHÉ
Courtesy The Metropolitan Museum of Art
George A. Hearn Fund

THE OLD MILL
THEODORE ROBINSON
Courtesy The Metropolitan Museum of Art
Gift of Mrs. Robert W. Chambers

lack of interest in the receding planes themselves: they are empty. And the picture has no human interest. Roy Hilton's *Underpass* (page 134) should be mentioned in this connection.

Bouché on the other hand wants us to walk along the deck of the ferryboat to the open door through which we see people and imagine a view of the harbor. Yet he slows our pace somewhat, and cleverly, by those newspapers which some passenger has left behind on the bench. These have a strong illustrative function in giving reality to the scene; they are fully as useful as a compositional device.

The impulse to follow a perspective path is well nigh irresistible.

TAXCO SYCAMORE EMIL J. KOSA

The Y-shaped tree trunk forms a frame for the vista of which the church is the focal point.

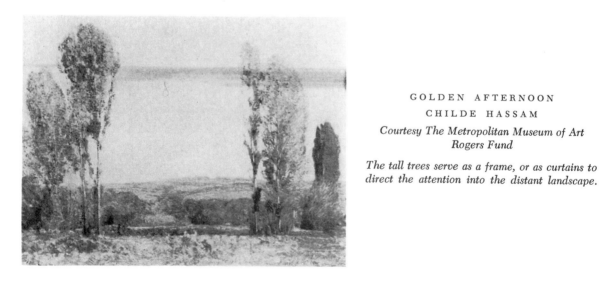

GOLDEN AFTERNOON

CHILDE HASSAM

*Courtesy The Metropolitan Museum of Art
Rogers Fund*

*The tall trees serve as a frame, or as curtains to
direct the attention into the distant landscape.*

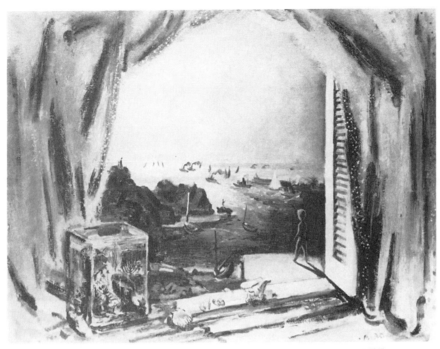

THE GOOD, GOOD MORNING PHIL DIKE

The abstractly treated curtains and the objects on the window sill
frame a distant vista, yet create an emphatic format design.

We have no choice but to travel Picknell's path along the river bank. There is a path, too, in Theodore Robinson's *The Old Mill*, but the large light building in the middle distance catches our eye ere it gets well started on the path; so that distance is less a factor.

In Eilshemius' *The Haunted House* we are carried swiftly into an uninteresting distance where the sharp contrast of the dark tree-mass against the light sky also attracts us like a magnet. The picture is empty; all it gives us is a swift walk in an uninteresting landscape.

In Phil Dike's *The Good, Good Morning* we are introduced to another phenomenon of seeing: the impulse to peer through parted curtains or through any opening. So here, Dike has projected our attention at once to the glories of the distant vista. The curtains are abstractly suggested and the objects on the window sill have no more than a casual interest. The small figure of the boy is important but we discover him after noting the boats sailing into the sunrise. He enhances the picture's illustrative quality.

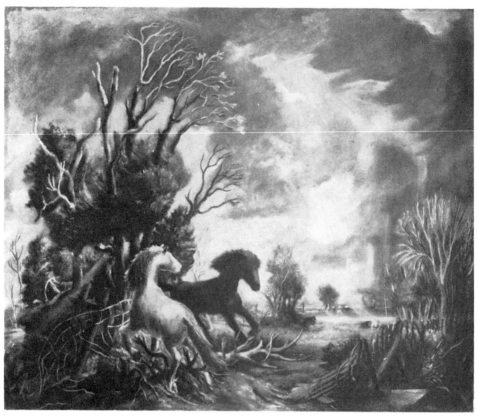

THE HORSES WILLIAM PALMER

Courtesy The Metropolitan Museum of Art

The encircling clouds, trees and dark foreground
serve to frame the picture's focal point—the horses.

In Emil Kosa's *Taxco Sycamore* the spreading branches of the tree represent the parted curtains. In spite of the fact that Kosa named his canvas after the tree, the cathedral is really its center of interest. Only after focusing on that and contemplating it can we attend to the tree and the buildings of the middle distance, despite the importance of these in the composition.

Golden Afternoon, one of Childe Hassam's fine canvases, substitutes majestic poplar trees for curtains. Our searching eyes dart through the opening to the distant scene which is so delightfully framed for us.

In William C. Palmer's *The Horses* a wholly encircling mass of dark cloud and land provides a frame for what the painter has

38

to say about horses. Like so many artists working in all media, Palmer uses the horse symbolically.

Many excellent paintings are far more subtle in composition than those selected for discussion here, and their analysis is a challenge to the student. In some, the eye is invited to travel back and forth between relative degrees of attraction in different parts of the canvas. We see this in Bentley Shaad's *Blue Decanter* on page 49 in which there can be said to be no *center* of interest, although the tall glass at the left commands our first attention. Some pictures purposely invite the observer to wander about with little or no direction from the artist, as in Dong Kingman's *Clay and Grand* (page 153) which is discussed in the chapter on Unity.

The fact is that pictorial composition is a very complex business. As we grow increasingly sensitive to design, the more deeply hidden pleasures in great pictures will become tangible to our ever expanding appreciation. Michelangelo once said that "Great painting is a music and a melody that only the most intelligent can understand and that with difficulty."

Still Life

"Still life is the chamber music of painting — it manifests the intrinsic values of art, very little diluted by incidental elements." Thus spake Wolfgang Born in *Still Life Painting in America*. And Jerry Farnsworth in his book *Learning To Paint in Oil** says that "Still life painting all through the ages has been an activity of the artist's playtime, his time to relax, to enjoy, and to observe." And to the student he says: "Since still life offers the greatest variety of textures and color, simplicity of form, and ease of drawing, it is the best kind of subject matter for the beginning student. And even the greatest of painters look upon it as a test of their creativeness. In my classes I set up a simple subject: a jug, a green wine bottle, a shell, a white plate, a lemon or apples, perhaps a piece of bright material or a white cloth — just an informal arrangement of ordinary objects.

"Plain everyday objects are best because they are not beautiful in themselves; you have to make them beautiful. Pots, pans, old cups, broken pitchers, odds and ends of things; almost any fruit except oranges and other perfectly round objects. . . . Above all avoid such gift shop stuff as candlesticks, cute little figurines, jewel boxes, beads and the like. Look around your house and you will find a wealth of material. Take a good look at the objects with an artist's eye and your appreciation for the simple and obviously unbeautiful will be greatly enhanced. On Cape Cod some of our students visit the town dump regularly, bringing back with them many of our

Learning To Paint in Oil — Jerry Farnsworth, Watson-Guptill

40

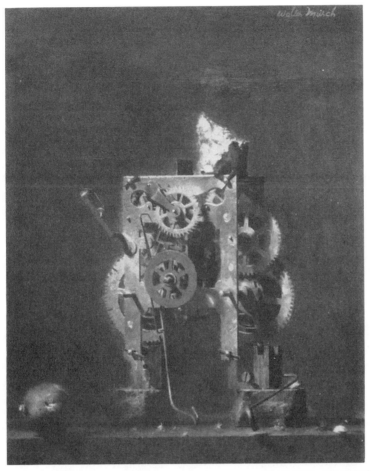

THE CLOCK OIL 22 X 16 WALTER MURCH
Collection Lester Tichy

This is one of many paintings of mechanical gadgets by Murch. Meticulously painted, it is an interesting example of what is generally known as "magic realism" — realism plus something beyond realism — in this instance perhaps a sense of nostalgia induced by the discarding of an instrument that once was important in people's lives. Note the lemon and dustlike particles on the bench.

best still life objects. They once found a honey of a pink chair, worn and discarded, broken pitchers, and miscellaneous weathered pieces with the patina of age upon them — colors you could never dream up. These have been painted again and again into stunning still lifes. It's the attitude that counts. There is beauty in nearly everything, if you have the eye to see it — perhaps even in 'ugly beauty.' "

BUILDING BLOCK AND
POMEGRANATE
OIL 16 X 21
WALTER MURCH
This crumbling block is one of those "impossible" subjects that so often have a strange appeal for Walter Murch. The painting is priced at $600.

Speaking of ugly beauty puts me in mind of Walter Murch, whom I had the pleasure of interviewing for *American Artist* a few years ago. I was led to him by an exhibition of the most unusual still lifes I had ever seen. His choice of still life objects seemed so unlikely as models for painting that I referred to him in my title as *Painter of the Impossible*. Because I believe that some unusual and challenging ideas came out of that interview, I shall quote from his own comments as I reported them in my article:*

"I think a painter paints best what he thinks about most. For me this is about objects — objects from my childhood, present surroundings, or a chance object that stimulates my interest, around which accumulate these thoughts. I suppose you could say I am more concerned with the lowly and forgotten object, the one people discard because they are finished with it."

These unusual objects appeal to Murch partly because of their "one-time association with people," of having been witnesses, nay participants, as it were, in the human drama: such objects as a discarded door-lock, clocks and mechanical gadgets of all kinds — his father was a watchmaker and his brother an inveterate tinkerer. Such things are enveloped for him in a nostalgic aura which he tries to translate into visual terms.

Now when a painting is provocative, when it makes us ask and makes us try to understand what is going on in the artist's mind, it is in a fair way of being considered a work of art. And while what

————————

American Artist, October, 1955

42

FIRE CHEMICALS WALTER MURCH

*One of several covers the artist
has painted for* Fortune *magazine.*

we see may not necessarily be pleasing or even acceptable, we are
at least made aware of a creativeness such as is not revealed in an
objectively realistic canvas or in the object itself when seen by our
eyes. Certainly paintings by Walter Murch do pique our curiosity.

What, for instance, can he have been thinking when in one
picture (not reproduced) he painted a dried herring resting on a
fragment of stone? Surely he was not merely trying to paint the
most faithful likeness possible of a dead fish.

And how are Murch's pictures received by the public and by
the art world? Are these paintings of "impossible" subjects salable?
At prices ranging from $600 to $1800 they are indeed attracting
enough purchasers to make many notable contemporaries envious.
They have found their way into the collections of many museums
and have led to an extraordinary career as advertising illustrator —
numerous covers for *Fortune* and *Scientific American,* a long series of

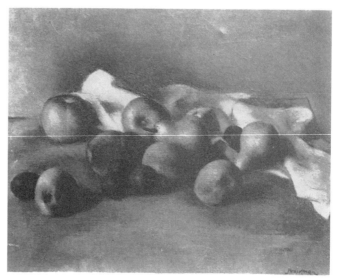

STILL LIFE OIL ROBERT BRACKMAN

full-page advertisements in color for National City Bank and many other commercial paintings for advertisements. Murch's performance in turning from mystical painting of impossible subjects to pictures that are contrived to turn the wheels of industry is indeed paradoxical if not unique.

It was in Grand Central Art Galleries in New York that I saw the Brackman painting, reproduced here in halftone. I am hoping that even with color subtracted, in the black-and-white reproduction and the great reduction of this small cut (the painting itself is 16 x 20 inches) the reader can share something of my enthusiasm for it.

The picture is full of the most delicious subtleties. The background — a reddish-gray — is deepened in value just behind that white spot needed for accent; the table top is alive with changing reds of slightly differing values; the fruit, which has a fine tactile quality, is painted with the most artful expressions of form. The pears, peaches and apples *feel* so good, not as real fruit — it is not very realistically painted — but as painting quality, appealing to the esthetic rather than the physical taste. The esthetic appetite is likely to pall when offered pictorial fare that too obviously appeals to the physical senses, when realism is more important to the painter than art qualities which have nothing to do with representation.

Of special interest is the very narrow range of values and color

44

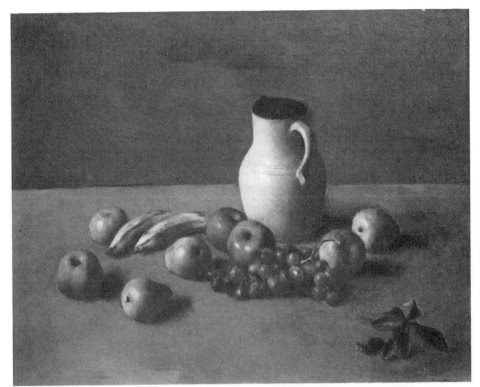

STILL LIFE IN GRAY ROBERT BRACKMAN

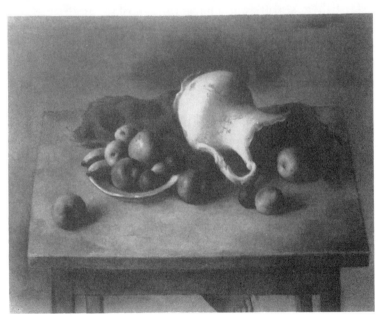

STILL LIFE ROBERT BRACKMAN

45

in this study. The lightest part of the white napkin is far from being white and the darkest notes (the shadow sides of the dark blue plums) do not touch the bottom of the value scale — a very restrained tonal scheme.

When I visited Brackman's studio in Noank, Connecticut, I looked about for three objects, one of which is almost certain to be seen in a Brackman still life: the two pitchers — one chaste and severe in form, the other flowered and frilled — and that glorious old table which, in its patined finish and rich coloring, adds so much to his canvases. The table turned out to be not glorious at all; it is a very ordinary kitchen table. All that color, texture and time-worn beauty of the table in the pictures are really from the artist's imagination.

The ornate pitcher might have come from the commode in any Victorian home. The other jug is really a beautiful piece, though it cost no more than a dime at a Salvation Army store. It has a fine form, as can be seen; its crackled glaze in an exquisite neutral gray makes it a good reflecting surface for purple grapes or green apples.

Perhaps the most important reference to the work of Bentley Schaad is his frequent resort to the type of composition seen in his *Blue Decanter* and in *Seed Harvest*, a later picture. This horizontal division of the canvas by vertical elements helps, he says, to establish a stabilizing character to play against the agitated forms that enliven the picture.

Speaking of *Seed Harvest* Schaad says, "I came across these dried plants in a potting shed and was very greatly attracted by the strange and beautiful designs of the paper containers used to collect the seeds for planting and the claw-like character of the dying leaves. I was struck by the mysterious aspect of this transformation. The color here is very limited: variations of somber grays in the light, with deep, rich blue in the shadows, and the earthy, warm, dark browns of the dying plants."

Schaad makes a practice of having his canvas in a frame at every stage of the painting. He says that this helps to accentuate the edge of the canvas to which he designs the picture. The frame also cuts out distracting background forms and colors. He prefers a wide scoop molding painted a neutral gray.

Paul Riba, whose painting on the cover appears in another chapter, has devoted a great deal of his time to still life painting and he has some interesting views on the subject. He says: "I am

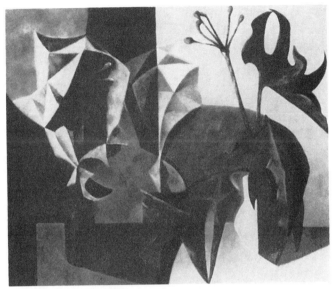

SEED HARVEST BENTLEY SCHAAD

especially interested in grouping unusual and unrelated objects into a harmony of color and association. Bells, new and antique, hang from weathered wood against blue skies; low horizons accentuate the scale and give my pictures a surrealistic aspect. What I paint sometimes reflects memories of the past, objects which become symbols — such as weathervanes, old carnival props and ornaments of the gaslight era, curios and cabinets of shells and trinkets. Oriental art has made a strong impression on me. I have a sizable collection of Oriental, American and European curios and antiques. My love for detail — not tight painting but intimate reaction to nature and its curious assortment of life — has enabled me to paint not only what I like but what seems to have general acceptance by artists, critics and laymen."

Riba explains that from very rough sketches a final drawing is developed — usually an abstract. Composition is created first, then articles are collected and arranged in accordance with the design. His final drawings are usually made the size of his projected canvas.

Edna Reindel, one of our most creative artists, has painted a great many still lifes in which flowers are the central attraction. A

47

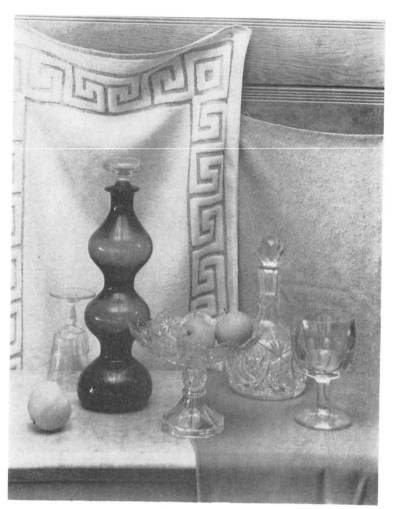

FIGURE 1

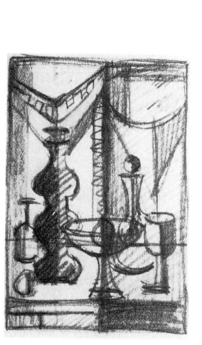

FIGURE 2

FIGURE 3

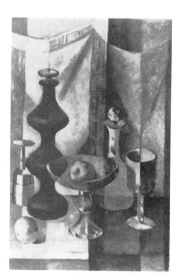

FIGURE 4

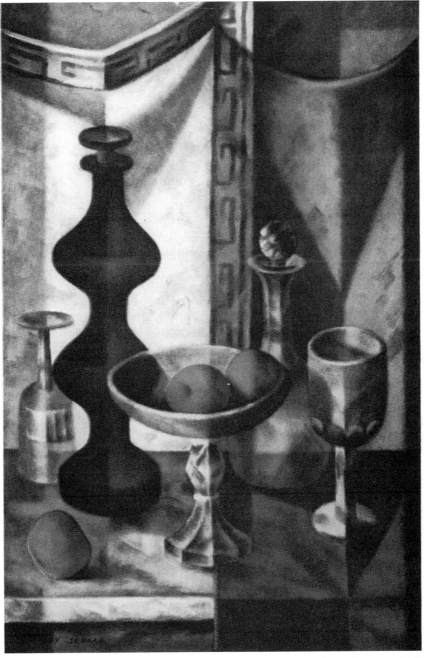

BLUE DECANTER OIL 30 X 20 BENTLEY SCHAAD

Collection Mr. & Mrs. Millard Sheets

An unusual composition: the horizontal division of the canvas by verticals helps, says Schaad, to establish a stabilizing character to play against agitated forms that enliven the picture. He has used the same device in his "Seed Harvest" on the preceding page. On the page opposite we see (fig. 1) a photograph of the still life group; fig. 2, a thumbnail sketch to establish composition and proportions; fig. 3, drawing on the canvas with a bristle brush and a thin mixture of cobalt blue and burnt sienna; fig. 4, start of the painting by establishing the local colors of the various objects and setting the dark and light pattern of the value range.

49

critic once said that she works somewhat like a great flower arranger. She has also been called an "intellectual poet," her art being based on descriptive realism yet inspired by lyrical feeling; her lyricism, however, passing through the deep wells of cerebration before she puts brush to canvas.

Miss Reindel enjoys painting abstractions and does not hesitate to bring abstract elements into her objective painting to achieve effects beyond the range of realism. In *Magnolias by the Sea* she has devised an abstract structure behind the flowers to produce a more positive sensation of depth. Still life is but one of the many facets of Miss Reindel's talent. Recently she has taken up welded, modernistic sculpture, symptom of an insatiable spirit of adventure.

The late Henry Lee McFee is, in my opinion, one of America's greatest artists, especially in still life. Some of his pictures are studied in another chapter. "Still life," wrote McFee, "I always have with me. I find the beginnings of a picture that interests me most in the corner of my studio or in the living room. I keep about me things that I like — common things mostly — shapes that touch me; inanimate objects that take on life when seen with understanding. I prefer a bouquet of wild flowers and field grasses in a common pitcher to the most beautiful peonies in a precious vase set against elegant drapery worth fifteen dollars a yard.

"Being careful not to get too much illumination on the table, I adjust the curtains of my north window so as to get exactly the lighting I want. If there is too much light, not only the table but the entire end of the studio is flooded and there will not be suitable contrast on the group. I arrange and rearrange objects and draperies, always endeavoring to find the organic rhythm that will give me a lead into the endlessly complicated thrusts and pulls of the organization. When I feel that I have the makings, I begin to plan the picture — the unit of design that I hope to make expressive.

"I draw with a light, rather thin, blue-gray oil color. The lines of the drawing are thin and gray at the beginning but as I proceed and the lines are moved back and forth to develop volumes and to secure balance, the canvas sometimes takes on a strange look that would not mean much to an untrained eye. Sometimes at this stage I have to stop and make pencil drawings of part of the group or of a single object, in order to measure my understanding. This is what I call the 'architecture' of the canvas. Even when not developed in

50

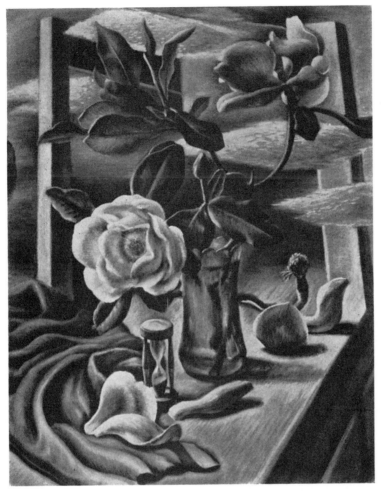

MAGNOLIAS BY THE SEA EDNA REINDEL

color it gives me a pretty secure feeling of how the canvas will build.

"When I begin to paint I place patches of color lightly touched-in on the important projections. Generally these color tones are the halftones just away from the highest light. These I use as tentative color 'anchors.' I then proceed quite rapidly to develop the color from dark to light throughout the canvas.

"I am always conscious of the necessity of preserving the picture plane, and I try to make the canvas tactile in every part — space to be realized as completely as the thing or object. Space becomes the thing and the thing, space."

51

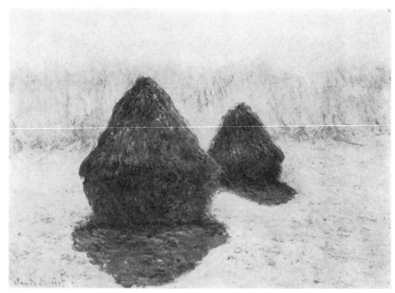

HAYSTACKS IN SNOW MONET
Courtesy The Metropolitan Museum of Art

These pictures reveal opposite creative interests of the two painters. Monet's preoccupation was with naturalistic color effects seen at different times of day. Avery translates nature into dramatic pattern in simplified colored masses.

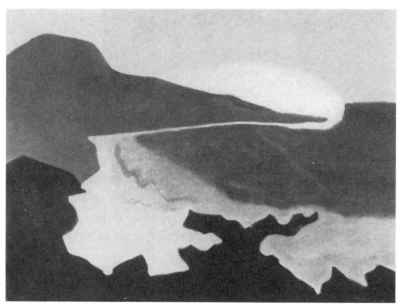

GREEN SEA OIL MILTON AVERY
Courtesy The Metropolitan Museum of Art

52

Landscape

It is not surprising that nature is the source of so much painting, because nature is the environment in which we live: we breath it; we are caught up in its varying moods; moods of rapture, peace, depression and excitation. Thus nature symbolically expresses a great deal of human emotion and serves as a language for the painter's deepest responses to life itself.

Many painters, to be sure, do not think of nature this way: those who are less introspective are likely to make more or less factual records of scenes that impress them by their obvious or superficial beauty. It may be a picturesque scene or just a "pretty" landscape. It may be, as it was with the impressionists, the effort to capture on canvas the illusions of nature's light and color. Recall Monet's famous series of haystacks each painted at a different time of day. It may be a dramatic or spectacular scene comparable to those that inspired the grand scenery painters of the Hudson River School (1825-1870) who were electrified by such natural magnificance as the Grand Canyon and the Rocky Mountains. Illustrative of the theatrical ambition of these men is the painting *Niagara Falls from the Canadian Shore*, by F. E. Church, an enormous canvas which of course nobody looks at today although it can be seen in the National Collection of Art in Washington, D. C.

The trouble with a spectacular subject is the practical impossibility, in a painting, of *using* it: *it* uses the painter because he is really unable to say anything in his picture except, "Oh see this wonderful thing!" Not so a mountain brook, an old orchard or a winding road. With these he can paint a thought, rather than a

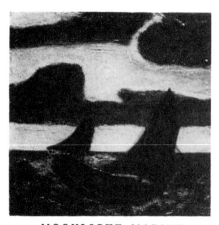

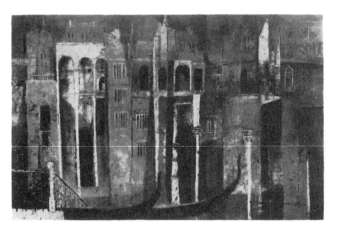

MOONLIGHT MARINE
ALBERT PINKHAM RYDER
Courtesy The Metropolitan Museum of Art

VENETIAN CANAL WILLIAM THON
Courtesy Midtown Galleries

thing. Out of such stuff he can create a mood, paint a poem.

The Fountainbleau painters found a wealth of subject matter in their little strip of woodland; Corot needed only a quiet pool and some bordering trees.

As for picturesque subjects, their quest leads many a novice over miles of terrain, perhaps taking him back home empty-handed. The search for a ready-made subject can prove very frustrating. This is not to deny that some subjects have greater possibilities than others. Some landscapes are especially *paintable*, others may have little or nothing to inspire a painter's brush. Indeed it is surprising what really creative artists do with subjects that most would consider unpromising material. A subject that leaves one person cold may spark the creative imagination of another. I am thinking of those Kenneth Bates paintings of the old apple trees in an abandoned orchard back of his home in Mystic, Connecticut. (See page 75.) "I tend more and more," Bates told me, "to the simplest of material and that which is most familiar. Whenever I swell up to do a grandiose theme I become tiresome. After a futile attempt years ago to paint mountains and palm trees in California, I returned and painted a whole series of things in my own home and yard.

"My effort is to abstract from the welter of landscape the shapes and forms which I believe will serve best as symbols of New England, discarding whatever seems accidental. Then I do a series of perhaps a dozen pastels, followed by three or four oils in which I try to

54

find the most effective way to make them represent our Connecticut country."

Not content with going out into his orchard to paint, Bates brings the orchard indoors. From the wreckage of fallen branches and decayed trunks he picks up fragments and carries them into his studio. One of these still lifes is reproduced on page 74.

William Thon, once speaking of his creative experiences, told me that practically nothing he paints actually exists. "I never paint from memory in the usual sense; never attempt to reconstruct the subject's appearance. Even my Italian canvases are not pictures of existing buildings. I suppose they might be called fantasies inasmuch as they are fictitious and make no pretense of being architectural entities. Often I started with nothing more definite than the merest fragment of a building, then constructed whatever the spirit dictated in form, pattern and color." Thus Thon brought back from Rome no architectural studies of the Arch of Titus, the Colosseum or the Roman Forum.

"Sometimes," he continued, speaking of his landscapes, "a picture is inspired by nothing more than the contrast of the golden color of a dead spruce against a gray boulder. The picture may turn out to be without a spruce or a boulder. This is starting with what might be called the 'wisp of an idea.' With that I strike out on a big canvas and, usually without any preliminary work or preconceived notion of what will finally happen, the picture grows as ideas flow into it or out of it. I mean the suggestions, as everybody knows, are introduced by more or less chance effects that come as surprises during the development of the painting. Some artists depend upon these adventitious impulses more than others.

"After I have something that seems promising, I put the picture in a frame and hang it in our living room. As I live with it for a few weeks, ideas for improvement occur to me and I take the canvas back to the studio, instructed by this leisurely contemplation."

To every artist nature presents a different face. To Winslow Homer the perfect day was one of ominous clouds, black sea and torrential storms when he could fling an oilskin over his shoulders and roam the Coast, pondering the ocean's restless spirit. Man and the sea. This concern occupied the major portion of Homer's life. Pounding surf, primeval rock, hurricane, battered islands, giant pines steadfast in the howling gales. Always profoundly entangled with

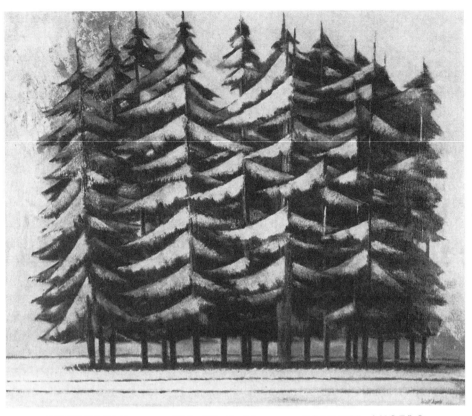

WINDBREAK OIL 25 X 30 VALENTI ANGELO

This canvas as many others by Angelo has been inspired by subjects of the Midwest and the West Coast.

nature's tumultuous nature, these things he painted with as powerful realism as he could.

Turn to a contemporary artist who might be thought of as an "exterior decorator." Valenti Angelo is highly sensitive to natural beauty but he sees nature in highly stylized organizations that emphasize the subject's essential character.

Regardless of the medium, a strong decorative character is fundamental in all of Angelo's work. He is first and last a designer; every visual impression that enters his consciousness passes through a screen, as it were, which translates it into decorative line and space organization. He has never been a "nature painter." In all his work, oils as well as prints (for which he is especially known), there is the same uncompromising definition of color areas, the flattening of

56

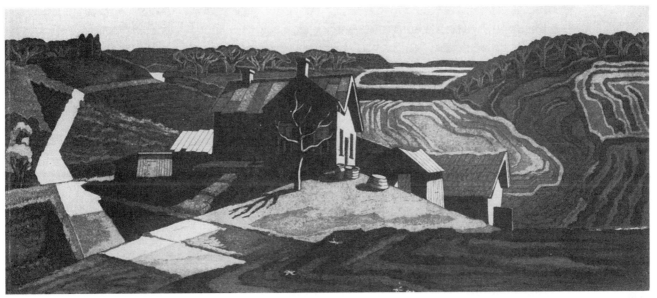

HIGHWAY #7 AQUATINT GEORGE JO MESS

Tonal and linear analyses of "Highway #7," pointing up the close-
ly knit design elements around a relatively simple basic motive

objects, the insistence on carefully planned and related shapes, simplification of form and avoidance of non-significant details. Nothing is left to accident; all is well-ordered and carried out with architectural exactitude.

Inability to see the forest because of the leaves is among the first of the beginner's difficulties. Indeed it is a problem in life itself; the confusions that clutter daily living are a serious obstacle to the clear perception of realities that are shaping our destiny.

Leaves, like the details of our days, have their importance: they supply color to the whole and so are a part of the over-all picture. But in art we always look for the grand pattern rather than minutiae, and we find it in *design* — not in an inventory of facts. So when the artist desires to paint the often seductive, superficial details — and there is nothing reprehensible about that — these should be organized according to a symphonic plan. This inevitably will incline toward simplification. We start with a simple unifying pattern and keep that clearly defined as the picture is being embroidered with the desired details. The danger is that these might camouflage the compositional structure. This underlying structure or pattern is our motive and this motive must always control every detail that is intended to express it. It should not be dissipated by irrelevant diversions.

Perhaps we encounter the absolute in simplification in the work of Milton Avery whose *Green Sea* is reproduced on page 52. This canvas is typical of Avery's work which always should be reproduced in color since color replaces in the original what may seem like emptiness in the colorless reproduction. Still, even in black and white it is a demonstration of the kind of creative vision that seeks the great essential simplicities. It would profit the student to emulate this vision at least as a discipline, even though eventually it may be more fully clothed with detail.

Simplicity, as here discussed, does not imply the severe simplicity seen in *Green Sea;* it contemplates simplicity in an underlying design which controls all elements of the composition, binding them together in a unity such as is demonstrated in that aquatint *Highway # 7* by George Jo Mess. While this is not a simple picture — it is full of interesting detail — a one-tone analysis of it reveals the big controlling motive which is so insistent that it never lets us forget it as we travel throughout the landscape, enjoying all the incidents of the scene. These, anyone can see, are beautifully related to this main

58

theme or motive: a compositional nucleus that draws every part of the picture to it and around it, creating a splendid unity. In spite of the richness of the picture's embroidery, this print has an unusual simplicity and splendid coherence.

A picture that has a simple basic pattern like this is not only easily "read": it has good memory value because simple things are more easily retained in the mind than complex ones. Perhaps a perfect example of this truth is illustrated by Whistler's *Mother*, a portrait so severely simple that almost anyone who has seen it can make a recognizable sketch of its composition. Memory value in itself has a practical importance to a painter: he would like to have his pictures so eloquent in design that they remain in the memory of those who might see them on exhibition walls.

Simplification, as has been said, does not necessarily imply emptiness; a painting can be both severely simple and searchingly realistic. Many of Andrew Wyeth's pictures are in this category, among them *The Cloisters* (see page 154). The cracked plaster and old timbers are rendered with extraordinary intimacy. Yet this illustrative treatment does not in any degree reduce the impact of the picture's simple pattern.

In dramatic contrast to Wyeth, and more related to Milton Avery, is the work of Albert Pinkham Ryder, American Old Master, whose *Forest of Arden* is reproduced on page 17, and whose *Moonlight Marine* is on page 54. The former has more detail than most of his canvases. The latter is more typical of the cryptic quality of paintings by this man who, as Bernard S. Myers says, "represents the finest spiritual emanation of his time." One might think that such canvases seemingly so simple and so small in size might have been quickly painted. The fact is that Ryder was an extraordinarily slow and painstaking painter, working over his canvases through long periods of time. It is said, whether or not in strict accordance with truth, that he worked on *Death on a White Horse* for twenty years. Time and all practical affairs of life had no importance to him; he was poet and mystic who "painted only for himself."

Painting from memory is one way to acquire the attitude of simplicity. I would like to recommend the following method of study as a means of developing it.

If, when driving through the countryside, you come upon an eye-stopping landscape — something you would love to paint — stop

59

your car and sit there trying to get such a strong memory image that you can carry it back without benefit even of a pencil notation.

Don't try to memorize it in detail that will enable you to make a photographic reproduction of all you see; that not only would fail, it would be worthless if you could do it. Ask yourself first what it is that makes the scene so dramatic. Fix those big elements in mind — their shapes, their essential character and their relative importance. Don't try to remember the rest; focus only upon the essentials. Plan your picture. Just how big will that sycamore tree be on the canvas and where placed with reference to the red barn? How much foreground, how much sky? Try to see all this on your canvas.

Take a good long time to record this picture on your *memory film*. Make it a broadly painted picture, elements massed-in simply, with no detail in them. When you try to remember detail you are lost.

Now, you'll find when you get back home to your easel, even if it is not until the next day, that you can remember that picture. Paint it just as you remember it, without detail.

The purpose of all this memory painting is to train yourself while painting on the spot to analyze the subject and seize upon its dramatic essentials. One might think this would be simple, but anyone who has seen much of beginners' work knows it is not; insignificant detail is likely to intrude and confuse the issue.

Try this memory experience and discover for yourself how it matures your painting. See how it sharpens your powers of observation, how discriminating it makes you. If your first experiments are disappointing — and they might be — persist until you see results.

Having experimented with pure memory, making no sketches while on the spot, try next to supplement your memory with quick pencil sketches.

When you come to an interesting subject, study it for exactly five minutes; then whip out your sketchbook — a small size is best — and give yourself five minutes, no more, to transcribe its essentials with color notations written in the different areas. Leave the scene immediately. Time yourself, don't cheat.

Next time allow ten minutes for mental analysis and ten minutes for the sketch. In the next experiment double the time for the sketch.

Now take the pencil sketches home and make small oil studies from each one. Keep the size small because you will not be working in much detail. Take as much time as you need with this but don't

go beyond the dictates of your memory; that is, don't try to make it more "finished" by improvising.

In working this way you will be following the common practice of many professional painters who sometimes find it inconvenient for one reason or another to paint on the spot. People would doubtless be surprised to know how many landscapes are painted in the studio from such sketchy notations.

Of course color is very much involved in these memory exercises; it is an inseparable aspect of composition. In analyzing your landscape subject try to see it in the fewest possible colors, determining at the outset what is the dominant color, then relating a few other colors to it. Color dominance is just as important to the unity of a picture as form and value dominance. Avoid, in these memory studies, preoccupation with subtle color nuances just as you avoid form details. Read what Russell Cowles has written about color in the chapter on that subject.

If you use rather large oil brushes — none smaller than one-half of an inch wide perhaps — you will find that these act as a wholesome

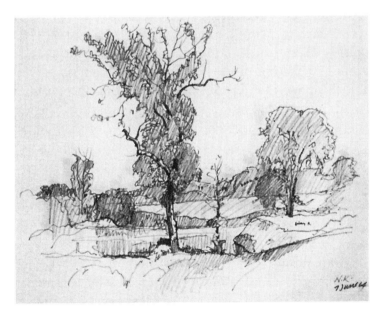

DRAWING 8⅞ X 11⅝ BY NORMAN KENT

While Kent often makes very careful drawings from nature, a rough sketch like this, with written notations, serves as the basis for many a watercolor that may be painted in his studio.

discipline in preventing your work from becoming fussy either in color or in detail.

Should you visit Norman Kent's studio you would at once be aware of his use of drawing as a means of study and as preparation for his watercolor paintings; pencil sketches and graphic notes are very much in evidence.

"Seldom do I paint from nature," Kent says, "without having first familiarized myself with the subject through the making of a separate sketch. Usually these studies are linear in character and are rapidly made. If there is any doubt that the light will fade or that there may be no time for the painting of an immediate watercolor, I often add tone to the line to record the shadow patterns. It is from such drawings that I have painted in the studio — being further guided by a set of color notations indicated on the sketch, to augment my memory, particularly as it concerns local color.

"Even when a watercolor has been painted *on the spot*, following the separate preliminary sketch, I find that on returning to the studio and placing the painting in a trial mat for study — for its subsequent adjustments, and/or alterations — my best guide is the initial drawing. Why? In those first few minutes the receptive eye is brightest, the salient forms that attracted me to the motif in the first place are plotted with intensity — some of which can be lost in painting.

"But apart from the making of these fragmentary sketches which have an immediate application, or at least have this potential, I produce many, many more that are *independent* drawings. These are usually carried out in a restricted set of values, drawn on a variety of paper surfaces in 9 x 12-inch size, and executed with a 3B carbon pencil — a favorite tool that I have used for thirty years. However, augmenting carbon, I have used graphite, charcoal, and ink. The latter is seldom used in the field but is employed with a brush in making compositions on successive sheets of tracing paper placed over the original drawings. This is the method I always follow in developing the designs for my woodcuts, sometimes 'taking up' a particular drawing made months, or even years, previously.

"One final observation: in returning to a subject after a lapse of time, I find that the making of new drawings under different light or seasonal conditions often provides a greater synthesis. Experience has taught me that returning to a good motif — especially a challenging one — is well worth the effort."

PEACEFUL WATERCOLOR 18 X 24 BY NORMAN KENT

Collection, Arnot Art Gallery, Elmira, New York

Language Of Line

*T*here is a language of line. Line has an emotional and esthetic impact in any picture whether, as in Paul Cadmus' *Snow Fence*, the composition is practically limited to lines, or whether the elements of form and color are so designed as to lead the eye in a line or direction of movement as in Kenneth Bates' two canvases reproduced on pages 74 and 75, and in other pictures in this chapter.

Snow Fence is reduced to a pure line construction in order to emphasize its beauty as an abstraction. And on page 66 I have drawn the contours enclosing the pickets to point up an interesting facet of the total design. This of course is no accident: all aspects of any design function harmoniously toward a unified composition. The four enclosures are numbered to call attention to a sequential relationship in size and area, stepping down from largest (1) to smallest (4). We often see this kind of orderly arrangement in picture areas. If a tracing of this enclosing form is made without the tall post, the necessity of that post from a purely abstract viewpoint will be seen; it is as much needed to support the abstract forms of the design as was the post itself to support the fence.

Some years ago when I was teaching composition, I gave my students the problem of creating an original snow fence design, asking them to set up the fence in various ways, working only with the abstract line structure in the manner of the accompanying analysis. The exercise proved very stimulating: the student drawings, when exhibited as a group, displayed a surprising variety. It was a most instructive performance, one that is recommended to my readers.

From the many pictures in this book I have tried to select for

65

SNOW FENCE PAUL CADMUS

A PENCIL DRAWING

Courtesy Midtown Galleries

This drawing was used as a cover for American Artist *and is reproduced from that cover, the original drawing not being available. Fig. 1 reveals well-designed shapes, created by outlining the fence pickets. Fig. 2 indicates the obvious direction of the eye travel in this picture.*

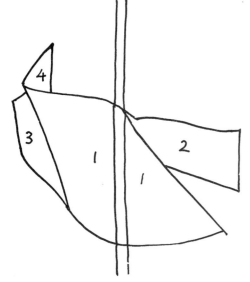

FIGURE 1

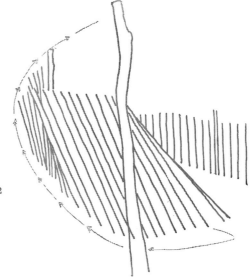

FIGURE 2

66

VIEW OF ATHENS OIL LAMAR DODD

This canvas has a very unusual line design as indicated in the accompanying analysis.

CASH ENTRY MINES
MARSDEN HARTLEY

Courtesy The Museum of Modern Art

The suave linear design of this canvas is not characteristic of most of Hartley's work. Usually his compositions have a bolder, less compromising attitude such as his "Smeltbrook Falls" on page 18.

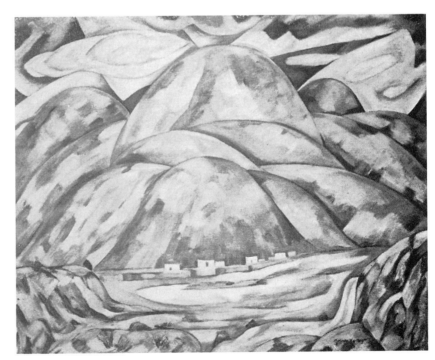

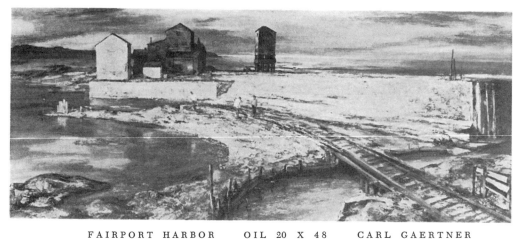

FAIRPORT HARBOR OIL 20 X 48 CARL GAERTNER

The linear design of this picture is noteworthy;
the long horizontal lines are held together by
the well-placed curved elements.

this chapter on line those which have a particularly impressive line composition. Marsden Hartley's *Cash Entry Mines* is predominantly a line design, as a pure line tracing of the picture will emphasize. It runs into some danger of monotony through excessive rhythm in the curvaceous lines of the dome-shaped hills and swirling foreground movement — there is such a thing as too much harmony. However, the jagged cloud lines and the rectangular buildings, small as they are, perhaps save the picture from this criticism. Seldom has Hartley indulged in this kind of rhythm: his works generally are characterized by robustness rather than gracefulness.

It is line that is first noticed in Lamar Dodd's *View of Athens* (Georgia) and most certainly it must have been that aspect of the scene that attracted the painter. It is an unusual linear pattern, one that, in its angularity, could have resulted in awkwardness. The way in which Dodd has opposed the angularity by insistence upon the curved landscape elements is, I think, a noteworthy compositional achievement. We may be sure that the balanced adjustment of straight lines, angles and curves in this design was arrived at creatively rather than by the accurate recording of the scene.

68

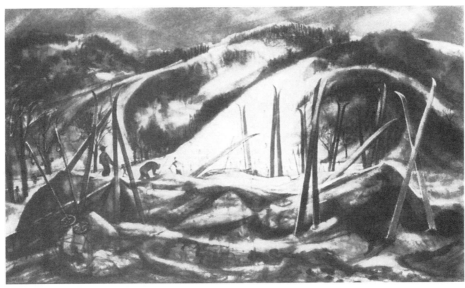

Linear interest dominates this canvas. The interplay of rhythmic lines is most skillfully managed. They have a wholesome opposition in the vertical skis which provide desirable tension and keep the ski run from being too "slippery."

In Carl Gaertner's *Fairport Harbor* we see another interesting combination of curved and straight lines that, like Lamar Dodd's painting, gives the canvas its predominantly line basis. An elongated composition like this is difficult to organize so that its great stretch of interest is bound together as a unit. The curved lines here are a strong factor in achieving this coherence.

William Palmer's *Snow Ridge, Turin* is another canvas that has a conspicuous line basis. Put tracing paper over this picture and trace its main lines with a heavy stroke; then with a lighter stroke add the subordinate lines. Next note how important are the straight lines of the skis that serve to oppose somewhat the flowing movement of rhythmic curves, while they give needed idea content to the picture. It would be interesting to make a line analysis of the skis alone, as was done with the posts in Julian Levi's painting, in order to be conscious of the painter's experience in arranging them. While of course they were designed in relation to the curved elements they will be found esthetically satisfying when seen thus isolated.

Stephen Etnier's *Winter* is an unusually simple composition with

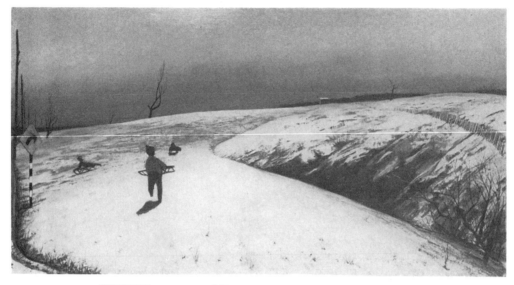

WINTER OIL STEPHEN ETNIER

a linear design that just had to be right because without the interest of many details that in some pictures can at least divert attention from basic structure, the linear design and the resulting shapes must stand boldly on their own. To discover how necessary that vertical figure of the boy with his sled is to the design, cover it with a scrap of paper, and you will find his absence from the *design* as serious as it would be from the picture's illustrative intention. The part played by the trees on the horizon, in spite of their delicacy, should not be overlooked.

In the paintings *Empire of Fools* by Henry C. Pitz and *Taxco* by Andrew M. Dasburg which seem at first glance to have nothing in common, we see upon study that the composition in each is motivated by a circular movement, particularly emphatic in the latter. In the former this movement is powerfully promoted by the arrangement of the placards and the lines emphasized in fig. 1. The sweep of the dark cloud-mass repeats this action at the top of the picture. This swirling movement in the composition is violent but it is held in check, and the composition stabilized by the triangular drapery (A) that crosses its path at the right and by the nearly horizontal lines B and C — also by the leaning columns which pierce the ellipse, diverting our attention and pointing it upward out of the elliptical path (page 72).

70

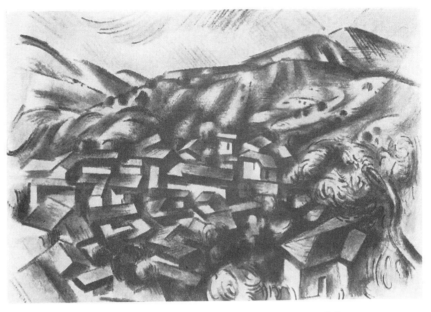

TAXCO ANDREW M. DASBURG

A composition with an unusual line pattern; it winds itself up in the manner of a watch spring. This movement is checked by the lines of the hills and the tree that projects into the picture from the right side.

Now from the following comments by Mr. Pitz on the compositional action, we are told that he is directing us principally *through* the arch instead of over it as indicated by the encircling ellipse of our diagram. And our attention is indeed drawn to that dramatic action on the slender bridge *after*, it seems to me, we have encompassed the big movement that takes us *over* the arch. I think there is no contradiction here because the movement I have indicated may be likened to a frame that encloses the intended action. It is interesting to see, in Mr. Pitz' preliminary studies, that in his first pen study of the composition he had this elliptical design in mind; and that he came back to it after experimenting with other compositions which lack the unity and coherence of his original idea. Mr. Pitz discloses the source of the idea for this strange picture.

"The *Empire of Fools* grew out of the three composition sketches reproduced here in small size. They in turn had come about because I had seen, in some newspaper, a photograph of a happy crowd at a circus, set against the shattered walls of a European city. From that chance glimpse of a photograph sprang two quite different thoughts: first, the consoling thought that man, even in the midst

71

FIGURE 1

FIGURE 2

FIGURE 3

FIGURE 4

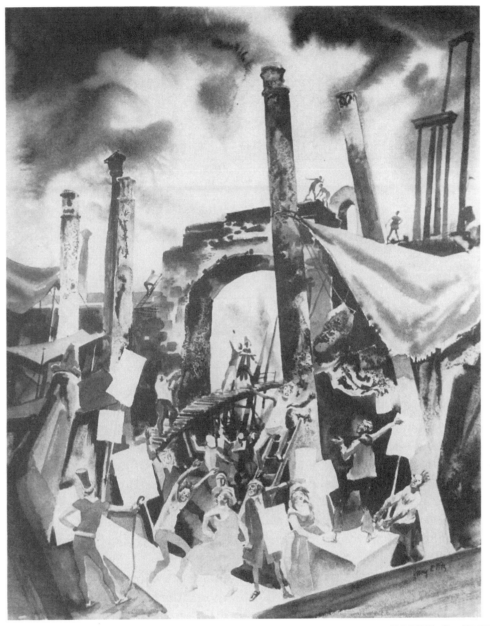

EMPIRE OF FOOLS WATERCOLOR 30 X 25 HENRY C. PITZ

*Fig. 1 on the facing page, the author's analysis of the picture's structure,
calls attention to its elliptical movement, pierced and delayed by the columns.
Figs. 2, 3 and 4 are the painter's preliminary studies done at intervals of about
a week while the pictorial idea was taking shape. None was followed ex-
actly: the first one, fig. 2 (and the last one executed), is the nearest to the
finished picture, though no attempt was made to use it except as a general
guide. It is interesting to note how confused the fig. 4 sketch became.*

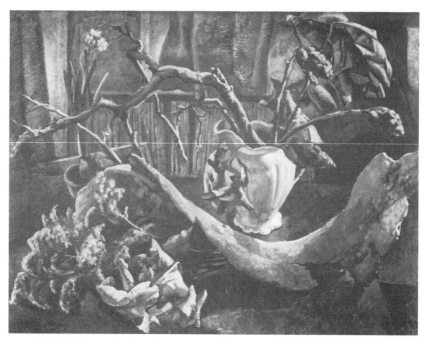

BRANCH AND BARK OIL KENNETH BATES

The rhythmic line movement in this canvas is its primary structural basis.

of ruin, tries to patch together something of pageantry and fun; and, second, that man, even with a large part of his hard-won civilization crumbling under his eyes, must dissipate his energies in a thousand-and-one foolish, selfish and knavish ways. The second thought found its way into this picture. Once the composition began to take shape, the commanding impulse was to make the most of the brightly colored pattern of the agitated figures and placards against the deep-toned sky and the bitter beauty of a ruined city. . . . I began to work on the areas around the long column that thrusts down over the orating figure in the foreground. I did this because I was following one of the major rhythms in the picture. Next came the figure on the platform. From here on, the step-by-step progress becomes too involved to explain, but in the main I worked on several more foreground figures and swung the rhythms around and back into the picture through the agitated figures in the middle distance and on through the procession coming through the archway."

In both Kenneth Bates' canvases, which are fully discussed in the chapter on Landscape, line is a major factor in their coherence, rhythm and grace of movement.

74

TWO TREES OIL KENNETH BATES

As in Kenneth Bates' "Branch and Bark" we are impressed in this picture by the rhythmic movement in the tree masses which give the suggestion of a handclasp between two sentimental old cronies. It is interesting to note how the intruder seems not only to oppose the rhythmic foliage flow of the apple trees, but to play an important idea role in the drama of the neglected orchard.

HOMEWARD BOUND COLOR WOODCUT 7 X 10 ERNEST W. WATSON

This is an interesting example of a symmetrically balanced com-
position. One diagram below shows how the picture is designed
around a vertical center. The other isolates the lightest shapes
to emphasize their importance in achieving the picture's stability
in a symmetrical organization. This reproduction does not quite
duplicate the values of the original: in the print the color of the
distant mountain is considerably darker at the summit. The
cemetery hill is in three shades of green, the water green-blue.

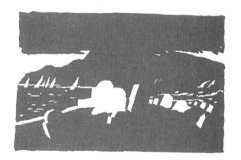

76

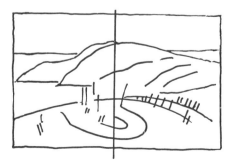

Balance

Balance is a fundamental law of the universe: All else is predicated upon it, both in nature and in the affairs of man. Growing trees put out their branches from the trunk in the most advantageous way to achieve stability. As for man, ever since learning in babyhood to balance his body on his feet he has become progressively sensitive to it, so much so that the *appearance* of balance is almost as essential to his comfort as is physical balance itself. To a highly trained artist and designer it *is* essential. Visiting in the home of a prominent sculptor, I witnessed an impressive example of this super-sensitiveness. As we sat talking, a six-year-old grandson passed through the room and bumped against a low cabinet, toppling a small sculpture on it. He replaced it carelessly. When the child had gone, my friend got up and without interrupting the flow of conversation set the piece in what obviously was its studied place among other objects.

Sensitivity to esthetic, visual balance is not so unusual. Practically everyone has it in some degree. Even the most unsophisticated housewife will place objects on the mantle-shelf in a balanced arrangement, disposing the candlesticks at equal distance from the clock in the center, or arranging a group of objects in dead center to satisfy her intuitive feeling for visual balance. But the average person's sense of balance, both physical and esthetic, remains rudimentary and uncultured unless persistently developed through study and exercise. The spectacular performances of professional acrobats make us aware of the tremendous physical gulf between trained and untrained muscular coordination. In the realm of esthetic balance the disparity between the artist's sensitivity and that of the layman is fully as great.

77

Symmetrical balance is elementary but only through much study can one achieve any appreciable degree of sensitivity to asymmetrical balance; and almost every move in picture-making involves that kind of balance.

Every picture ought to have stability, even one that has such violent action as Joseph De Martini's *Wreck at Squeaker Cove* on page 171. When we study that picture carefully we discover that despite its turbulence it is solidly balanced. The action is wholly within the frame; it does not invite our thought outside the area of the canvas. The drama is complete within it.

Now that we have referred to the analysis of a rather complicated picture, let us get back to where it is more natural to begin: to the simpler compositions that we will now consider.

Alexander Brook had a very good purpose in using symmetrical balance in his *Family Unit.* Like every good painter he has a sound reason for everything he does. In this canvas he is portraying an indigent couple standing passively before their desolate shack. Victims of circumstances beyond their power to change, they are anchored to their little shabby world, hence in a static state of helplessness. This is not a situation that suggests action: the stark symmetry of the picture with its dead-center balance is a telling dramatization of the painter's message.

In James Peale's still life, *Balsam Apple and Vegetables,* the painter has relieved the rather mechanical centering of his group by darkening one side of the canvas and thus giving it a sense of asymmetry that, otherwise, would be lacking.

Workshop of Chardin's *Supplies for Lunch,* an exceedingly awkward bit of symmetry so far as the composition of the entire group is concerned, is saved somewhat from its triangularity by the way in which the plate, the cup and the loaf have a tendency to isolate themselves in a detached ensemble — since they hold together as a light silhouette — and form one asymmetrical design by themselves.

Charles Burchfield's choice of symmetrical balance was particularly appropriate for his *February Thaw,* painted during a season when vertical lines are expressive of melting and dripping and of reflections in watery streets; static, windless, placid days, contrasting dramatically with a different mood that we see in his *An April Mood* (page 163). In that canvas the wind-blown clouds and stark trees, wounded by a severe winter, create turbulent action that could not

78

FAMILY UNIT OIL ALEXANDER BROOK
Courtesy Rehn Galleries

BALSAM APPLE AND VEGETABLES
JAMES PEALE
Courtesy The Metropolitan Museum of Art
Maria De Witt Jesup Fund

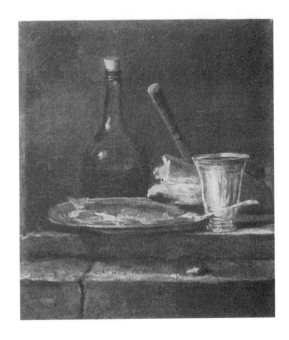

SUPPLIES FOR LUNCH
WORKSHOP OF CHARDIN
Courtesy The Metropolitan Museum of Art
Wolfe Fund

79

FEBRUARY THAW WATERCOLOR CHARLES BURCHFIELD

Courtesy Brooklyn Museum

An example of the expressive use of static balance — this inaction of melting snow and unruffled reflection. Compare this picture with An April Mood on page 163, a picture that is in violent action.

WINTER HARBOR MAINE CRAYON STUDY SYD BROWNE

Balance of opposing rock masses and thrust of sky lines

80

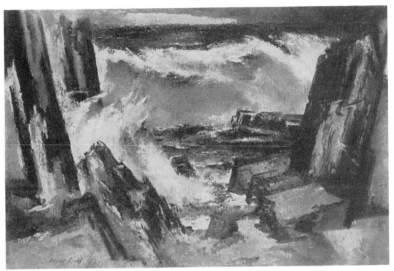

MONHEGAN THEME OIL LAMAR DODD

Courtesy The Metropolitan Museum of Art; George A. Hearn Fund
Balance of opposing rock masses held to-
gether by the horizontal lines of surf and sea

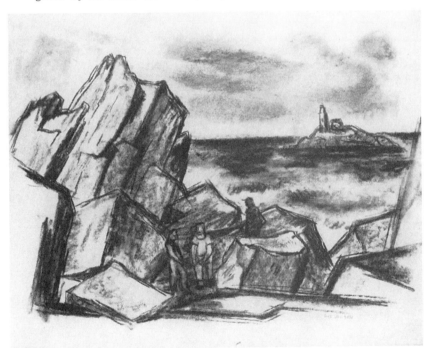

THE LITTLE ISLAND CHARCOAL STUDY SOL WILSON

Balance of interest. The little island with its lighthouse be-
cause of its idea interest balances the huge rock mass.

81

THE BLUE CART, OUTER HEBRIDES WATERCOLOR OGDEN PLEISSNER

The cart, though the heaviest mass in the picture, acts mainly as a foil for the more interesting distance. Balance of mass and interest. The line sketch is shown to call attention to the line of flying birds, which helps to lead the eye back into the distance.

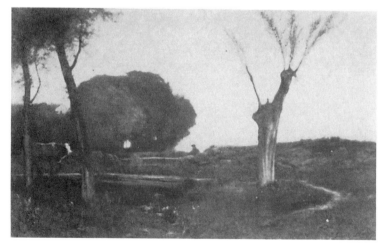

EVENING AT
MEDFIELD, MASSACHUSETTS
GEORGE INNESS

*Courtesy The Metropolitan Museum of Art
Gift of George A. Hearn*

*Balance of mass with interest similar to
that of "The Blue Cart" above*

82

possibly be fitted into a static composition. Turn again to Childe Hassam's *Golden Afternoon* (page 36). How appropriate to its mood is the picture's symmetrically balanced composition!

In Lamar Dodd's *Monhegan Theme* we see a quite different type of balance: a state of equipoise between two nearly equal opposing forces, the equilibrium maintained by the horizontal lines of the sea which hold them together in a state of tension that might be likened to that produced when two persons standing somewhat apart clasp hands and lean backward, mutually supporting each other with outstretched arms.

The painter is forever concerned with the *thrusts and pulls* of line, volume and color, which can become very complicated as they are in De Martini's canvas, to refer again to that extremely active, yet perfectly balanced painting. It is the thrusts and pulls — tension — that I referred to formerly when I spoke of a picture "working."

The uninstructed person, of course, is wholly unaware of these forces operating in a picture unless they are not properly controlled, in which case he may well feel disturbed without understanding why.

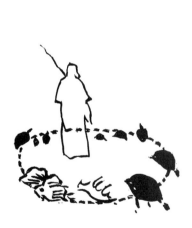

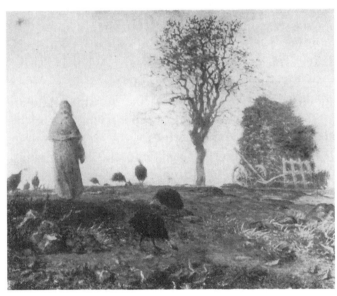

THE AUTUMN JEAN FRANCOIS MILLET
Courtsey The Metropolitan Museum of Art

Here also we see the balance of interest and mass. The eye always focuses upon that which has the greatest interest. The diagram calls attention to an interesting compositional factor—the figure encircled by the turkeys.

83

Syd Browne's sketch for his painting *Rocky Coast* (page 80) displays a type of balance similar to that seen in Lamar Dodd's *Monhegan Theme*. Here, the dominant sloping mass of rock at the right pulls away from the low-lying mass at the left; but this and the slanting lines in the sky, taken together, are sufficient to compensate for the heavy pull of the greater rock mass.

In Sol Wilson's *The Little Island* also, and in George Inness' *Evening at Medfield, Massachusetts*, we see how *interest* alone can balance weight. There is tension here too; tension in the competition between two points of interest for our attention — the distant isle with its lighthouse and the large rock-mass. In the Inness, that isolated dead tree bears a similar relationship to the tree-mass on the left: its compelling interest challenges the weight of the larger bulk on the left. The balancing of interest against weight is strikingly demonstrated in Will S. Taylor's *Lookout Rock* on page 147. Here the tiny sail is a powerful balancing foil for the huge rock-mass.

Ogden Pleissner's *The Blue Cart* is in the same category. The cart, a large interesting mass in the immediate foreground, is bypassed in our first glance which goes immediately to the white cottage, thence to the small house on the distant hill — the two buildings holding their own with the big cart in the balance of the picture. The eye is always drawn to what is most interesting. A mouse crossing the street will get far more attention than a big red truck standing at the curb. The line study of Pleissner's canvas is shown in order to call attention to the curving line of the flying birds (which may not be seen clearly in the reproduction) and which is important in leading us back into the more distant part of the picture.

In Millet's *The Autumn* the mass attraction is on the right, where the tree and the grain stack first catch the eye. But only for an instant: we quickly turn to the figure of the farmer and the turkeys and our interest focuses on the left half of the picture where, indeed, that horizontal branch also leads us as would a pointing finger. And note how important the turkeys are in this composition. As a matter of fact they are indispensable, as is the darkened ground at this point which provides a mass-balance for the haystack. Could it be coincidence that the turkeys and the stones form a circular stage, as it were, for the farmer?

Chardin's *The White Tablecloth* is interesting in the matter of balance because it demonstrates that a dark mass (the bucket at the

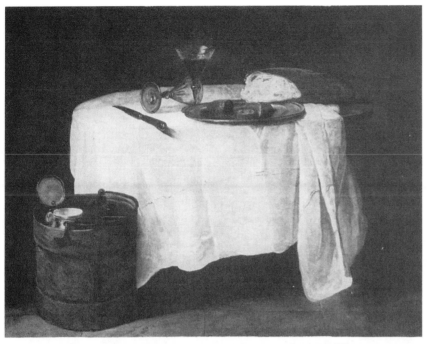

An interesting example of the balance of light and dark elements—the white tablecloth on the right and the dark keg on the left. The eye, intrigued by this object and its contents, enters the picture at that point and travels through it as indicated in the accompanying diagram.

THE WHITE TABLECLOTH CHARDIN
Courtesy Art Institute of Chicago

Mr. & Mrs. Lewis L. Coburn Memorial Collection

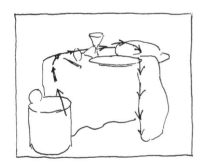

BRIGHT INTERIOR
WILLIAM G. VON SCHLEGELL

Courtesy The Metropolitan Museum of Art
George A. Hearn Fund

This painting is shown to introduce the subject of balance of rectangular shapes—the window, the pictures and the chair back.

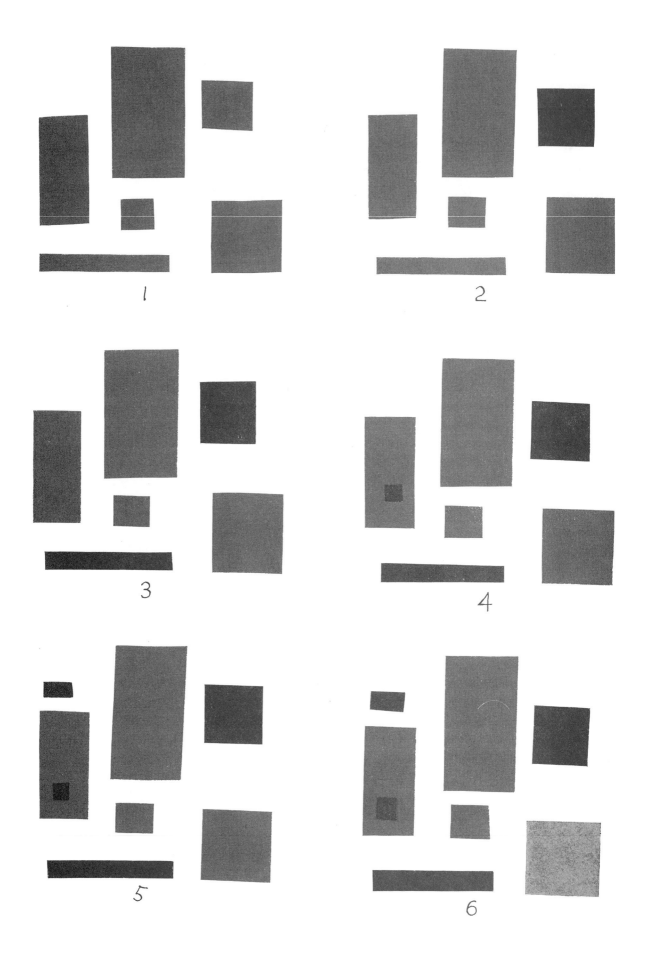

1

2

3

4

5

6

left) can balance a light mass (the hanging tablecloth at the right). Does the eye follow the path of interest indicated in the accompanying diagram? I think that it does, because in spite of the visual pull of the white cloth, the bucket with its contents has a strong enough illustrative appeal to lead us into the picture at that point.

A very common and useful kind of asymmetrical balance is seen in Von Schlegell's *Bright Interior* where a variety of shapes or forms of different sizes are composed in an agreeably balanced composition. This kind of treatment calls for a highly trained sensitivity to design which can be cultivated only through continued practice until the rightness becomes a feeling rather than a mechanical weighing of masses and/or interests.

On the opposite page there is an experiment with a composition involving balance of a few rectangular objects. This looks very simple, but similar exercises conducted with a group of students will demonstrate that individual judgments vary considerably.

Take any set of rectangles of uniform value and keep the same shapes throughout the exercise.

Let us assume that we have a balanced arrangement of six units in fig. 1. When in fig. 2 we blacken one of the units, we throw the design out of balance, and in fig. 3 we offset this by blackening the narrow horizontal unit. While this improves the design, we think that the addition of more black at the left is needed and we add the small black square in fig. 4. We may not be completely satisfied with this and feel the need of more black, particularly higher up at the left (fig. 5) to compensate for that large black square at the right. Now, do we have a reasonably well-balanced composition?

In fig. 6 we throw the entire scheme out of balance again by lightening the lower-right rectangle. The reader is invited to make whatever changes in the design are needed to restore the balance which this lighter unit has upset.

This exceedingly elementary exercise may perhaps lead students to a greater appreciation of such abstract paintings as Ralston Crawford's canvas, *Third Avenue Elevated*, which is like going from five finger exercises to symphonic composition. Those who are fortunate enough to be receptive to art in the absolute will find an esthetic thrill in this canvas as in the best work of this famous modern painter. Of course the halftone reproduction, translating the colored image into gray tones, reveals only a part of the picture's message,

THIRD AVENUE ELEVATED 30 X 40 RALSTON CRAWFORD
Collection of Walker Art Center, Minneapolis

but for the purposes of reference in this discussion of balance it serves very well. It will no doubt be difficult for those who are conditioned to enjoy only what is "recognizable" to appreciate what has been accomplished here. I suggest that those who want to learn make a careful tracing of this picture and attempt to reproduce it with tempera paint as perfectly as possible. That experience will prove to be educational; it will lead to better realization of the fascinating problems in the balance of tones and shapes, and it will be a lesson that will apply as practically to realistic painting as to abstraction or non-objective work.

88

Drawing

Michelangelo wrote, "Let this be plain to all: design, or as it is called by another name, drawing, constitutes the fountainhead and substance of painting and sculpture and architecture, . . . and is the root of all sciences. Let him who has attained the possession of this be assured that he possesses a great treasure."

I quote these words of the great Renaissance master because they express the truth about drawing as it concerns the painting student: the interdependence of drawing and design. The late Maurice Sterne expanded this idea during my interview with him some years ago. He said: "It is axiomatic that a good painter must be a good draftsman. Yet students often ask if I think it important for the painter to draw well. Evidently they imagine that color in some way is a substitute for drawing, at any rate that it helps out when drawing fails. But must not every touch of color, laid on canvas with brush, have a shape? How can you control that shape without a knowledge of drawing? So often the beginner will start loosely without form to his painting. As the painting develops, a sound knowledge of drawing will make his task much easier, more enjoyable and much more direct — for it is the constant struggle with the drawing which destroys all freshness and, in the end, will turn something spontaneous into a tortured battlefield. Yes, painting is drawing with a vengeance! By all means get a good fundamental training in drawing."

Well, no one can disagree with that. However, it might occur to some to ask for a definition of good drawing since, obviously, the traditional concept of good drawing is by no means wholly valid today. Warren Wheelock once answered that question with con-

siderable clarity: "Everybody," said Wheelock, "has his own conception of what good drawing is, but as everybody has his special degree of idiosyncrasy of artistic sensibility (or lack of any sensibility) a multitude of concepts of good drawing results. The common, insensitive concept of good drawing is that it need only have an exact delineation or faithful reproduction of something seen; or have so-called 'good craftsmanship.' A better concept which comprehends a wider field of artistic appraisal is one in which there is verisimilitude but with a quality of workmanship which we may call 'spiritual,' for want of a better word, connotating refinement and sensitiveness in the drawing technique. Then there is the good drawing that has slighted resemblance in favor of a synthesis of simplification. And finally there is the good drawing which has left exactness out, or done away with resemblance entirely, and which appears to be accomplished with feeling and so fluently that it is calligraphic in character or has become an invention, seeming to be intuitively, almost unconsciously produced. In between these classifications are countless nuances of concepts of good drawing."

It might be added that, contrary to the notion that every eye receives the identical visual impression of any given object — the photographic report of a camera lense — is the fact that things look different, often radically different, to different people. We are not mechanical receivers of visual impressions; many conditions, physical and highly personal, have provided us with what may be called distorted vision, if there can be said to be such a thing as normal vision. The present-day ready acceptance of odd-angle camera shots illustrates how easy it is for us to modify concepts of appearance. Before the days of the skyscraper, for instance, a photograph having converging vertical lines was inexcusable; now when we are accustomed to look upward at a towering facade we accept that convergence without question because we see it that way.

The discovery and development of scientific perspective in the Fifteenth Century caused a revolution in visual concepts. Before then, pictorial appearances were readily accepted that were quite unlike the photographic reality that we now think of as *true appearance*. Actually there is no such thing as true appearance. The eye can become conditioned to almost any concept through familiarity and common usage. Modern art has indeed conditioned us to acceptance of what traditionally minded people consider bad drawing — distortion. The

90

modern artist wants freedom to arrange the forms and direct the lines of his composition whatever way they will express most adequately his esthetic intention without the necessity of conforming to illustrative accuracy. This attitude presents a conflict between design and natural appearance and gives rise to distortion that is unacceptable to many people even today when it is a commonplace.

Not that there is anything new in distortion. One has only to be reminded of almost all pre-Renaissance art — that means much of the greatest art ever produced — to realize that except for a period of about five centuries there has been little art without it.

Be that as it may, it is still difficult for many people to accept the validity of distortion in contemporary art. "Why," one may ask, "should Isenburger draw such a cockeyed chair as we see in his *Still Life?* Why should André Derain have drawn his table (page 129) with its back-edge longer than the front, contrary to normal appearance? Why should Sigmund Menkes draw so 'carelessly' as he did in his *Still Life with Half Melon* (page 95)?"

What really is important in Isenburger's *Still Life?* Is it that he should make a photographically correct drawing of that old chair? Obviously it is not an *objet d'art* which he offers for our admiration; the broken chair merely gives him forms and spaces with which to create an intriguing design. Note the arrangement of spaces between the chair legs and rungs to see how artfully he has arranged these elements. It is in that sort of abstract relationship, and of course in the color which illumines the whole, that the painting claims our interest and affords us pleasure.

As to the distorted ellipses of the jar, observe how they lean into the picture, clinging, as it were, to the chair-forms to create coherence with them through integration of form and pattern. "Correct" the drawing of the jar — try making it stand upright with mechanically accurate ellipses, to prove the rightness of this distortion.

If we had to find a reason for the distortion of the teapot, other than the painter's natural preference to paint it that way, the obvious one is that it *has* to be distorted to be in harmony with all other distortions in the picture. And of course the spout has to be turned inward. This is the same teapot that appears in *The Fading Poppy*. Evidently the painter warps this favorite still life property into any shape that may be suggested by the exigency of the composition.

Furthermore, the true ellipse — like the circle it represents —

is a purely mechanical form. *In itself* it lacks the esthetic interest of a distorted ellipse. Very few painters will draw a *perfect* ellipse; even a slight distortion which may not be noticeable to the casual observer serves as relief from geometric rigidity. Mechanical perfection more often than not is actually incompatible with esthetic purpose. A distorted form can record the artist's emotional response to his subject as he molds all elements into harmony with the spirit of the whole work.

Yet there is no inherent virtue in distortion; it is just a manner of speech available to those who are more eloquent when speaking in that way. We might compare distortion in painting with dissonance in modern music that coexists agreeably with the classical.

Among many other fine American artists known as traditional painters, Robert Brackman and Henry Lee McFee work in what may appropriately be called the classical style. Their canvases painted in a realistic manner have a poetic affinity with the best of Chardin's, wholly devoid of affectation and expressing homely sincerity enhanced by a jewel-like technical quality. They have a just-rightness that gives very great pleasure, a quiet charm that contrasts strongly with the more restless nature of much modern painting. Their canvases have no need of distortion, at least not appreciable distortion. Many of them, on close inspection, will reveal a subtle distortion that has a purpose in enlivening the composition, as in McFee's *Still Life, Dead Leaves* (page 98) wherein the ellipse of the dish slants upward into the group instead of being horizontal in accordance with scientific perspective. Should one inquire if perhaps this is accidental, the

One-tone pattern analysis and line analysis of Isenburger's "Still Life"

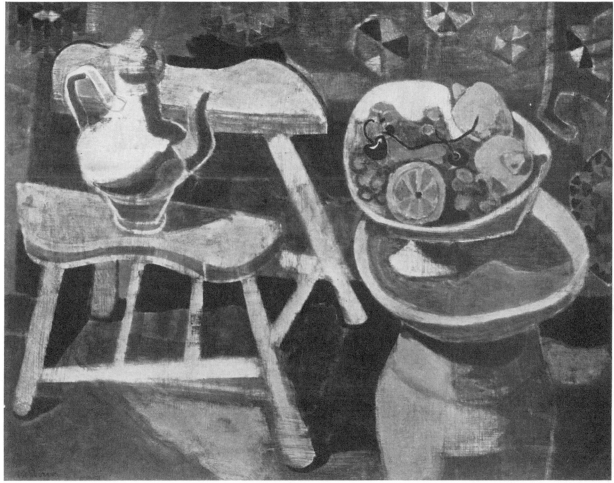

STILL LIFE OIL 30 X 40 ERIC ISENBURGER
Courtesy Knoedler Galleries

Isolation of pattern of interstices within the structure of the chair

These two drawings of the same pitcher (see page 4) illustrate how the artist used this object creatively to suit requirements of a particular design situation.

93

THE BANKER'S TABLE WILLIAM MICHAEL HARNETT
Courtesy The Metropolitan Museum of Art
Elihu Root Jr. Gift Fund

FRUIT AND WINE VIKTOR SCHRECKENGOST
WATERCOLOR 22 X 30

94

Author's sketch of the vase that served the painter as model for the object in his painting

same question may as well be raised about some subtle harmony in a Beethoven symphony.

Distortion, as has been said, is good drawing when it contributes to the realization of the artist's intention. But even in highly realistic work there is a wide gulf between merely correct drawing, such as we see in *The Banker's Table* by Harnett and the sensitively rendered drawing in Chardin's *Kitchen Still Life* on page 12. In the Harnett picture we find very limited pleasure in the painter's super-photographic technical performance; in the Chardin, we are seduced by esthetic qualities of the work as a whole, the grandeur of composition rather than factual inventory.

Cézanne's *Still Life with Fruit Basket* is a classic example of creative distortion of visual appearance. In his book *Cézanne's Composition*, Erle Loran has made an interesting study of this canvas. He has generously permitted us to use his diagrammatical analysis which is reprinted at the top of page 96.

First note the various eye levels I, II, IIb and Ia. The objects lettered D and E are drawn as viewed from a much lower level than the jar F and the basket, though all are on the same table top. Mr. Loran calls attention to the top of the ginger jar, F, and the basket which are viewed from a much higher level, II, as is the table top

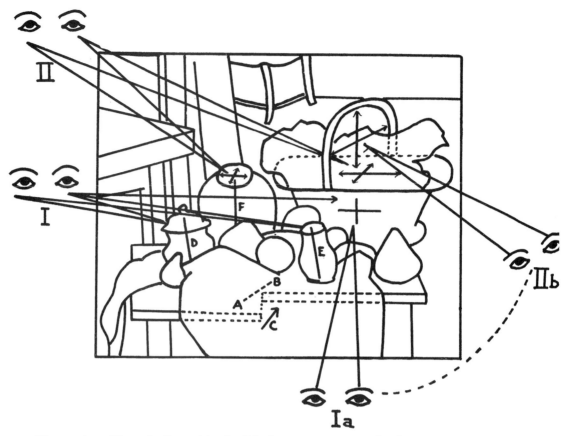

Diagram from Cézanne's Composition *by Erle Loran pointing out what he terms "Universal Perspective." This means the drawing of objects in a picture as seen from different eye levels.*

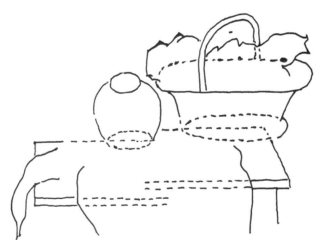

Diagram to indicate the "impossible" positions of the basket and jar on the table. They overhang the table edge.

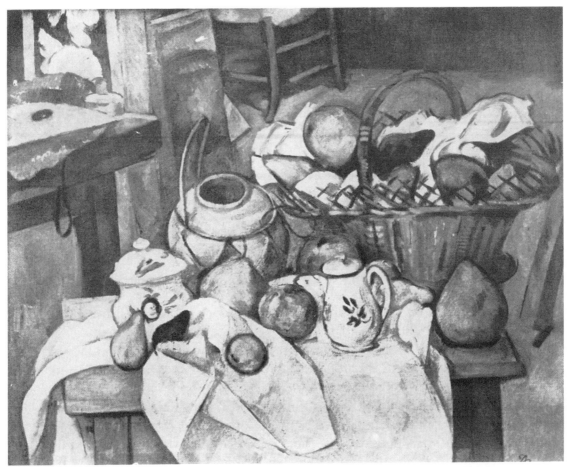

STILL LIFE WITH FRUIT BASKET OIL CEZANNE

Diagram to indicate the obvious direction of the eye movement in this canvas.

This is how the basket would look in a normal view when the handle is seen in the position Cézanne gave it in his painting.

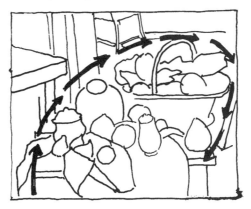

97

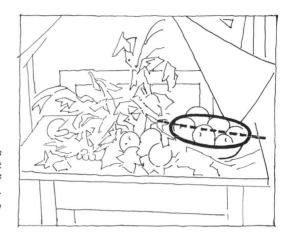

From tracing of Henry Lee McFee's Still Life, Dead Leaves *to point out the slight yet important distortion of the ellipse of the dish which slants upward toward the center of the group instead of being horizontal.*

itself; also noting that the sugar bowl, D, and the small pitcher tilt to the left appreciably. "Another distortion," says Loran, "shifts the viewpoint from the left side to the right side of Cézanne's motif, increasing the illusion of space, of 'seeing around' the object. The change may be traced from the vertical arrow, Ia, which indicates the straight front or slightly left-hand view from which the table and most of the objects are seen. But the handle of the basket is turned, as if seen from a position far to the right, IIb." If the handle is viewed in this position the normal view of the basket would be as indicated by the author's diagram on page 97: the long axis being at right angles to the short axis. Another extraordinary distortion pointed out by Loran is that seen in the splitting of the table top which falls back from A to B in his diagram, an effect that may pass unnoticed by the casual observer, as might the impossible position of the basket which overhangs the table as shown in the author's sketch on page 96.

What is the esthetic result of these distortions? Quoting Mr. Loran, "The endless tensions between planes seen at different levels but related also to the picture plane are the basis of the mystery and power of this still life. An emotional, non-realistic illusion of space created by the changing of eye levels has been the point of departure for Abstract art as well as for a revived interest in Byzantine icon painting. This device is sometimes called 'universal perspective.'"

Well, this is one of Cézanne's handsomest still life pictures. The strangest thing about it perhaps is that the distortions of natural appearance, radical as they are, probably are overlooked by the casual

Note the purposeful distortions of the bottle, its right contour shaped to be sympathetic with the line of the drapery on the right and to lean toward the center of the group.

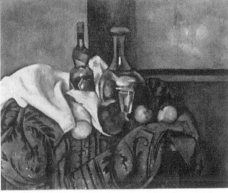

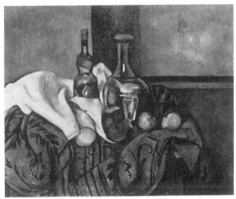

STILL LIFE CEZANNE

National Gallery of Art Chester Dale Collection

observer. Loran explains that he does not think Cézanne arrived at these effects through a conscious intellectual and theoretical approach. He says, "Such extraordinary space illusions developed spontaneously, in the process of painting, and there is no ground for believing that Cézanne would have been able to explain them as they have been analyzed here in this diagram. Cézanne worked by feeling and intuition; the accidental distortions arose from the inner necessities of the particular problem at hand."

One who is unaccustomed to viewing drawing as an absolute, from a strictly realistic viewpoint, that is, will hardly concede that there is any drawing whatsoever in Viktor Schreckengost's creative still life, *Fruit and Wine.* Others, admitting that the function of drawing in art, as distinct from illustration, is to serve the purpose of design in creating a symphonic arrangement of form and color, will not think of "distortion" in this watercolor. Design, design and again design creates a stimulating picture that uses delineation only as a "starter" for the imagination (page 94).

In this watercolor, form has no solidity and the objects intersect each other as though they were ethereal bodies, a pictorial attitude that is common in contemporary painting. Consider however that such effects are actually real, that when we look at objects with eyes out of focus the objects are seen in this manner. And in life do not things often overlap and appear confused?

Anyone who has looked out over the jungle of confused forms such as those that crowd David Fredenthal's *Rooftop* is likely to agree that his distortions are dramatic expressions of truth.

99

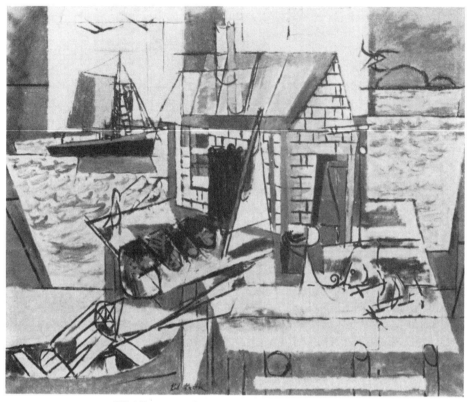

GEAR　　　OIL　　　KARL KNATHS

In such pictures as that by David Fredenthal, painters purposely warp appearance to respond to impressions that come through contemplation of the scenes themselves. Is this good drawing? Each one of us has to answer for himself. If the picture gives us pleasure, whatever its essence, the answer is yes. I think that anyone who has looked out over the jungle of forms seen from a window on New York's East Side will admit that no picture is likely to exaggerate the effect of disorder Fredenthal has painted in his *Rooftop*.

What about Karl Knaths' *Gear*? Is that good drawing? Knaths in this canvas evidently has wanted to convey the feeling of his subject without identifying places and things, although to what extent he was actuated by idea we cannot say. But his design intention and his color intention are unmistakably evident. The end result is impressive enough to have moved the Jury of the Carnegie Institute's *Painting in the United States* (1946) to award this canvas its first prize.

100

ROOFTOP WATERCOLOR DAVID FREDENTHAL

In the work of the surrealists (see Yves Tanguy, page 156) we are confronted with a kind of representation that has to be judged by standards which do not apply to other forms of art expression, because its intention has a psychological basis that competes with purely esthetic ideals. To the extent that it attempts to play upon the observer's imagination rather than upon his sensuous response to design, form and color it can be classed as a picture language of ideas.

A surrealist canvas is always painted in a dramatically minor key. It usually displays exaggerated perspective and eerie light-and-shadow effects in scenes which combine normally unrelated objects, much in the manner of dream pictures. The technique is characterized by a more-than-photographic rendering of forms and the minutiae of detail. The drawing probably can be called good drawing in the sense that it serves its special purpose much in the manner of story illustration. Surrealism, while a fascinating phenomenon in art's continual search for truth, needs no more than passing reference here because it has little if anything to teach about drawing or composition.

101

CHARACTERISTIC PAINTING BY PIET MONDRIAN

Courtesy The Museum of Modern Art

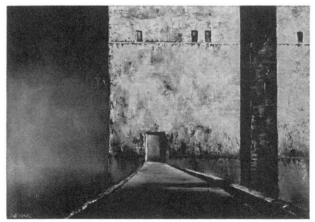

THE ARSENAL OIL ROBERT WATSON

Courtesy Toledo Museum of Art

Analysis of the simple abstract compositional basis of "The Arsenal"

Pattern

For many people the word *pattern* suggests design when applied to wallpaper, rugs, dress goods and other decorated materials. In painting it refers to relationships between pictorial elements. Every picture has a pattern of some sort: as soon as two marks or brush-strokes or two areas of color are set down on canvas or paper there is pattern. It might be a purely accidental pattern such as is often seen in nature, but in a competent painting it is a consciously created, purposeful pattern.

When we speak of a picture's "composition" we are referring to the totality of its pattern, to the basic design or plan of all structural parts. But the composition of a picture is made up of details which are likely to be complete patterns in themselves. Thus the five ducks in Roy Mason's watercolor *Mallards Getting Out* (page 136) when separated from the rest of the picture are seen to be a very pleasing isolated pattern; they were not haphazardly arranged that way. Similarly the three sandpipers in Paul Riba's painting on page 150, when considered as a separate element in the composition, are recognized as an artfully designed, unified pattern (page 144) which, of course, is creatively related to the whole structure of the picture.

Every picture, or nearly every good picture — for there are exceptions — has a basic pattern or structure upon which all its details, its subordinate patterns, that is, are held together in a unified composition. The picture's format is divided into areas or spaces within which the action takes place. Piet Mondrian's reputation as a modern artist rests wholly upon pictures — if so they can be considered — made up of crossing lines that divide the format into rectangular

103

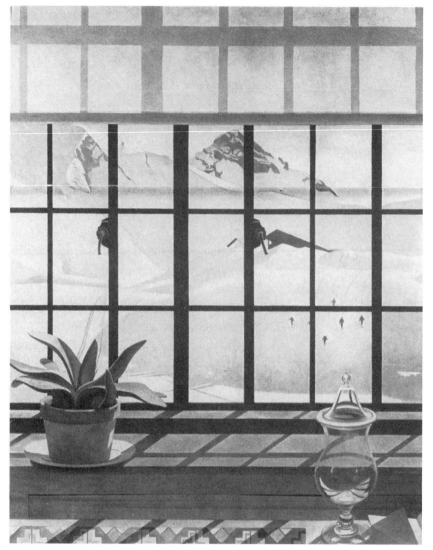

WINTER WINDOW OIL CHARLES SHEELER

104

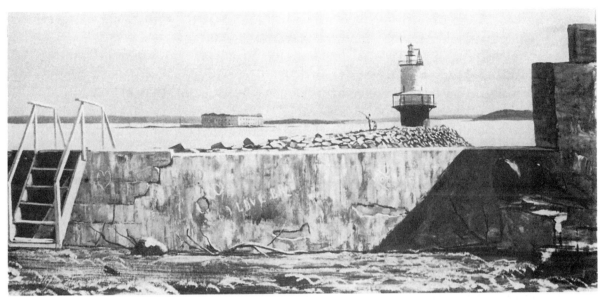

PORTLAND HARBOR STEPHEN ETNIER

Fig. 2 Line analysis of the primary space division in "Portland Harbor"

Fig. 3 Line analysis of the primary space division in Alexander Brook's "Family Unit" (page 79)

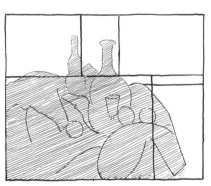

Fig. 5 Analysis of primary space division in Cézanne's "Still Life" (page 193)

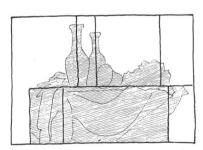

Fig. 4 Analysis of primary space division in Alexander Brook's "The Sentinels" (page 194)

105

areas. Aside from the color which fills these areas they are devoid of content or interest. If Mondrian has any significance in art it is to emphasize the importance of underlying structural pattern in all pictures. Many painters compose their pictures with as great severity of pattern, but having erected the framework, so to speak, they endow it with esthetic and/or idea content. Thus Robert Watson's *The Arsenal* can be reduced to the simplest possible rectangular pattern. While the road or path that leads into the building is a definitely qualifying factor in the composition, it does not substantially modify its severe rectangular basis.

Charles Sheeler's *Winter Window* is designed upon a rectangular structure but it has an idea content that is lacking in Mondrian's non-objective patterns. In spite of the almost inconsequential perspective of the window sill, patternwise, the composition is primarily a symphony of crossing lines upon a flat picture plane. To be sure, a distant vista is seen through the window, but this is treated in such a perspectiveless manner that it registers as format spacing rather than as space depth. In Stephen Etnier's *Portland Harbor* we can see that the painter's first consideration had to be the suitable division of his picture space into four horizontal, rectangular areas (fig. 2). Alexander Brook's *Family Unit* pictured and discussed in the chapter on Balance (page 79) is constructed (fig. 3) upon an exceedingly simple geometric basis, as is his still life *The Sentinels* (fig. 4) and Cézanne's *Still Life* (fig. 5), on page 193.

Many canvases which are not so conspicuously dependent upon a rectangular basis are none the less indebted to it, as in McFee's *Still Life with Striped Curtain*, on page 111, a wonderfully composed picture which, later, we shall study with considerable thoroughness.

Thus it will be seen that a student might do well not only to study Mondrian but to compose many Mondrians for himself and not forget them when designing his paintings.

When we leave rectangular design and consider pattern created by diagonal lines and curved lines, as in Lamar Dodd's *View of Athens*, on page 67, we might refer to a great many of the pictures reproduced in this book. The study of these in other chapters includes their line pattern, so it is unnecessary to refer to them here. What we do want to include in this chapter is the study of shapes, both in the over-all picture pattern and in the details of which they are comprised.

First let us consider silhouette. A silhouette may be defined as

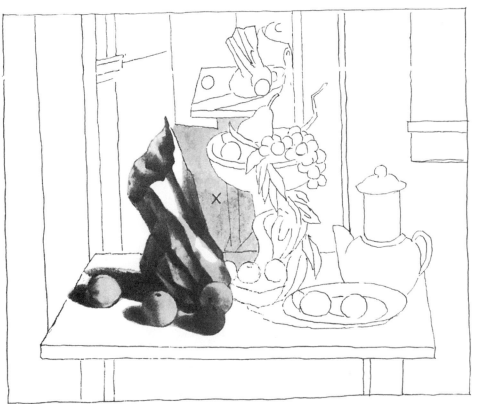

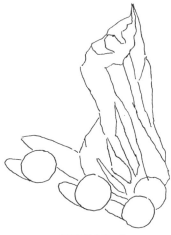

FIGURE 4

DRAWING AFTER HENRY LEE McFEE'S "BLUE COMPOTE"

In this study, traced from a photograph of McFee's painting, the paper bag has been isolated to call attention to its meticulous design. In fig. 1 the shadows of bag and fruit are rendered in a single black tone. Fig. 2 reverses the light and shadow treatment of a part of the bag. Fig. 3 is a fill-in of the space marked X in the drawing. In fig. 4, a line analysis, we note that the design structure of this element constitutes a handsome arabesque.

FIGURE 1

FIGURE 3

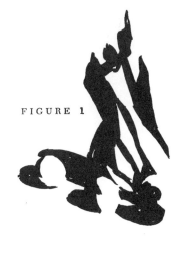

FIGURE 2

107

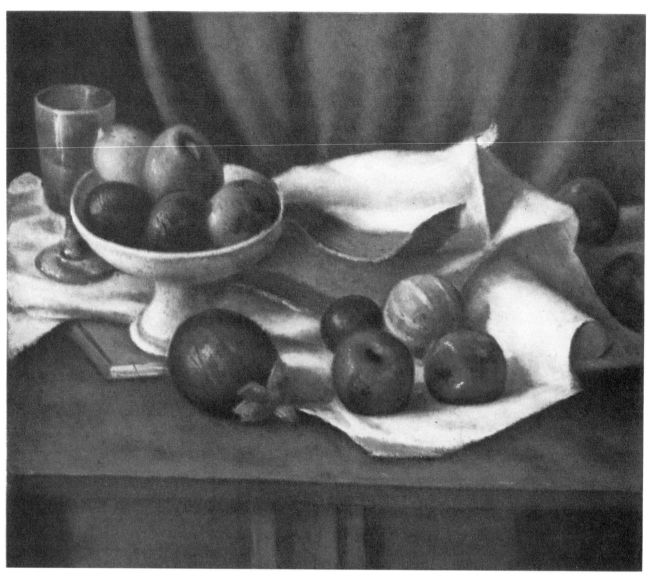

BLUE TABLE STILL LIFE OIL 20 X 24 HENRY LEE McFEE
Courtesy Rehn Galleries

108

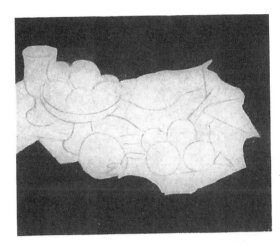

Fig. 1 *This diagram shows how the light cloth nearly encloses the entire group, giving it a compact unity. The light mass is a well-designed silhouette.*

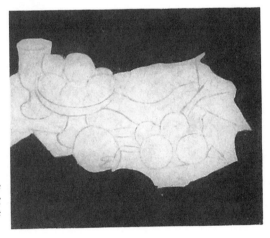

Fig. 2 *Within the enclosing silhouette we see another very interesting pattern that embraces the darkest colors of the still life group.*

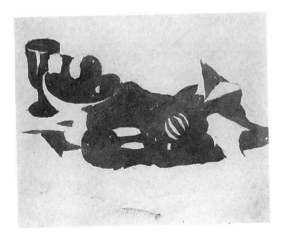

Fig. 3 *Here the shape of this dark mass is made to stand alone to emphasize its silhouette character.*

109

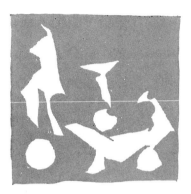

FIG. 2

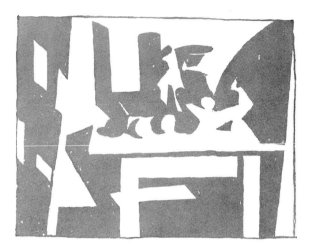

FIG. 1

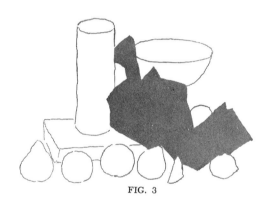

FIG. 3

On these facing pages are studies of McFee's "Still Life with Striped Curtain" to point up design factors similar to those seen in "The Blue Compote" on page 107. In fig. 1 there is a one-tone analysis which, though somewhat arbitrary, does demonstrate the splendid all-over pattern scheme of this picture. Fig. 2 picks out some of the lightest shapes of a part of the group; figs. 3, 4 and 5 are a few more of the shapes that can be isolated from the composition; and fig. 6 shows how a line analysis assists in revealing the picture's orchestration of elements.

FIG. 4

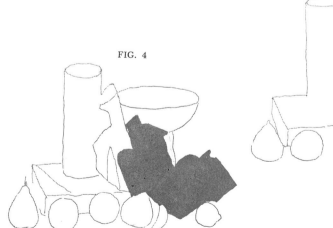

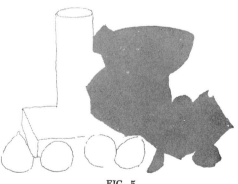

FIG. 5

FIG. 6

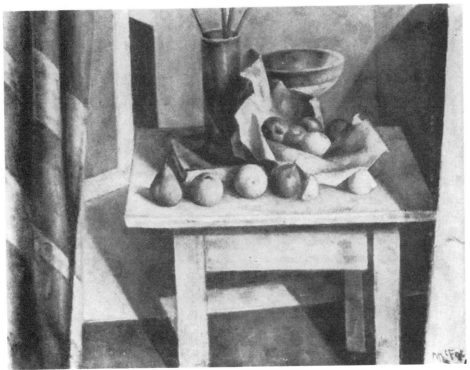

STILL LIFE WITH STRIPED CURTAIN HENRY LEE McFEE
Courtesy The Metropolitan Museum of Art, George A. Hearn Fund

111

EDGE OF HARBOR, MOUSEHOLE, ENGLAND ERNEST W. WATSON
The original pencil drawing is only slightly larger than the reproduction.

a more or less unbroken area of light, dark, gray or color. A tree or
a group of trees against a light sky forms a dark silhouette mass, as
does a building or a group of buildings. Even when the objects are
broken up somewhat by light and shade they are likely to be a con-
sistently unified mass whose silhouette character is obvious. And we
cannot ignore the silhouette aspect of design even when the light and
dark aspects of the picture are so emphatic that actually there is no
silhouette — in the sense of the dictionary definition which describes
a silhouette as "a representation of the outlines of an object filled-in
with some uniform color." But, referring again to Alexander Brook's
canvas *The Sentinels*, we see that the inclusive shape of all elements
is a very well-designed silhouette. Thus the group arrangements of
any set of objects of whatever value or color constitute what may be
called an *invisible* silhouette, visible though it is in the artist's mind.

Going quite thoroughly into an analysis of Henry Lee McFee's
still lifes we discover that good silhouettes, or "shapes" as they are
more appropriately called in this connection, are to be discovered
throughout a well-composed picture. Thus we see how in his *Blue
Table* (page 108) there is, first of all, a fine enclosing shape (fig. 1)
within which the various objects are practically enclosed, a shape

112

This tonal analysis, made from the pencil sketch, shows the basic design structure which the artist had in his mind although the sketch was made on a cloudy day when such a definite pattern was absent. Architecture usually is most effectively rendered in positive light and shadow.

which unifies the whole design. Then note in fig. 2 how this shape, or silhouette, is pleasantly occupied by another shape made up of the darkest tones of the objects and their shadows on the drapery. In fig. 3 this dark shape is isolated in order to reveal its pattern with greater emphasis.

In McFee's *Blue Compote* represented by the line drawing on page 107, I have isolated the bag and four pieces of fruit which seem to comprise a unit by themselves, in spite of their complete integration in the whole composition. That superbly designed paper bag so impressed me that I made tracings of its light-and-shade pattern and translated them into non-objective designs (figs. 1 and 2), fig. 2 being a filling-in of the lighted areas with black ink. Fig. 3 is the area marked X between the bag and the fruit bowl. In every well-composed picture, spaces surrounding objects or between them, as in this instance, have equal design interest with the subject itself; indeed they are an inseparable aspect of the design and receive equal consideration from the painter. The student becomes more conscious of this space aspect of composition with increasing experience and observation. The linear tracing (fig. 4) was made to demonstrate how a line analysis of any picture or a portion of it, having good spatial qualities, automatically makes a fine arabesque.

The analytical drawings of McFee's *Still Life with Striped Curtain* are similar studies of that picture, now in The Metropolitan Museum of Art. Fig. 1 is a reduction of the entire canvas to a black-and-white abstraction. It emphasizes the picture's unity, balance and fine pattern. The other studies I think are self-explanatory: they demonstrate that a good picture is generously pregnant with abstractions that are visible to any trained observer.

Very often the artist finds his pattern interest ready-made in sunlight and shadow on forms that have only to be faithfully recorded with, of course, simplifications that dramatize the pattern effect. This was the case with my drawing of a row of old houses on the beach of Mousehole Harbor in Cornwall, England. I realized at once that the light and shadow of this subject would provide the most perfect composition. This was undoubtedly more important for a pencil rendering than it might have been for a painting in color — yet I believe that picturesque architectural subjects are usually best expressed through emphasis upon form rather than by color, which of course does not ignore the importance of color.

Note here the gradation of shadow-tone which realistically expresses space depth. And, purely aside from its illustration aspect, it provides a beautiful abstract tonal effect.

I could refer to pattern values in all of the pictures in this book but I will leave to the reader the pleasure of studying them in this connection and making his own discoveries.

114

Color

*C*olor, of course, is a factor which cannot be ignored in any discussion of composition. Indeed in many modern works it is by far the most important of all, form being almost non-existent. This does not imply that pictures with form content cannot be just as thrilling colorwise. Indeed form actually gives color an added dimension and certainly it offers no restriction whatever to an artist's creative use of it.

In much contemporary painting color is often used as *counterpoint*; that is, "a melody added to a given melody as accompaniment," to quote a definition as the term applies to music. Or, "The art of plural melody, that is, of melody not single, but moving; attended by one or more related but *independent melodies.*" I italicize those words because the kind of color counterpoint I refer to is arbitrarily overlaid upon the picture's forms as in the watercolor painting by Donald Pierce on page 125.

However, most readers will be more concerned with color as it is traditionally used in association with form. Fortunately I am able to pass on to readers some very practical instruction in the use of color by Russell Cowles, a progressive contemporary painter whose work is reproduced elsewhere in this book. The following remarks on this subject were first printed in *American Artist* magazine and are reprinted here by his permission.

"The business of color is complicated. While it is probable that the supreme masters of color are 'born that way,' I am certain that whatever native gift they may have has been developed through training. Our painters seem to me to submit willingly to self-discipline

115

in drawing, composition, organization of their pictures in light and dark balance, but to leave the matter of color to feeling or 'instinct.' The result is usually accidental or capricious.

"Of course if you are a 'primitive' or wish to be one, then not only color but all the other elements in your work will remain undisciplined. But good primitive painting is rare, even on the level of quaintness and charm, and the added gift of intuitive grasp of structure and organization is extremely rare.

"If, then, you decide to train yourself as an artist I see no reason why your use of color should be the one anarchistic element in your work. Emphasizing again the prime necessity of developing the greatest possible sensibility of the eye, without which no system or theory of color will do you any good, and disclaiming any interest in color systems, good or bad, I still think that certain things about color, the result of long experience by many artists, can be stated for the benefit of others.

"Perhaps the first of these is the balance of cool and warm colors. Cool and warm are relative terms. A neutral gray alongside a hot red will feel cool, while the same gray next to a cold blue will feel warm. Neutral tones, incidentally, are extremely important. So much so in fact that a fine colorist can almost be distinguished by the way he uses neutrals in modifying and balancing his strong colors.

"Next in importance might be the use of a dominant color. Everybody knows the old gag of what would happen if an irresistible force met an immovable body. The answer can be found in most any large art exhibit. When a picture contains two opposing colors, each in its fullest intensity, and of relatively equal quantity and importance, a conflict occurs that must destroy the unity of the picture in spite of anything the painter can do about it. The answer is that one color should dominate the others, just as one form in a composition must dominate the rest. A saturated color in a small area may balance a large area of another less-saturated color in a way that does not destroy the picture unity. Two opposing colors that clash when adjacent to each other often live happily in the same picture when separated by a neutral area. Strongly opposing colors set up a tension between them, and such tensions should not occur in haphazard fashion in a picture, but should be reserved for the occasions when needed.

"Color can be used for its shock value, and often is, frequently at the expense of other and perhaps more durable qualities. But when

116

employed knowingly and intelligently it can be very effective. Perhaps the greatest color shock comes from the combination of intense red and intense green. It is widely used by our American painters, rarely by Europeans. If it is a national characteristic, I hope it will eventually be outgrown. Surely there are other and better ways in which our national temperament can find expression.

"To get the most benefit from the study of color and to develop a sense of color organization, I think it is very desirable to experiment with the plan of starting a picture in color, rather than taking up the color question after drawing and composition have been determined. For such experimentation I would suggest employing a set palette. That is, pick out three, four or five colors that seem interesting together, add one or more neutrals — grays for a more quiet effect, black and white (to be used pure) for a more exciting result — and plan to compose the picture with these elements only. Decide at the beginning which is to be the dominant color, and stick with the same palette, but choosing one of the other colors as the dominant.

"Much can be learned about color from the study of other people's paintings, particularly those of outstanding colorists like Matisse and Braque. The Rosenberg Gallery in New York recently showed three canvases, representing the early, middle and late periods, by each of several modern artists. Among them was a superb Matisse, showing a room interior, with a seated figure by a table. The whole canvas was planned on a red, yellow and blue scheme, while on the table was a group of flowers and fruit painted in orange, green and violet. This transposition to another color range at the key point in the picture was electric in its effect. I wish it might have been seen and studied by all the students in the country, and by the older painters as well. I have since spoken of it to a number of painters who saw the show, but I have yet to find one who noted the particular effect I have described. Now the point is that this original and beautiful color scheme did not happen by accident. It was deliberate."

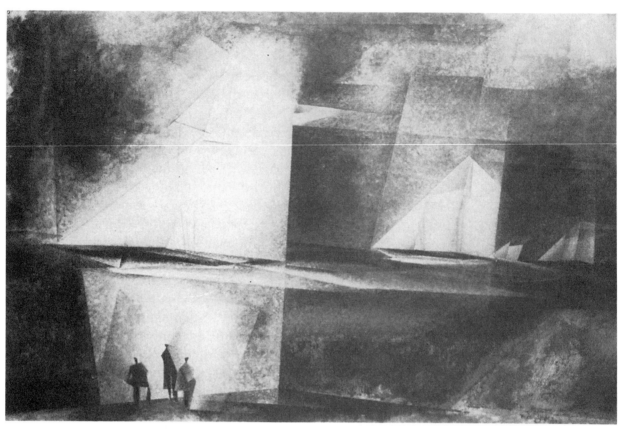

GLORIOUS VICTORY OF THE SLOOP MARIA LIONEL FEININGER
Courtesy City Art Museum of St. Louis

*Although this canvas is shown here as an illustration
of pictorial counterpoint—a matter of mass and color—
the line tracings on these facing pages reveal an ex-
pertly organized linear design. The analysis of the
sailboat reveals, I think, something of a masterpiece
of non-objective design both in line and shapes.*

118

Pictorial Counterpoint

*L*ionel Feininger, if not the originator of what may be called pictorial counterpoint, is perhaps the best-known among modern artists for paintings in that category.

Its origin of course is in cubism for which we are indebted to Juan Gris, Picasso and Cézanne. Counterpoint in musical terminology refers to "a melody added to a given melody as accompaniment."

That definition is certainly applicable to painting in which arbitrary overtones do add another melody of color, tone and pattern to a pictorial theme. This technique is one which appeals to many contemporary painters who employ it with varying degrees of emphasis. In Feininger's work the overlays dominate and camouflage pictorial interest to a considerable extent. In Sperry Andrews' *Buttery's Mill* they break up the surfaces of forms, providing opportunity for prismatic color effects without camouflaging the forms themselves. His *Melody Fair* approaches abstraction as prismatic overtones take precedence over form and illustrative character. (Pages 122-123)

In John Maxwell's watercolor *Spring Afternoon* the geometric divisions of the sky support a considerable variety of blues, from green to purple, an effect which in halftone reproduction can only be hinted at by gray tones. In his oil painting of the same motive the overlaid pattern is not so insistent. In both I think we can see the usefulness of this technique in giving something of an epic quality to a merely picturesque scene. (See next page)

119

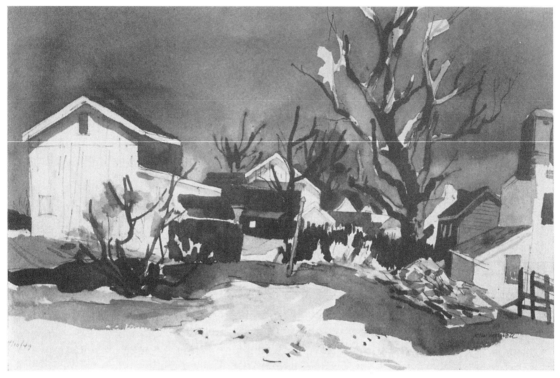

SPRING AFTERNOON ON THE SPOT SKETCH JOHN MAXWELL

In all of these paintings it will be noted that the shapes of the overlays are very definitely associated with the pictorial forms. In Feininger's canvas most of them, though not all, are related to the sailboats. Maxwell constructs them by extensions of the roof lines of the buildings. Notice also how this treatment with its emphasis upon flat pattern overcomes perspective appearance and compresses the picture space to a very shallow depth.

Although in Feininger's canvas we are most aware of its tonal pattern, when we make a line analysis of it we are impressed by the ingenuity of design encompassed by lines that can be drawn with a straightedge. Furthermore, when details of the composition are studied, isolated from the whole, we find combinations of carefully designed geometric shapes that help us appreciate the splendid organization of the entire composition.

120

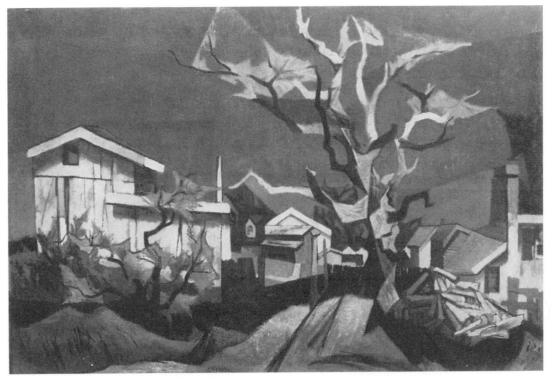

SPRING AFTERNOON OIL JOHN MAXWELL

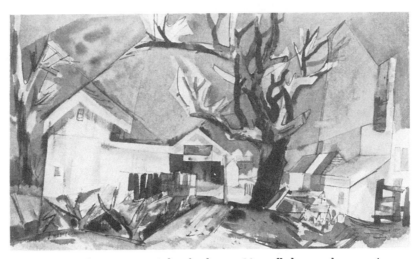

In this watercolor version of his landscape Maxwell has made use of counterpoint in a considerable variety with overlays of blues, from green to purple. The color planes of the overlays are definitely related to the forms in the painting, though the colors are purely arbitrary.

Although John Maxwell makes no mention of this counterpoint aspect of his painting, I am going to quote what he told me of his painting procedures because they embody some very instructive suggestions: "The original sketch, made on the scene, is realistic and rather literal. The next attempt was the watercolor where I made a genuine effort to 'stay with nature' and yet translate the subject into something of my own creation, emphasizing abstract qualities in design and color. I try to oppose certain lines against certain forms, this color against that, soft areas against hard areas; striving to produce something with its own movement, based on nature but *existing as a painting by itself* without too much literal reliance upon nature.

"Next, the very large oil was painted, and once more a further attempt at simplification, strong opposing forms and glowing color.

"Extremely helpful to me, but not without danger, is the three-dimensional camera and viewer. Here's how I use it. I paint or draw the subject in preliminary fashion as always. If I feel it has possibilities I take a three-dimensional shot of the subject on the spot. I have to

BUTTERY'S MILL OIL 18 X 34 SPERRY ANDREWS

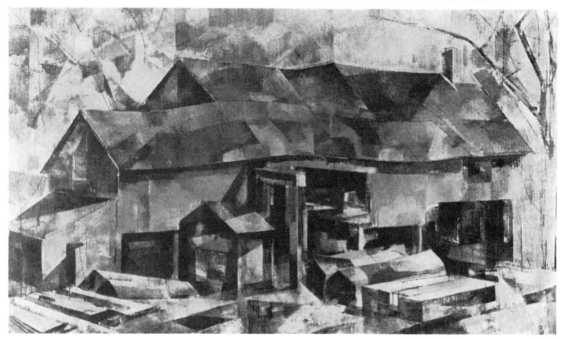

122

MIDNIGHT QUARRY WATERCOLOR 27 X 40 WILLIAM THON

Collection Whitney Museum of American Art

Although this impresses one at first as practically a non-objective painting, anyone familiar with quarries sees a very direct idea source in the blocks of marble.

Sperry Andrews likes to use pictorial counterpoint to enrich his subjects with overlaid pattern and color. In "Buttery's Mill" these overlays of abstract pattern do not interfere with form definition; they merely give opportunity for livelier expression. In "Melody Fair" this treatment is much more abstract; the foreground appears to be rendered in non-objective pattern conformations.

MELODY FAIR OIL SPERRY ANDREWS

123

wait two or three weeks for this to be processed; a very fortunate circumstance because I can't use it as a 'crutch substitute' for my own creative impulses. So, without waiting for the photograph I start painting from my sketch and develop it as well as I can.

"By this time my transparency has probably arrived from the processor, and I now view it — only to help me to recapture the feeling that first moved me. This device when used as described is of inestimable value to me, helping me to reinstate, if necessary, something of the original 'spiritual quality.' The danger involved in this should be obvious: start using it indiscriminately, merely for copying nature, and one is doomed."

Pictorial counterpoint provides almost unrestricted scope for the symphonic color organization seen in Donald Pierce's *Barn*. Here the color would seem to be used creatively without much reference to the actual coloration of the subject; but from Pierce's own comments he "saw" color that probably no one else could have recognized. He says, "The picture began as a quick, sketchy drawing made from my car after a sudden rainstorm temporarily halted an outdoor painting session. The painting itself was done later the same day while the original impression was still fresh in my mind."

Mr. Pierce works in an unusual technique. "My medium-weight paper," he explains, "clipped to a Masonite board, may be thoroughly pre-soaked or it may be only partially dampened. The laying-in of washes and the superimposition of calligraphy with India ink may proceed alternately — always working from light to dark and preserving transparency. I have a predilection for sensuous textures and am fascinated by the particular qualities that result from the superimposition of washes, wet and dry manipulations, and effects achieved when India ink is used on a moist surface. Although I rework a painting considerably, using several superimposed washes and completely rewetting the surface from time to time, I always try to maintain the spontaneity and freshness that are the very essence of the watercolor medium."

124

NEW ENGLAND BARN WATERCOLOR 11 X 15 DONALD PIERCE

This painting demonstrates the usefulness of counterpoint in glorifying a rather ordinary subject. It will be evident to anyone that the color overlays in the picture are largely independent of the subject's coloration and that the painter's aim was to create fine organization of pattern and color.

Tracing of a photograph of the subject from which Cézanne painted his "Landscape at La Roche-Guyon"

Diagrams from

CÉZANNE'S COMPOSITION

by Erle Loran

Refer to pages 138 and 139

These diagrams are tracings by Erle Loran, author of Cézanne's Composition, *from Cézanne's canvas "Landscape at La Roche-Guyon" and a photograph of the scene itself. They point up Cézanne's manipulation of picture space through adjustments which reduce deep space of the subject to a relatively shallow picture space and focus upon the picture's design structure. Says Loran, "It is an eloquent demonstration of the creative process of reorganizing an unruly motive into a balanced, plastic unity."*

Tracing of Cézanne's "Landscape at La Roche-Guyon"

Pictorial Space

The science of perspective was perfected by Paolo Uccello, an Italian painter (1397-1475) who was its most enthusiastic promoter if not its actual discoverer. Vasari tells us that Paolo was so completely enamoured with his study of the subject that he begrudged time for sleep and neglected his painting seriously.

This new method of simulating depth through the convergence of parallel lines and the foreshortening of surfaces was enthusiastically adopted by the Renaissance painters who were his contemporaries, and it has been in continuous use ever since. But we must remember that prior to its introduction in the 15th century picture-makers had other means for representing distance and the third dimension that appear to have served art very well indeed. The mere placing of one object behind another is a convincing way of giving an illusion of depth, although without the realism of photographic appearance. See Giotto's *St. Francis Driving the Demons from Arezzo* on page 128. No doubt this picture was wholly satisfactory to those who saw it at that time. Giotto could not have been ignorant of perspective appearances, though as was the case with his contemporaries he might have been unaware of their scientific basis.

In many pre-perspective times there was utter disregard for the principles of diminution of size with distance. There was a much more important purpose in a picture than perspective effects: that was the desire to symbolize the relative greatness of things through size comparisons. A king on his war horse was likely to be depicted in heroic size and his subjects put in their lowly places by shrinking them in size regardless of their relative positions in the picture. In early picture-making, receding planes were turned away from the spectator but without convergence of their outlines as we see in the 15th century woodcut on page 128.

The Renaissance artist who was under the compulsion of his day

127

15th century woodcut reveals the artist's ignorance of natural perspective effects; the back edge of the table is longer than the front edge.

ST. FRANCIS DRIVING THE DEMONS FROM AREZZO GIOTTO 1266-1337

Here we have perspective appearance due entirely to the overlapping of objects.

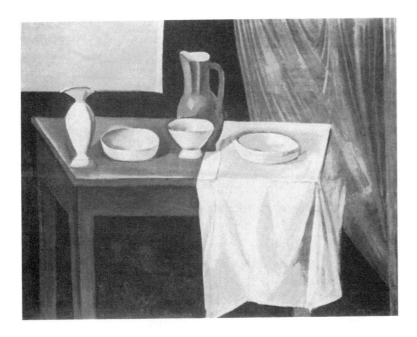

Derain, who knows all about perspective, draws his table in reverse perspective as did the 14th century wood engraver, but for a different reason. He is concerned here with pattern instead of natural appearance; violation of perspective tends to emphasize the picture plane rather than suggest space depth.

to paint in an illustrative manner must have welcomed the aid of scientific perspective in giving his pictures a maximum sense of reality. Indeed naturalism in painting continued as a tradition almost up to the 20th century when photography and mechanical reproductions of pictures in books and magazines gave birth to the illustrative arts. Painting and illustration then became separate professions. Painting, relieved of the constraints of factual representation, was free to adventure into purely esthetic realms.

The modern painter rather logically has claimed the freedom of pre-perspective painters and we find him purposely flouting perspective appearances which formerly were violated in complete innocence. For example, André Derain in his still life *The Table* commits the same perspective error seen in the 14th century woodcut.

Until people have arrived at an understanding of contemporary art philosophy and can accept the idea of art as independent of illustration, they are bewildered by much painting and sculpture of our own time. Many indeed cannot, or have not, been able to understand that the aim of much modern art is not the representation of nature, or even the beauty of nature; that its ideal is the creation of man-made beauty which *may* have little obvious reference to nature.

In this concept of art, line, form, pattern and color are dictated by creative imagination having a symphonic purpose as contrasted with an illustrative purpose. This concept, while generally accepted today — unequivocally so in sophisticated circles — has by no means made traditional art obsolete. Nor is there necessarily any incompatibility between the modern and the traditional attitudes; the intelligent modernist looks only for creativeness. That this spiritual quality can be found and is found in highly realistic painting is demonstrated, for example, in the painting of Andrew Wyeth. His paintings, even more realistically penetrating than photography, have won the admiration of both traditionalists and modernists, an attainment that is rewarded by some of the highest prices recorded in contemporary American painting.

However, the objective of much contemporary painting is to avoid emphasis on perspective or at least to flatten it out. The simulation of deep space has been superseded in modern art largely by the intention of relating the picture to the flat surface of the canvas. This is accomplished by avoiding obvious perspective devices that funnel the eye into distance, notably by squeezing or shrinking the third dimension into relatively shallow depth.

The purpose of this shrinking of deep space is to focus upon design, two-dimensional design and the design of space that encompasses objects, an intention that is likely to be thwarted by preoccupation with deep space. Writing in *American Artist** about the painter's problem of space, Russell Cowles says, "It is an extremely difficult subject to explain in words, just as it is an extremely complex matter to handle in painting. And it is vitally important, in fact it lies at the core of the artist's creative activity. Suppose, then, we start at the beginning. Let your imagination dwell for a few minutes on what your sensations and feelings would be if you had the misfortune to be confined in a torture chamber within a cage not high enough for you to stand upright, and not large enough for you to sit or lie down. Then by contrast imagine being alone in the Sahara Desert or in some Arctic waste where space stretched away to a limitless horizon in all directions. You live in space. All objects exist in space, and you can't imagine them existing otherwise. Your painting represents objects in space, or you might say your painting represents space, with objects in it.

*American Artist, April 1949

130

"In the broadest sense, space is the matrix of reality, the field, the frame of reference. In a narrower, technical sense the artist's canvas is the frame of reference, which brings us at once to the heart of our difficulty. For the external world of space is three-dimensional, and it has to be transposed into a satisfactory statement on a two-dimensional canvas.

"This transposing has been done in various ways. The most common is by means of linear and aerial perspective. This way is so common, so widely practiced, so thoroughly understood, that it needs no exposition. Its use does not really involve transposing, but simply transferring onto the canvas surface the appearance of the external world. That it has not satisfied everyone must also be more or less obvious. In fact, this dissatisfaction could almost account for the birth of the modern movement.

"When modern painting is attacked for failing to express certain things, such as the aspect of things as they might appear in a color photograph, for instance, its defenders often content themselves by replying that such was not its intention. Which of course is true, as you no doubt know. What you should also know is what its intention *is*. Until you do, you can hardly have an intelligent opinion about it. The most frequent criticism leveled against modern painters is their distorted drawing. Objects, figures, are pulled out of their natural shape, or compressed, in the interest of design, or pattern, or for heightened expressiveness. But in many cases it is really space which is distorted for these reasons, and the objects get distorted by the distorted space. For this thing that interests painters so much, namely, space, cannot be expressed or represented directly, but only by means of forms, shapes, colors, lines, which, through their relations delimit and define it. A great deal of a painter's apparent concern with objects, their placement, volume, and relation to other objects, is really a concern with space relations, which these objects reveal and express. And the freer a painter is in searching for psychological truth as against the obvious factual truth of photography, the farther he will go in allowing his manipulations of space relations to involve a concomitant distortion of the objects.

"Of course there are many painters who do not go this far, who play with space relations without doing much or any violence to the natural appearance of objects. In many of the paintings of Salvador Dali, or the early Chirico, space is stretched out in depth, creating an

almost unbearable feeling of nostalgic solitude and melancholy. In the cubist paintings of Picasso and Braque space is contracted. It is contracted, telescoped, in its third dimension, depth, to a matter of a few inches, while at the same time it is often condensed in its two-dimensional design, resulting in a compactness that heightens the intensity of its pattern, and creates another kind of feeling, to which, in the case of these painters, the accompanying distortion of forms contributes.

"Aside from the surrealists, most ultra-modern painting contracts its third dimension, depth, almost out of existence. I say 'almost' because with the best men of this school it is a case of extreme condensation, and *not* elimination. They want the subject, the content of their painting, to become identified completely with the physical canvas, and to do this they try to relate all depth sense to the picture plane. The picture plane is their frame of reference, and must be felt at all times in conjunction with the sensation of depth. Each area of their picture, each color, shape, tone, plays a dual role, existing both on the picture plane and back of it in space.

"It is possible that the extreme modernists carry this business too far, that their insistence on the importance of the picture plane becomes an obsession. But in any case they have opened up a new field of painting, enlarged the range of art expression."

As a matter of fact many of our best contemporary painters have not been unduly influenced by this concept, preferring to use natural space depth in their canvases in the traditional manner when that serves a particular intention.

The "flattening out" of depth, or the compressing of space within a relatively shallow area — which might be thought of as a theater stage — is accomplished in several ways, some of which are illustrated by paintings in this chapter.

One is the avoidance of prominently converging lines such as we see in Louis Bouché's *Ten Cents a Ride* (page 35), already discussed in another chapter, and in William Picknell's *On the Borders of the Loing* (page 34) wherein we are led into distance along the river.

Now in Dasburg's *Road to Lamy* there is also a road leading into as great a distance; but note that the painter has arrested our eye along the way so that it is not distance that intrigues us but the interest in forms — the buildings and their shadows in the foreground and middle distance. If the distance is as great here as in Picknell's

132

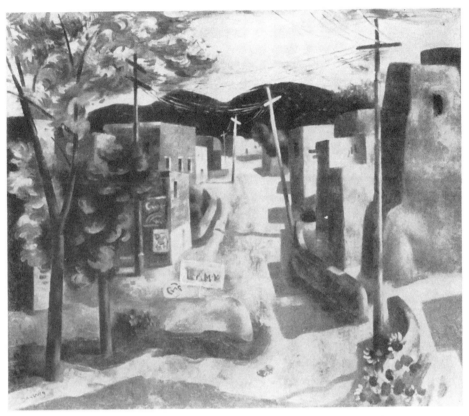

ROAD TO LAMY ANDREW M. DASBURG
Courtesy The Metropolitan Museum of Art, George A. Hearn Fund

canvas we are not conscious of it because of the form and pattern
interests that divert us. The hills beyond also tend to contradict any
impression of great distance because they are very dark and tend
to come forward instead of retreat as they would if rendered with
atmospheric effect.

Roy Hilton, in his dramatic *Underpass*, has very ingeniously pre-
vented us from rushing along the thruway at speed limit by creating
a dramatic pattern that emphasizes a plane that is parallel with the
picture plane. Pattern dominates perspective.

In Sheeler's *Golden Gate* (p. 140) it is practically impossible for
us to interpret these converging lines and diminishing volumes as
space symbols. Those perspective factors lead us nowhere; they are
designed that way in accordance with line and pattern needs of the
composition. Pattern also plays a similar role in the perspective-

133

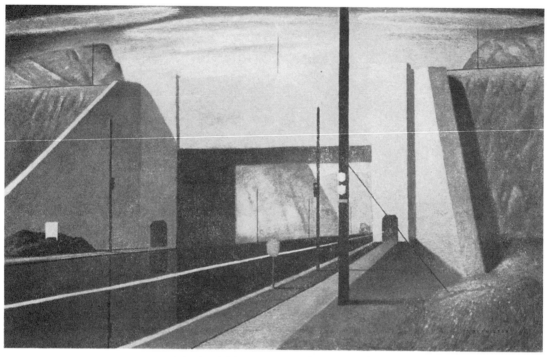

UNDERPASS ROY HILTON

Although all of the ground lines recede and converge violently into the distance, the impression of this picture is one of pattern that falls into a plane parallel with the picture frame.

134

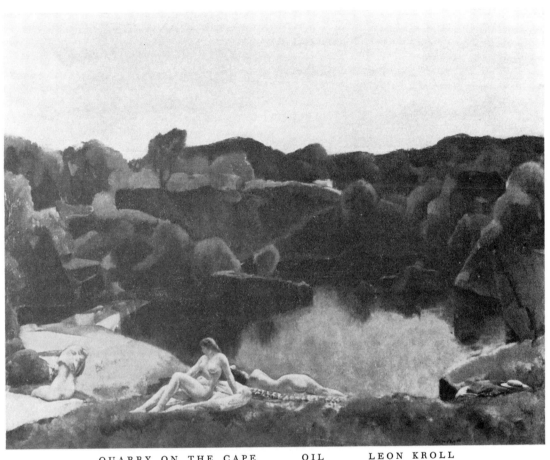

QUARRY ON THE CAPE OIL LEON KROLL

Collection Dr. Julius Lempert

This painting, doubtless inspired by the quarries at Pigeon Cove in Rockport, is one of Kroll's most successful and most poetic pictures. It has a tapestry-like quality that emphasizes color and tonality rather than any sense of deep space. What distance there is in the canvas is created largely by the overlapping of planes—suggestive of stage scenery—and by color.

defying canvas of *The Table* by André Derain, opposing the impression of depth as much as does the reverse perspective already noted.

The device of indicating distance merely by a sequence of overlapping planes is well demonstrated in Leon Kroll's handsome *Quarry on the Cape* (descriptive caption above). The picture is lacking in atmospheric effect such as we see in Roy Mason's *Mallards Getting Out* where the setting is a natural one with the distant trees painted in an atmospheric haze. There is poetry in both pictures but the intentions of the two painters are wholly different; Mason paints for

135

MALLARDS GETTING OUT WATERCOLOR ROY MASON
Collection Horace Chapin

an audience of nature worshipers who, whatever their esthetic interests, are more likely to respond to realism that evokes memories of vacation days with gun or rod.

Outlining of the picture's forms is another way of destroying or mitigating the illusion of deep space. Outline flattens form and outlines, being non-existent in nature, contradict the impression of natural perspective and serve the painter's arbitrarily designed picture space. Russell Cowles' superb canvas *Adam and Eve*, a beautiful, poetic painting, is a provocative example of the phenomenon, especially in connection with his quoted comments on the problem of picture space. It is interesting to note that whereas the figure of Eve is almost without modeling, and the giraffe is entirely flat, Adam's figure is given more form by partial light and shadow rendering.

It is clear that Cowles' intention is to avoid perspective distance, to reduce space to a shallow depth much as though the action were taking place within what Erle Loran in *Cézanne's Composition* calls the *picture box*. In that book he shows a diagram of a shallow box

136

ADAM AND EVE RUSSELL COWLES

In this canvas the painter avoids appearance of space depth, "flattening" the scene in a man-ner suggestive of a shallow diorama. He is concerned here with space surrounding objects rather than with distant space.

within which he has sketched one of Cézanne's landscapes that can be envisioned as entirely enclosed within this compressed space. In that book also another demonstration of Cézanne's methods of contracting pictorial depth is reproduced here by the author's per-mission. While *Landscape at La Roche Guyon* (page 139) is of an unfinished canvas, it clearly demonstrates the painter's characteristic strategy in translating perspective reality into a picture organization that has balanced, plastic unity. In the photograph we note the vio-lently converging road and see in the painting that it has been rendered in a perspective-less way that puts it on a plane which compresses space and relates it to the picture plane. The building on the left is

137

PHOTOGRAPH OF THE LANDSCAPE AT LA ROCHE GUYON
From Cézanne's Composition *by Erle Loran*

turned, in the canvas, as though it were viewed from the right-hand roadside. In doing this Cézanne also got rid of the steep sloping line of that building which carries the eye up to and out of the upper-left corner. (See diagrams on page 126)

A most important revision of the photographic appearance is the raising of the hills, reducing the empty sky to a very narrow strip and enhancing the interest of the hillside with detail that does not appear in the scene itself. Distant buildings have been enlarged and given definite form interest.

Of course we do not know just what this canvas would have looked like had it been completed but that doesn't matter for our purpose of study; it shows Cézanne's customary practice of compressing perspective depth and rearranging things so as to relate them creatively to the picture plane.

We see this device applied in many contemporary paintings. If you will turn to page 167 to Rex Brandt's *The Brother's Light* you will see it in the enlargement of the island which is brought forward

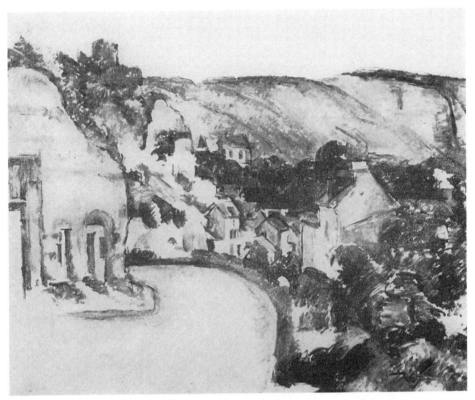

LANDSCAPE AT LA ROCHE GUYON CÉZANNE
From Cézanne's Composition *by Erle Loran*

to take its place in the picture's composition; in the photograph it is
a small spot in space. The distant hills likewise have been moved
up and made an important design factor.

Karl Knaths in his painting *Gear*, on page 100, has employed
nearly every technical device to confine the picture to the surface
of the canvas, line predominating. Drawing, as commonly understood,
is consciously violated here for the sake of design. One form runs
into and overlaps another: planes are juggled with practically no
regard for reality. It is not an "illustration" in any sense of the word.
It is pure design, and so successful as to win one of the most coveted
of painting prizes in the U.S.A.

Once more we turn to Cézanne to note how, in his *View of
Gardanne*, he achieved a perspective effect merely by overlapping
planes. He has ignored atmospheric impressions entirely and to a

139

GOLDEN GATE CHARLES SHEELER
Courtesy The Metropolitan Museum of Art
George A. Hearn Fund

large extent diminution in size relative to distance. Furthermore he
has outlined buildings with bold, dark, brush strokes. All of these
devices have emphasized two-dimensional aspects of picture-making;
they indicate the painter's preoccupation with the picture plane. Turn
back to page 128 and Giotto's *St. Francis Driving the Demons from
Arezzo* for an interesting comparison of these two pictures painted
centuries apart.

One more example of interest (p. 143) is Robert S. Rogers' water-
color *San Miguel and Oldest House, Santa Fe*, because he has given
us his own analysis of his thinking in its creation. He writes: "I was
interested in the street in Santa Fe because of its old world look. The

140

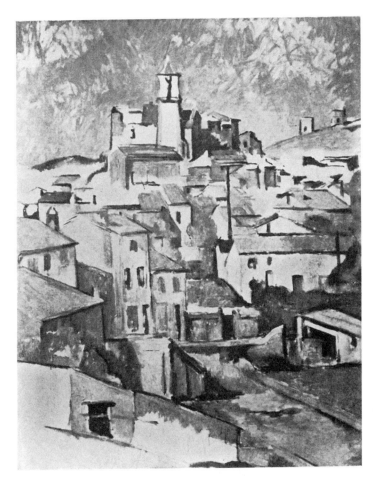

VIEW OF GARDANNE CÉZANNE
Courtesy The Metropolitan Museum of Art

back of the old Mission of San Miguel on the left and the oldest house
on the right were perfect foils for each other. With their weathered
adobe walls they were as monumental as the walls of a canyon. The
horizontal lines of sky appeared in my imagination as the top of a
huge tunnel leading past the very entrancing little pink building in
the distance to the distant green trees — which I developed into the
shape of a church. The various poles with crossbeams and the white
cross in the church emphasized and repeated the ecclesiastical motif.

"In the actual scene the sides of the buildings and the poles are
vertical. It would have been all right to have left them that way, in
which case the whole composition could have been built on rectangles.
However, I preferred the irregular shape formed by the two poles

141

Pencil sketch to show planes and angles of the composition

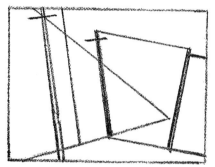

Pencil sketch of trapezoid motif

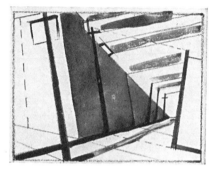

Diagram of subject visualized as a tunnel

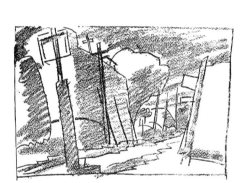

Rough preliminary sketch

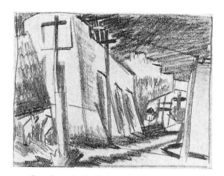

Sketch of light and dark pattern

Brush and ink drawing used to begin the actual painting

142

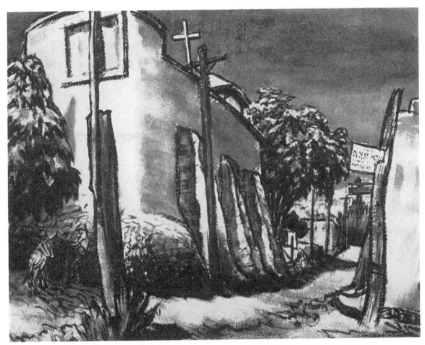

going in opposite directions, forming the distorted trapezoid of my first diagram. This shape, regular and inverted, became the dominant motif for the composition and the key for the entire painting."

The especial relevance of the picture in this chapter is the way in which Rogers actually avoided the funnel aspect of his street which first impressed him in favor of a composition that holds our interest on a foreground plane.

From all this discussion we can conclude that space and its treatment are among the major problems of the student painter. An entire book could profitably be devoted to this factor in picture composition, but perhaps what has been shown in this chapter is sufficient to stimulate independent study.

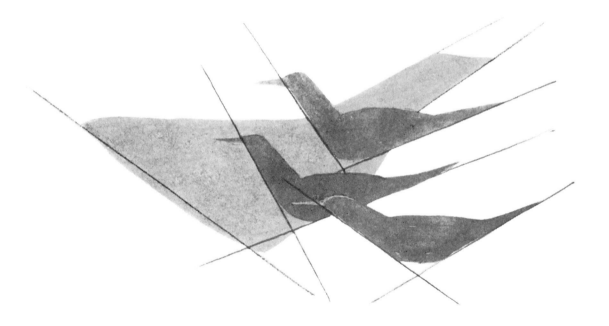

144

Unity-Coherence

*U*nity and coherence, in dictionary definitions, are nearly synony-
mous terms; coherence is implicit in unity. When a composition has
unity, it has coherence; we say that it "hangs together well." All parts
serve one end, and no element can be eliminated without disturbing
the whole or leaving a vacuum in the ensemble. A well-organized
picture serves to hold the eye within the boundaries of the canvas and
to lead the eye from one object to another until the intention of the
painting is realized, points which have already been discussed.

Unity is a matter of relationships. When there is no relationship
or insufficient relationship among a picture's elements it lacks unity;
when the parts are related through linear, tonal or color association,
or through all of these factors, unity is established.

An interesting demonstration of unity through line relationship
is seen in Paul Riba's *Sandpipers* (pages 150 and 151). Compare
his first and third ideas with the final composition wherein the grouping
and drawing of the birds is united by line with the strong linear
character of the drapery. To achieve this element of unity, Riba
abandoned the curving lines in his *First Idea*, in favor of the nearly
straight lines of the birds' necks, repeating this vigorous action in
the drapery. A line analysis of the entire picture will disclose a closely
knit construction of horizontals and verticals that support the beauti-
fully organized bird group.

In this picture also we are impressed by the part that color plays
in achieving unity; the reds, the blues and the yellows being artfully
repeated throughout the design, red being the dominant color.

Unity is also achieved when the several elements in a picture
have similar characteristics. Thus in McFee's *Still Life, Dead Leaves*
(page 195) nearly all design elements in the canvas reflect and repeat
the triangular character of the dead leaves which constitute the pic-
ture's theme, just as in a musical symphony there is a consistent

145

repetition of elements of its theme. I said *nearly* all elements, not overlooking the importance of curved linear and form contrasts in the bowl and the apples: *too much harmony* is as unpleasant as too little.

Now refer again to Riba's birds. I emphasized the interrelationship between this group and the red drapery, due to the harmony in direction of lines, indicated in my analytical sketch on page 144. Note however that these four emphatic directions are not *quite* parallel but, while definitely related in direction, they have a slight and pleasing linear disagreement.

There is no more instructive demonstration of unity through the effective operation of *all* abstract elements than is seen in Will S. Taylor's *Lookout Rock*. The artist, at my request, made the accompanying diagrams which speak for themselves. This picture is a splendid orchestration of all the means at an artist's disposal.

Unity is often achieved by enclosing or enveloping the design elements in one way or another. We see this device in McFee's *Blue Table* on page 108 and in several pictures in the chapter on drapery, in which a drapery-mass encloses the various pictorial elements. Now

This diagram emphasizes the static rock formation placed off-center, held in balance by the horizontal sky lines, water and shacks. The sail at the left, though small, is an important balancing foil for the rock mass.

This diagram emphasizes the rhythmic interplay of sky and foreground elements. The dotted lines indicate the related movements that unify the elements. The slow-moving lines (flat curves) of the lower cloud formation are sympathetic with the skyline and water, developing a sense of repose. The upper clouds, which gain momentum by the fast-moving lines (arcs of smaller circles) accentuated by the angular opposition, respond to similar elements in the rock formation.

 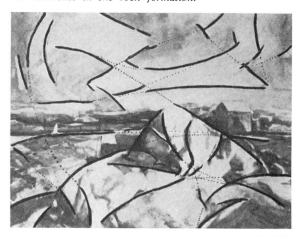

146

LOOKOUT ROCK WATERCOLOR 17 X 24 WILL S. TAYLOR

The geometrical structure of rocks repeated in cloud patterns suggests the dynamic activity of fast-moving forms. There is no obvious vertical movement here. But note that the central focal interest of the sky is in a vertical line that would pass through the apex of the rock below. The upward pull of the highest cloud lines also gives a vertical effect to counteract the horizontal skyline.

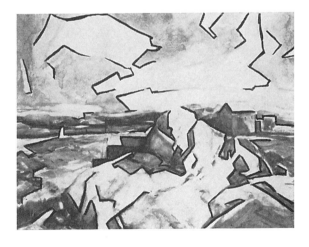

147

EMBLEMS OF PEACE OIL WILLIAM M. HARNETT

Courtesy Springfield (Mass.) Museum of Fine Arts

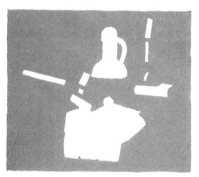

FIGURE 1

An example of the "prosaic eye"; preoccupation with facsimile reproductions. The picture lacks unity because of the separation of light elements. The spotty effect is noted in fig. 1. If all elements in the group were made a light silhouette against the background (fig. 2) as in Chardin's "Kitchen Still Life" (fig. 3), unity would be achieved. Harnett was a master technician and his works are highly prized in museum collections.

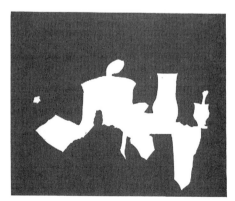

FIGURE 3

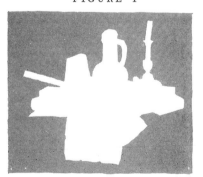

FIGURE 2

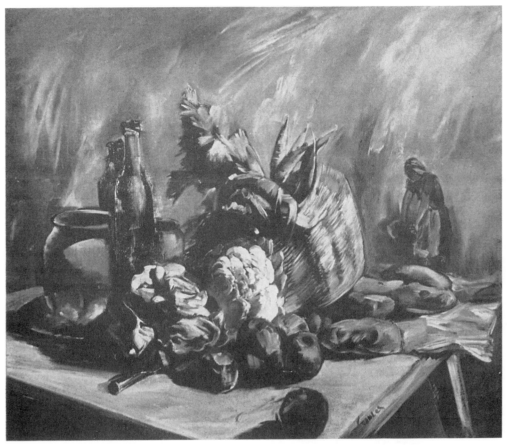

KITCHEN STILL LIFE FREDERIC TAUBES

in contrast, William M. Harnett's *Emblems of Peace* lacks unity be-
cause the entire collection of objects has a separated effect even
though the objects all form a good silhouetted group — or would do
so if they were close enough in value actually to register as a silhouette
against the dark background. As it is, the light-colored jug, flute,
book, newspaper and candle separate themselves from the mass and
lose their association with a group as a whole. The darker books are
so low in tone as to belong to the background. So we see that associa-
tion of interest or of ideas is not necessarily a factor in achieving unity
in a picture; it resolves itself in a matter of *design*, a purely abstract
quality that is the absolute in all art. Contrast this lack of unity with
the indivisibility in Chardin's *Kitchen Still Life* and in Viktor Schreken-
gost's *Fruit and Wine* on page 94.

149

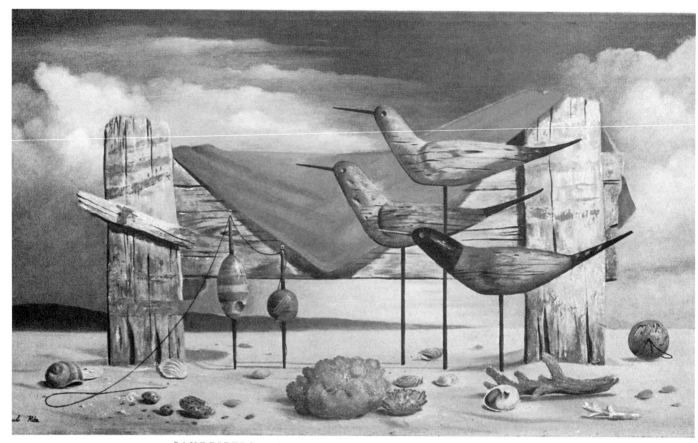

SANDPIPERS OIL 17 X 30 PAUL RIBA
Collection Mr. & Mrs. James Crall

The sketches on page 151 represent studies in the development of the picture's composition. Fig. 1 was Riba's first trial; fig. 2 his third. Fig. 3 is his final drawing in pencil and charcoal, 14 x 28 inches, nearly the size of the painting itself.

150

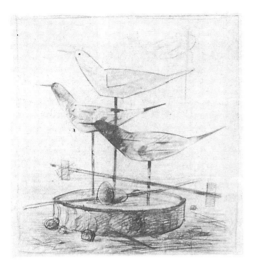

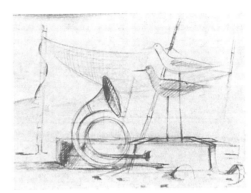

FIGURE 1

FIGURE 2

In Frederic Taubes' *Kitchen Still Life* unity has been achieved by merging the objects on the table with the background tonality. Here there is no silhouette grouping of the objects; rather they emerge from the background both as dark shapes and light shapes. Yet if isolated from the background, the objects would present a fine integrated mass that might indeed be as agreeably displayed against a light background as a dark one. Note the importance of the table which provides triangular darks in both lower corners of the canvas to give the group a firm support.

FIGURE 3

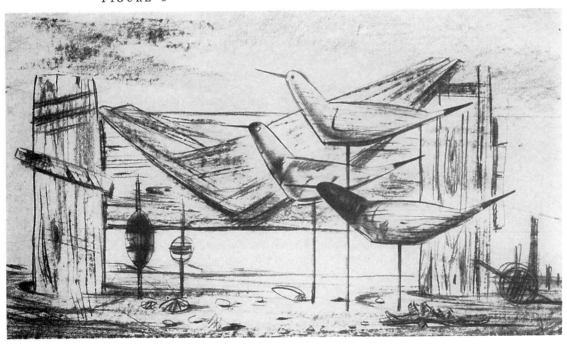

In many pictures we note an interesting means of achieving sympathetic relationships through distortion of natural forms. A good illustration is the drawing of the jug in Cézanne's *Still Life* on page 99. Note how the right side of the lopsided jug bulges out in such a way as to sympathize with the sloping drapery line at the right. In Eric Isenburger's *Still Life* on page 93, the rims of the jug and bowl are "warped" in a directional gesture that draws these objects into the picture. Is it not obvious that a "correct" drawing of these would separate them from the rest of the picture?

Unity is often achieved by the interrelation of lines, as in Karl Knaths' *Gear* on page 100, and more dramatically in Ralston Crawford's abstract canvas on page 20.

Some paintings, such as Dong Kingman's *Clay and Grand,* possess a less obvious kind of unity. Here is a picture in which Kingman seems simply to have led us to this busy corner in San Francisco's Chinatown and left us to explore the whole confusing scene as we would do if actually visiting it in person.

This is characteristic of Kingman who, more than any painter

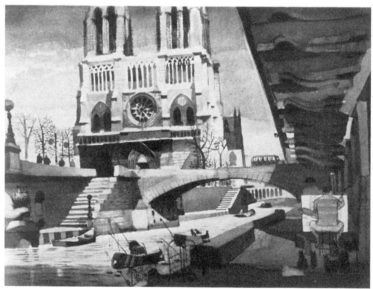

NOTRE DAME BY DONG KINGMAN

Collection Mrs. Priscilla Endicott

One of Kingman's most beautifully organized compositions. The Cathedral, which of course is the center of interest, is framed on the right by the dark overhang and shaded pier; on the left by the street lamp.

152

CLAY AND GRAND WATERCOLOR DONG KINGMAN

Courtesy Midtown Galleries

*An intentional lack of unity, has no center of interest. Kingman leads us into
a busy corner of San Francisco's Chinatown and leaves us to explore with
him the whole confusing scene as we would if actually visiting the spot.*

who comes to mind, is so boyishly excited by the sights and sounds
of contemporary life that he delights in picturing their initial, un-
inhibited impact upon him. So we wander about in his pictures, dis-
covering the numerous incidents of the scene and experiencing the
kind of bewildering thrill that comes to a child on Christmas morning
when confronted with an avalanche of presents. But in spite of the ap-
pearances of confusion, there is always a basic design structure that
holds all parts together. In *Clay and Grand* the eye finally comes to a
focus at the building's corner which is set within a rectangular frame of
posters on one side and the lamp on the other.

153

THE CLOISTERS OIL ANDREW WYETH
Collection Lincoln Kirstein

154

Mood

When we speak of mood we think of a state of mind. Mood of course encompasses the entire range of emotional experience: the mood can be gay, somber and a dozen or more other mental responses to conditions, thoughts and things. However the usual connotation, at least when applied to art, favors the meditative, with accent on serious or profound contemplation as opposed to a merely agreeable or light-hearted sentiment. Mood is most likely to have a nostalgic implication as in the two canvases on the following pages: one by Robert Vickrey, the other by Robert Addison. In both of these pictures we are led to think of the impermanence of life's pleasures. In Vickrey's *Autumn Landscape*, happy summer days are over. The playland once gay with children's laughter is deserted; a threatening cloud bears down on the once-joyous vacation scene. Robert Addison's *Carrousel* pictures a more poignant sadness: the complete abandonment of the merry-go-round for one reason or another. Never again will children clamber into the saddles of the once-proud galloping steeds. This canvas thus conveys a permanence of sadness not seen in *Autumn Landscape*, which quite likely will witness a renewal of pleasure when next summer comes around.

Andrew Wyeth in *The Cloisters* projects a more subtle mood. We have to ask ourselves, thoughtfully, what it is that creates the melancholy mood; the title does not help at all. Is it perhaps our surprise in finding a modern ceramic in the bleak attic of an ancient Maine farmhouse? Or is it the sobering reminder of the many inhabitants, long departed, who once gazed upon the cracked plaster, the slowly rotting timbers of this now-empty room — an attic once littered with castoff things that could not be thrown away?

In this eloquent emptiness but one thing remains — the ceramic bird. Or has it recently been placed there? At any rate it is a picture of "fate," of mortality, of the ephemeral nature of man who once sang from his hymn book, "We are but strangers here."

155

MAMA, PAPA IS WOUNDED
YVES TANGUY
Collection The Museum of Modern Art

In El Greco's famous canvas *Toledo* there is a wholly different quality of mood; a mood of violence which Thomas Craven discusses in his comment on the picture in *A Treasury of Art Masterpieces.** He writes, "His *Toledo in a Storm* was painted during his last period 1604-1614, when he was in full command of his volcanic style. It is the first pure landscape in Spanish art, and in controlled vitality and bizarre, dramatic force, it is hardly surpassed in any art. A man of his temperament could not have painted his adopted home in a quiet mood — when the city rose from the crest of a great hill like a mirage; he must paint Toledo when the elements were at war with man in a dark background overhung with greenish clouds and illuminated by spectral flashes. Nor could he respect the topography; he must alter it to suit his own purposes, moving the Cathedral from the center of the town to the hillside below the Alcazar, widening the ravine of the Tajo, and eliminating many of the twisted streets. With a few basic lines he binds the landscape together, communicating movement and threatening terror to all the parts, creating a living organism consistent with his perception of the convulsive Spanish world."

————

*Excerpt reprinted by permission of the publisher, Simon & Schuster, Inc., New York

156

AUTUMN LANDSCAPE TEMPERA ROBERT VICKREY

Purchased by the National Academy of Design through the Ranger Fund

CARROUSEL EGG TEMPERA ROBERT W. ADDISON

Collection Dr. & Mrs. William Knospe

157

VIEW OF TOLEDO EL GRECO
Courtesy The Metropolitan Museum of Art
Bequest of Mrs. H. O. Havemeyer

RAIN ON SUPERSTITION MOUNTAIN ROY MASON
Collection Dartmouth College

An April Mood, Charles Burchfield's canvas on page 163, is also a mood of violence, with threatening, dark clouds that bear down on a harsh landscape, a landscape that suffered much from a cruel winter. This is an April that has no promise of summer's benign days.

It may not occur to many to associate Burchfield with Wyeth, yet there seems to be an affinity in their emotional natures. I have just been looking at an early Burchfield painting, *In a Deserted House,* and I find in its rendering of the barren interior and its cracked plaster walls an emotional response similar to that evoked by *The Cloisters.* Burchfield may be said to be more violently moody and Wyeth more subtly moody. Henry C. Pitz, writing about Andrew Wyeth, tells us that, "drama is inherent in the Wyeth quest and is consciously sought, not the drama of violence or the theatrical ignition of passion, but the drama of inevitability, of the long endured, of facing the best and worst — drama achieved by understatement, not the drama of a moment but of a lifetime."

159

If Douglas Parshall's watercolor *Trees and Rocks* comes close to being an abstraction, none the less it is a very "moody" picture. It is a restless, agitated picture, and desolate. Those tortured white tree shapes are skeletons stripped of bark by gales and bleached by sun. Other dark, branch-like forms must be branches, broken and lying in disarray completing a scene of destruction. The sky bespeaks the violence that has wrought such havoc and the enveloping atmosphere adds harmonizing accompaniment. The picture unmistakably conveys the painter's impulsive attack with a nervously thrusting brush.

Mood may be inspired by purely abstract qualities, notably by tonal relationships such as we find in Feininger's *Glorious Victory of the Sloop Maria* on page 118, where gradations of tone and color are successfully used to create it. Roy Mason employed this device in *Rain on Superstition Mountain* to express the mood of depression felt by the drenched horsemen.

Mood is a transcendent characteristic of surrealist painting. According to the 1924 definition of André Breton, the intellectual leader of the movement, surrealism was "pure psychic automatism by which it is intended to express verbally, in writing or by any other means, the real process of thought, i.e. subconscious thought. It is thought's dictation, all exercise of reason and every esthetic or moral preoccupation being absent." "All exercise of reason" does indeed seem to be absent in Yves Tanguy's *Mama, Papa Is Wounded*. If any concrete idea was in the painter's mind it is not legible in his picture.

When in 1942 I interviewed Burchfield for an article that appeared in the May issue of *American Artist* magazine of that year, I wrote: "In order really to understand the emotional undertones in Burchfield's pictures one needs to be acquainted with his first experiments in which he attempted — in his early twenties — to re-create the sensations and emotions of childhood, to express the forebodings of childish imaginations. Of the *Night Wind*, an early picture, the artist wrote, 'To the child sitting cozily in his home the roar of the wind outside fills his mind full of strange visions and phantoms flying over the land.' In *Church Bells Ringing*, the church tower assumes a face like an African mask and sways with the swinging spiral motion and sound of the bells. Invisible sound and resulting emotion are thus expressed in visual forms. . . . Burchfield has made us all feel with him the strange and compelling beauty of things which, without the revealing touch of his brush, would seem devoid of all

160

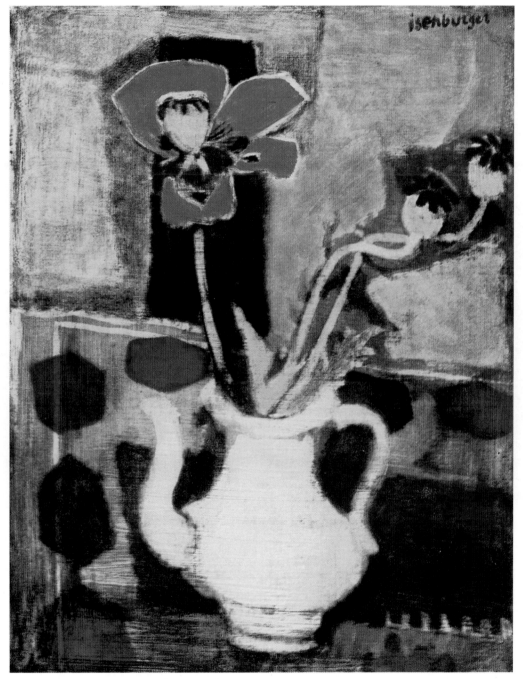

THE FADING POPPY OIL 26 X 20 ERIC ISENBURGER

Collection Mr. Vincent Connally

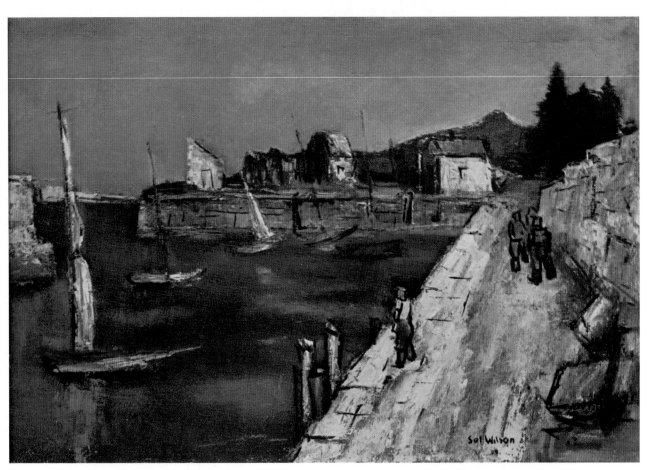

SAILBOATS IN HARBOR OIL 20 X 30 SOL WILSON

Courtesy Babcock Galleries

BLUE DECANTER OIL 30 X 20 BENTLEY SCHAAD

Collection Mr. & Mrs. Millard Sheets

BLUE TABLE STILL LIFE OIL 20 X 24 HENRY LEE McFEE
Courtesy Rehn Galleries

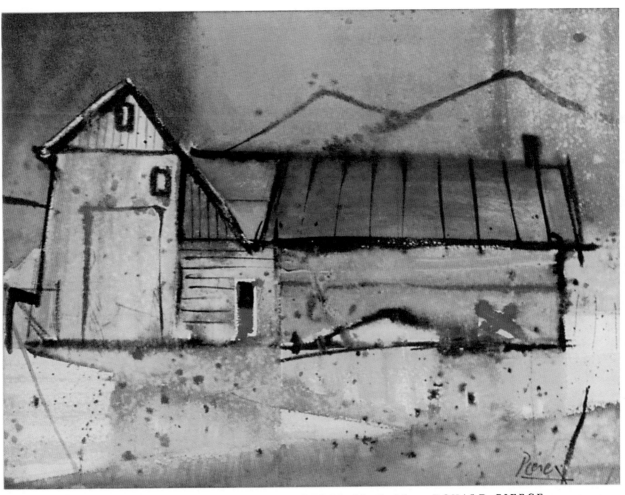

NEW ENGLAND BARN WATERCOLOR 11 X 15 DONALD PIERCE

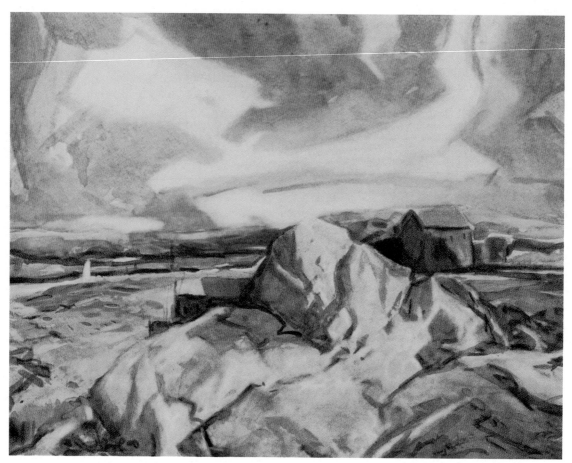

LOOKOUT ROCK WATERCOLOR 17 X 24 WILL S. TAYLOR

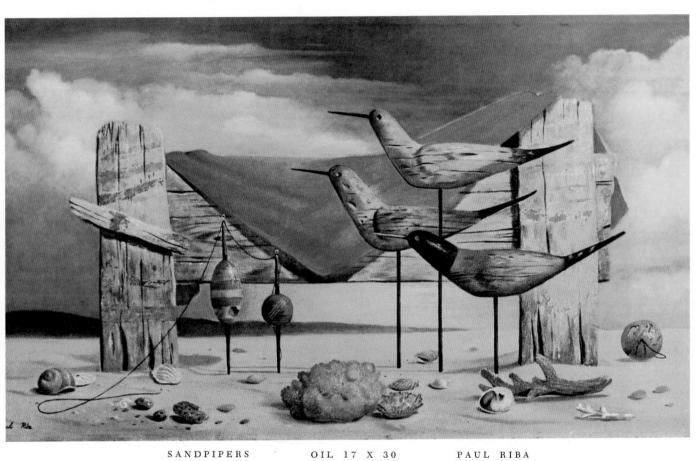

SANDPIPERS OIL 17 X 30 PAUL RIBA

Collection Mr. & Mrs. James Crall

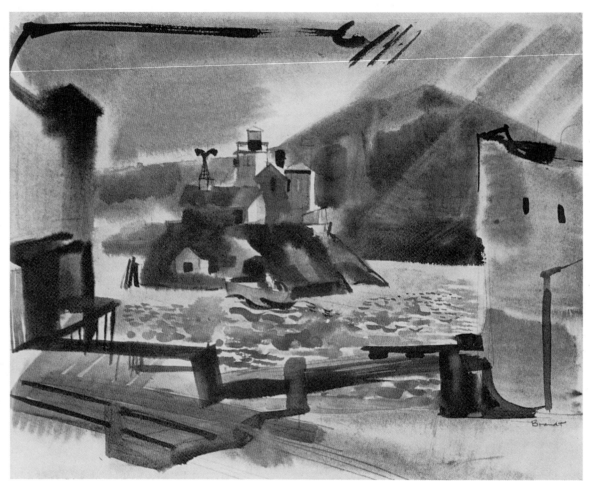

THE BROTHER'S LIGHT WATERCOLOR REX BRANDT

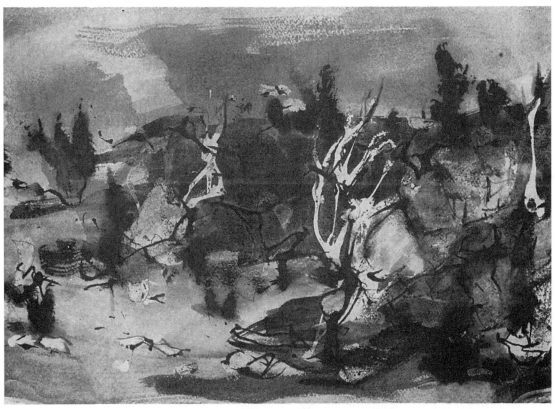

TREES AND ROCKS　　　WATERCOLOR　　　DOUGLASS PARSHALL
A painting charged with a mood of violence

charm. On the other hand he does at times turn to subjects that have a universal appeal, such as *The Great Elm*. Here the sun shines upon a farm where house and rambling barns are pleasantly viewed from the spreading branches of the old tree. But more often it has been snow; wet, reflecting streets, leafless trees and lowering skies — all vehicles for the expression of the 'Burchfield Mood.'" Although that was some years ago, I quote it because it is just as applicable to his more recent work. After all, the basic charactertistic of an artist's personality does not change no matter how often it may find fresh ways of expression through the years.

At the time of my interview with Burchfield he told me of his love of music and how greatly it is reflected in his painting. Referring to Moussorgsky's songs, he said, "They're a great stimulation to me.

161

I feel that painting ought to be like that — not necessarily gloomy or tragic, but it ought to speak directly to us."

The romantic and poetical basis for some of his painting experiences is also revealed in what then, at any rate, was his occasional practice of painting his picture in words before taking up his brush. This is such an extraordinary "feeling out" of a pictorial mood that I am going to reprint one of those word pictures which was included in the article referred to. He is speaking of *Sunday Morning* (the picture is not shown here).

"It is Sunday morning in mid-August. The day crawls slowly around from a dull listless dawn. Gradually there swells into a chorus the irritating 'tick' of countless insects—the sounds proceed from crab-grass and scrawny ragweed standing despondently in the dismal heat. Down a sun-drenched street, whose vista extends out to fields of Queen Anne's lace and chicory, dim with hot steam-like mist, come languidly the worshippers. Those who come from out in the country have come over a dirt road which is lined with dust whitened weeds. Just before the road crosses a one-track railroad, and widens out into a brick-paved street, it passes a wretched farm which has an ill-smelling pig-pen from which issue grunts and squeals. (The memory of this sight influences the character of the clouds mounting up into the sky, giving them a tired tawdry look.)

"A few early arrivals are clustered about the entrance, talking of the heat. There is the inevitable heavy-set lady with raw sunburned face and neck, dressed in a blue-and-white flowered dress, fanning herself. One by one, after desultory greetings have been exchanged, they file into the church. A brief silence; then the opening hymn, followed by the 'responses,' another hymn, and presently is heard the hollow voice of the minister delivering the sermon. The world outside is left to itself.

"(The foregoing is a sort of preliminary mood. Somehow or other, I could not make the eventual picture fit into the realistic manner that such a description calls for. The mood from here on changes, becomes more mystical, and abandons almost completely the ironical touch. The last sentence should be repeated to open this mood.)

"The world outside is left to itself. White clouds that have a melted look appear in the faded hot blue like moths seeking annihilation in a flame, trailing behind them shadows across the sky like dark rays. Pale orange sunlight, that strikes the bizarre steeple with

162

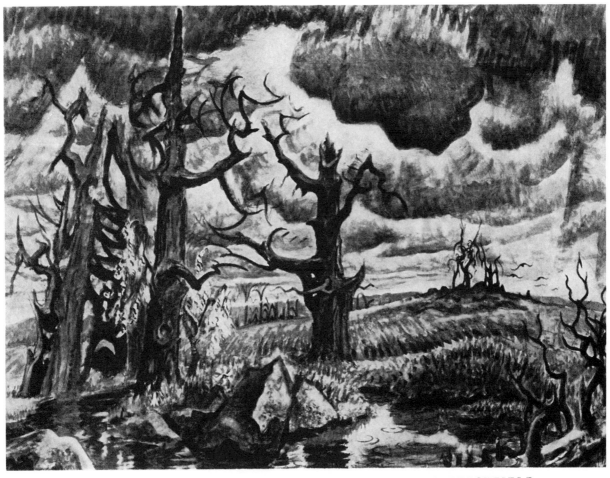

AN APRIL MOOD WATERCOLOR CHARLES BURCHFIELD
Collection Whitney Museum of American Art

quivering intensity, seems to die before it reaches the base of the
church. Round about stand tall gaunt poplars—for once these normally
nervous quaking trees stand motionless, shrouded in a warm violet
haze. From the topmost branches of one comes the pulsating metallic
drone of a cicada, which mingles with the voice from the church,
sounds that only seem to emphasize the profound silence that has
settled down over the town. Clouds, trees and the church all seem to
yearn upwards, ever upwards."

163

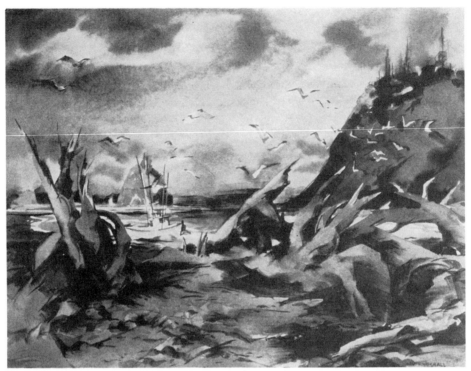

DRIFTWOOD WATERCOLOR 19 X 27 MAY MARSHALL

164

Subject To Canvas

*T*he title of this chapter doubtless is ambiguous. The examples that are brought together in it might as well have appeared in other chapters; and other works in the book could appropriately have been included in this one. The chapter is merely a convenient section for the assembling of paintings with which I am able to show photographs of the scenes that inspired the pictures. The paintings, of course, were not made from the photographs: many painters like to make photographs of their subjects as a record of places and things where they have painted.

In some pictures the painting follows nature more closely than in others; in all of them, nature has been *used* rather than "copied." The experienced painter requires little more of nature than an objective hint and general familiarity with the type of subject it represents. Note for example how little there was in May Marshall's *Driftwood* for her to "copy." But what was there was quite sufficient because she had the essence of her picture in her mind before she saw even that. She is a capital composer, a resourceful designer; the mere suggestion of uprooted dead trees was enough to set her creative apparatus to work inventing forms. Equally important, she was filled with the *spirit* of her subject; she could do much better with

Two photographs of the scene which served May Marshall as source material for her water-color "Driftwood"

Rex Brandt made this sketch to reveal something of the emotional basis of his painting "The Brother's Light." Brandt explains it this way:

"The primary plan—rectangular boxes expressing essential structure of buildings, boats and hills—provides a grid against which the forces of nature can play. A secondary movement, originating in the strong feeling of sun and wind, sweeps the composition diagonally, setting up little eddies and counter movements. This culminates in a third force, the hooked curve, derived from the sun and water elements and repeated in the livelier parts of boats. This is the intense expression of these natural forces and I tried to build it in a sort of musical crescendo."

it than could any painter who was not on intimate terms with that kind of subject.

Looking from the photographs to her watercolor, one may be surprised to hear her say that although she will often "make small sketches, quickly blocking-in the composition and values, in the case of *Driftwood* the painting was there just waiting to be put down." She says, *"Driftwood* was painted on the spot — at Lapush, a colorful Indian fishing village on our Washington Coast. My husband Fred, a fine painter, and I, on an August vacation were sketching at various spots on the Coast from the Columbia River to the rugged coast of the Olympic peninsula. Lapush, rich in color, with rolling logs and silver driftwood, was our painting ground for a week. With watercolor kits we entrenched ourselves on the beach between towering masses of driftwood. The subject looked good — waterway with fishing boats bucking the tide, breakers crashing against the rocky islands, and sea gulls weaving patterns in the sky."

Now note what Rex Brandt did with his subject in *The Brother's Light.* From his vantage, the island with the light appears small in relation to the foreground stuff. The mountain recedes far into the distance. In his painting both are brought forward because *they* are his subject; then see how he has increased the sizes of the lighthouse buildings relative to the land-mass which, itself, is shaped in accordance with his own compositional needs. He has almost destroyed

166

THE BROTHER'S LIGHT WATERCOLOR REX BRANDT

Photograph of "The Brother's Light"
taken on the day Rex Brandt painted
his watercolor

167

distance in his eagerness to emphasize the design and color elements that are the basic inspiration and structure of his picture.

A wreck, a wreck! Such a cry once sent the rapacious populace of coastal towns scurrying to the beach for plunder. Today, a storm-riven ship, tossed upon Monhegan's rocky shore, is fair game of quite another sort. There is scarcely an artist of the island's summer art colony who, at the cry, will not hasten to the headlands and "fall upon" the ill-fated vessel eagerly with brush and paint.

Monhegan is a small island off the coast of Maine in the tempestuous Atlantic. Its precipitous cliffs and pounding surf have attracted many painters since Rockwell Kent, Eric Hudson and George Bellows, among others, a generation ago discovered its paintable scenery.

One stormy night in 1950 an ocean-going tug was driven aground at Lobster Cove where it lay broken upon the rocks. Some months later the St. Christopher, a Gloucester fishing boat, caught fire off the island and was brought into Squeaker Cove in the faint hope of salvaging her. These two wrecks inspired many canvases. The canvas by Joseph De Martini titled *The Wreck at Squeaker Cove* is especially interesting in its structural organization, as will be seen by the diagrams on page 171. We stated in the chapter on Balance

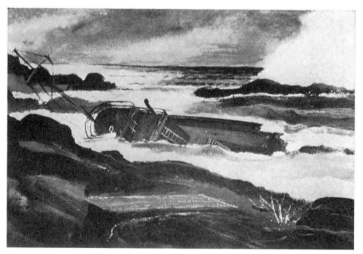

WRECK AT LOBSTER COVE WATERCOLOR
JOSEPH BARBER

168

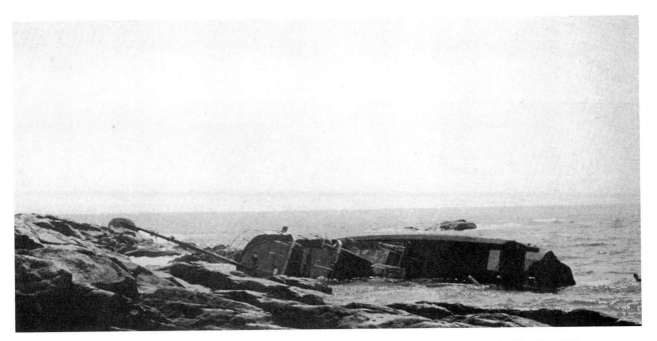

PHOTOGRAPH OF WRECK AT LOBSTER COVE, MONHEGAN, MAINE

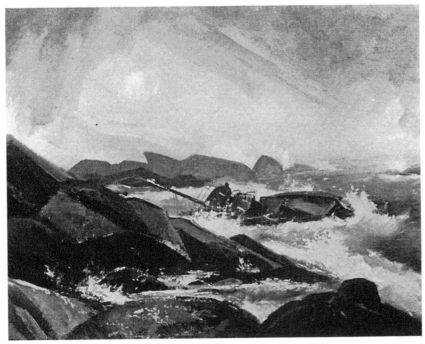

WRECK AT LOBSTER COVE WATERCOLOR
EDWARD GUSTAVE JACOBSSON

PHOTOGRAPH OF A WRECK ON SQUEAKER COVE, MONHEGAN, MAINE

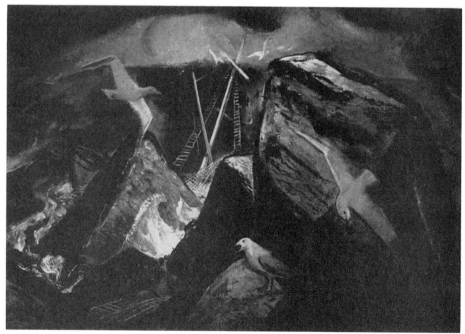

WRECK AT SQUEAKER COVE OIL FERDINAND WARREN

Collection Dreher High School, Columbia, South Carolina

170

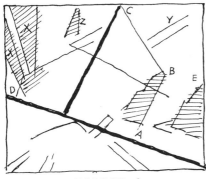

FIGURE 1

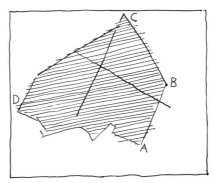

FIGURE 2

*These analytical diagrams are the author's interpretation of
the picture's compositional structure. See text on page 172.*

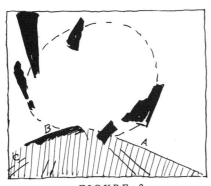

FIGURE 3

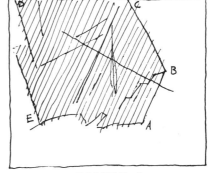

FIGURE 4

WRECK AT SQUEAKER COVE
JOSEPH DE MARTINI
Collection New Britain (Conn.) Institute

171

that every picture ought to have stability, even one that has such violent action as this which despite its turbulence is solidly balanced. How is this accomplished? The downward thrust of the foreground rock-mass (D-A, fig. 1) to the right corner is opposed by the mast which is at right angles to it and by the two shapes B and E parallel with the mast at the right side. These forces are echoed by Z above, which, though a small mass, is important in uniting the dark accents X, X which might be visualized as existing in a circular orbit suggested in fig. 3.

Less emphatic, though no less instrumental in the action, is the thrust of Y against the whole falling mass, approximately A, B, C, D in fig. 2 or A, B, C, D, E in fig. 4.

In fig. 3, I have suggested what I feel as a firm triangular support in the foreground, formed by the strong direction of B, pointing generally to the left corner and forming an apex to the triangle.

De Martini did not make this analysis for me. I have not consulted him about it; but this is the way his picture "works" for me.

In comparing George Jo Mess' aquatint *Goat Farm* with his on-the-spot oil sketch, which is how it started, we are impressed, as we are in *Highway #7* (page 57), with this artist's great ability as com-

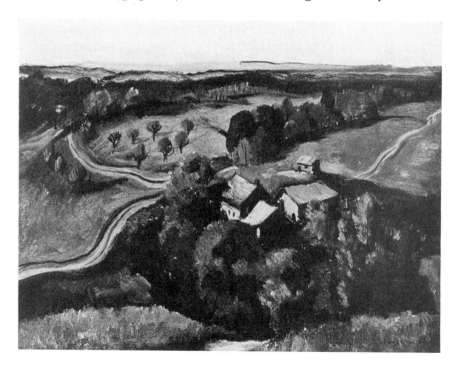

172

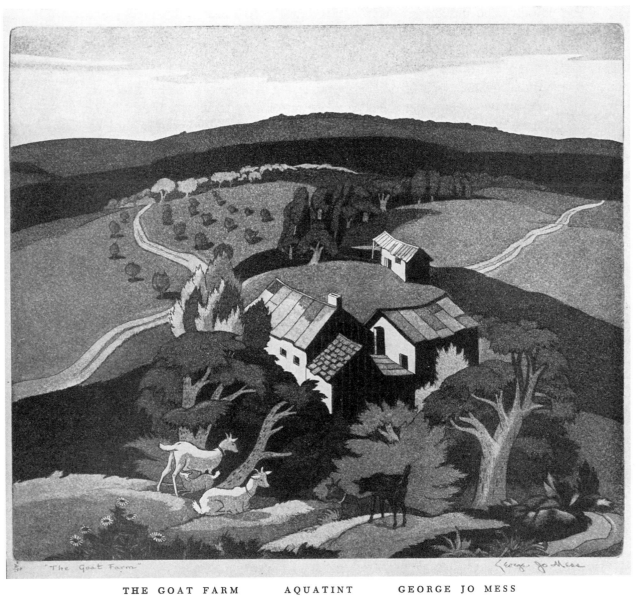

"The Goat Farm" George Jo Mess

THE GOAT FARM AQUATINT GEORGE JO MESS

On the opposite page, an on-the-spot painting of the scene by Mr. Mess shows what he had to work with in creating his splendidly organized composition.

173

poser. The picture might as appropriately be placed in any chapter in this book, so completely does it embody almost every facet of compositional strategy.

Because its *tonal values* are so beautifully designed the print invites special mention of this important quality in it. Cut a window, one by five inches, in a sheet of white paper and lay it over the picture. Move it about in all directions and observe the fine relationship of light, middle-gray and black tones that makes each segment a splendidly balanced tonal design.

In Will S. Taylor's *Wood Interior* there is an interesting contrast in approach to that of his *Lookout Rock* (page 147). In the latter, discussed in detail in our chapter on Unity, we see the painter involved in a multiplicity of compositional problems that resulted in an emphasis upon the picture's abstract structure. We are more conscious of that approach, and delightfully so, than in *Wood Interior* which seems so obvious in its composition that we are not aware of the creative thinking which produced it, until we see the photograph of the subject and the thumbnail studies which represent the painter's analyses of his problem and its solution. "Painting in the woods," says Taylor, "is the most severe test of the artist's creative ability. The light effects change radically every few minutes as the sun picks out new areas of light. After contemplation of the scene one must resolve the natural confusion into a simple pattern that will convey the impression which inspired the painter in the first place."

The seemingly hypnotic response of painters to a particular subject is often surprising, and very difficult for others to understand. To

WOOD INTERIOR OIL 28 X 34 WILL S. TAYLOR

Photograph of the subject taken at the spot where Taylor painted "Wood Interior"

Two pencil studies, opposite, much reduced, of the same subject which illustrate the kind of preliminary thinking that often precedes Taylor's work with his brush. Of the extreme left sketch he says: "The obsession to inventory the material of the foreground detracts from the desired feeling for the flowing brook. Note in the second sketch, improved area relationships. Here also the developed energetic pattern of light and dark tree forms emphasizes the brook's slow-moving curves."

175

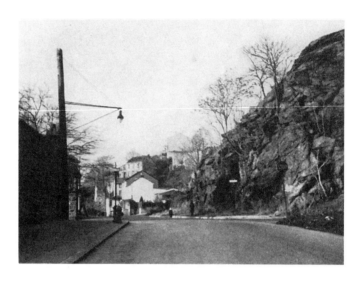

Two photographs of the subject of Antonio P. Martino's "Tower Street" canvases on the opposite page

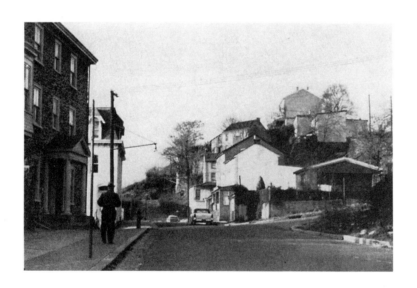

176

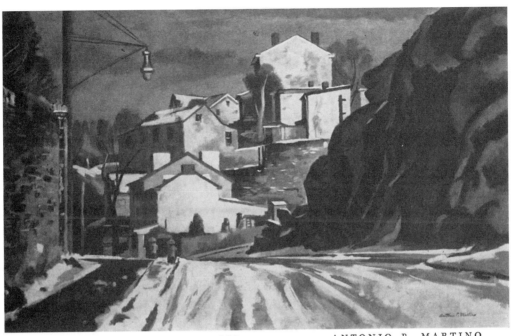

TOWER STREET OIL ANTONIO P. MARTINO

This version of the subject, a more literal impression, took the
First Altman Prize at the National Academy of Design in 1943

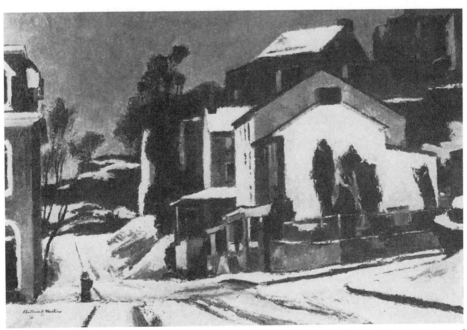

This canvas was painted in 1952 when Martino was more interested in abstract aspects of
the subject. Note the avoidance of perspective effect seen in the earlier painting. This
canvas won the Third Purchase Prize of $1500 at the Terry National Exhibition in 1951.

177

hear Antonio Martino say — about *Tower Street* — "I feel as though I could go on painting this subject for the rest of my life" is dramatic testimony to the tremendous activity of the creative mind. He says he has painted Tower Street at least five times, from as many different viewpoints. "With each new canvas," Martino says, "I get more of a feel for the abstract in design with a recognizable subject, keeping my shapes and patterns simple and developing my color as a design element throughout the painting. It is the type of subject that interests me more and more as my feelings for the plastic qualities in painting keeps growing."

The two canvases reproduced, painted nine years apart, show very clearly the artist's change in approach from the earlier, more objective attitude to a more perceptive appreciation for the subject's design possibilities. In the later rendering we see scant recognition of deep space, emphasis here being largely upon the picture's two-dimensional aspect, with distance compressed into a relatively shallow picture space. A comparison with Cézanne's *Landscape at La Roche Guyon* on pages 138 and 139 will reveal similarities in compositional strategy.

I had the two photographs of Tower Street taken just a few weeks before this book went to press. Said the artist, who went to some lengths to get the photographs taken for me, "I would like to get back to Tower Street soon, to see how I would express my feeling about that subject now."

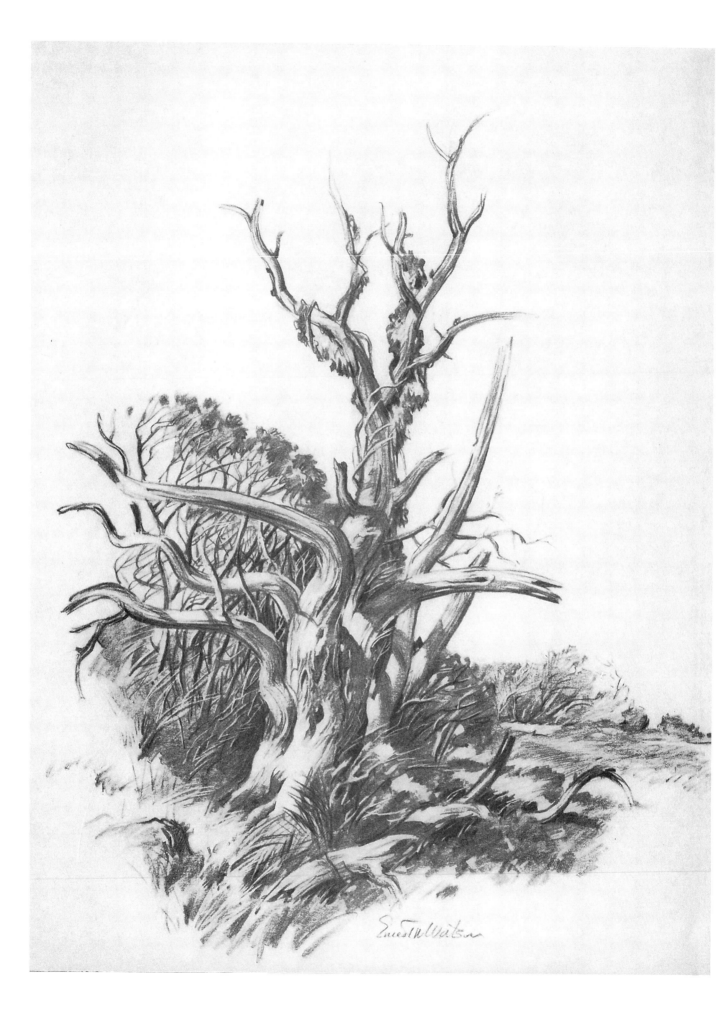

Trees

"There is hardly a problem in painting that you cannot solve when painting a tree." Those are the words of Jacob Getlar Smith whose watercolor painting of two trees is reproduced on page 189. And, says Henry C. Pitz, in his book, *Drawing Trees,** "Certainly one of the noblest things in the growing world is a tree. It is not only an amazing, living organism, but a constant delight to the eye; and visual delight is the life of art. An artist could not wish for more inviting, challenging and inexhaustibly refreshing material. This wonderful material is within reach, but we must grasp it. To make it our own, to acquire some command of its resources, we must pay a price of interest, effort and study. The principal means at our disposal are constant and intelligent observation, and diligent recording. They must go together. Aimless and lazy drawing will not achieve much; observation by itself will not teach the hand to find graphic symbols for the things observed."

To many unthinking people trees are only trees, objects of beauty to be sure, but just pleasant objects among nature's accessories in the grand spectacle of landscape. To the artist — and of course to the lover and student of nature — trees are infinitely more than that; they are a language, a voice that transcends human speech in expressing the mystery and wonder of life. To the painter a tree becomes a symbol of whatever truth he may wish to demonstrate. Compare, for example, those naked skeletons of Charles Burchfield's in his *An April Mood* (page 163), stark reminders of the harsh winter that has twisted and broken them, and the friendly old apple trees (page 75) in Kenneth Bates' *Two Trees;* in their senility these veterans seem to clasp hands, grateful for each other's company.

The old gnarled tree trunk in Ryder's *Forest of Arden* (page 17), bearing a cloud on its up-reaching stump, no doubt has a mystical

*Watson-Guptill Publications, Inc., New York

DRAWING OF A DEAD CHESTNUT ERNEST W. WATSON
From COURSE IN PENCIL SKETCHING *by the Author. Reinhold Pubs., Inc.*

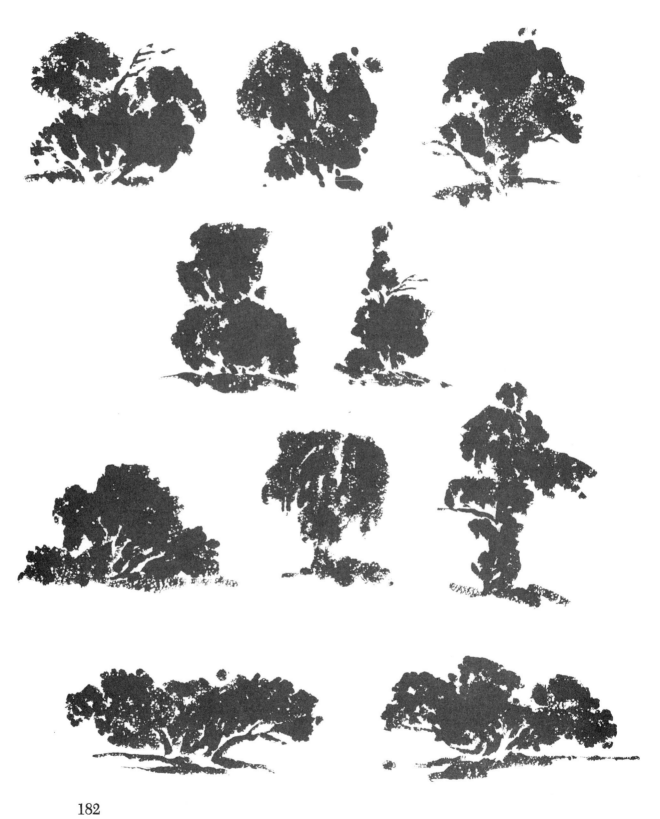

182

This is the first step in a light-and-shade development of the tree in the upper right corner of the group on the opposite page. All that has been done was to indicate sunlit areas of foliage masses with another flat tone. From this basic light-and-shade pattern the painter should proceed cautiously, avoiding the tendency to complication.

The tree sketches on the opposite page are from oil originals (considerably reduced here) such as are suggested (page 184) as a means of studying tree character in terms of silhouette mass.

significance. To Ryder the dreamer, who often spent meditative years on his canvases, that tree must have been more than a decorative abstraction.

In Robert Addison's painting *The Swing*, the beautiful dead or dying apple tree establishes the picture's mood, the memory of the almost forgotten past of that decaying old house.

Well, how shall we begin our tree study? That will be determined by climate. If it be winter and the trees are bare, we have no choice but the study of skeletal structure and we would do well to fill a sketchbook with drawings of all manner of naked individuals.

If it be summer, the first impression of a tree is the shape of its mass, its silhouette. The silhouette of a tree in full leaf is its essential character. Even when seen in brilliant sunlight the difference in values of lighted and shaded foliage-masses is usually too slight to interfere with the impression of its totality, its silhouette.

So with bristle brush and a *single color*, on panel boards or canvas, make innumerable studies of tree silhouettes in the manner of those on a preceding page. These are reproduced at about one-third size of the originals. The color used is not important. I prefer a gray-green, made by mixing a bit of raw sienna and white with a dark green. The important thing is to keep the silhouettes perfectly flat, avoiding any attempt at shading or tone variation. It is the tree's simple design we are now studying.

As you make such studies you will be surprised to discover how satisfying they are, how little more than silhouettes you will be likely to need in future painting, except for color variation which need not interfere at all with the flatness of the silhouette. Indeed it will be instructive, after making many of the one-color sketches, to do some experimenting with them in color, trying to keep the three or four hues you may use in exactly the same value. You can do this in your home studio, working from the one-color studies you bring home from the field. Avoid the use of brilliant colors; work in a subdued color scheme. Naturally you will be more successful doing this after considerable outdoor painting.

Now you ought to make a great many of these one-tone silhouette studies. And, having done so, you will find your landscape paintings getting more exciting. Often it happens that the tree or trees in an otherwise inviting landscape are not quite as dramatic as you would like them to be, but the color, the sky and the over-all

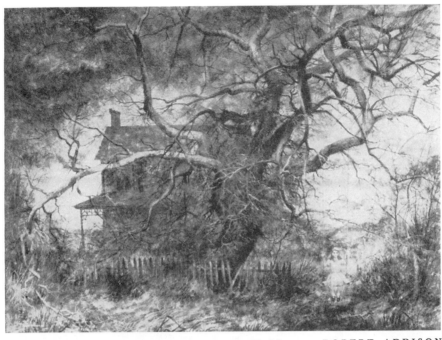

THE SWING EGG TEMPERA 20 X 29 ROBERT ADDISON

This fine rendering of a dead apple tree contributes a melancholy accompaniment to the decaying house beyond. The nostalgic mood is enhanced by the child whose presence in the somber setting is a commentary on the impermanence of life on its periodic renewal.

composition of the subject are so inspiring that you want to paint it. With the memory of some of those unusual tree forms in your sketch collection and the knowledge they represent, you will be able to re-design your tree in a satisfying way.

Do I hear the proposal to substitute the camera for the brush and pencil in this kind of tree study? I feel inclined to say "leave the camera at home." It would be rash, of course, to deny its value to artists in some circumstances, but it is a dangerous tool because it tempts one to substitute it for the inquisitive human eye. The secret beauty of any subject is never quite realized until it has been *earned* by intimate study with a searching pencil or brush. The camera will not reveal it no matter how perfect the photographic image. It has to be *felt-out;* it cannot be captured by the click of a shutter.

The character of a tree's silhouette is determined, of course, by the structure of its trunk and branches. Although these may be largely hidden by foliage, enough of the skeleton usually shows through gaps

185

in the greenery to more than hint at its design. These structural fragments often show light against the shaded interior. Seize upon these as you mass-in the silhouette, leaving them untouched by your brush, and your tree will look remarkably complete.

Everyone who has drawn or painted trees has had the disappointment of failure to capture their essential character when done too hurriedly and without careful analysis of its design structure. A glance at the pencil drawing of an oak that attracted my attention on a Maryland highway, during an automobile tour in that state, will explain the kind of analysis I have in mind. This happens to be a particularly interesting subject for demonstration. Not all trees, to be sure, are so readily analyzed but every tree can be analyzed on a geometric basis of some kind.

First determine the tree's *stance*. How does the tree stand? Is it erect, or does it lean? If it leans, what is its exact angle with the ground? That is important because all else in the tree's character is dependent upon it. Next, note the principal subdivision of foliage masses. Make a small line diagram of your analysis before beginning the large study; its enlargement is a simple matter. This is the only way to obtain a correct drawing of your tree!

Thus far we have focused upon the silhouette aspect of trees. Now let us consider light and shade. After the tree has been sub-

The pencil drawings on these facing pages indicate an analytical procedure for the correct portrayal of a tree's character. Usually the analysis can be made with geometric references.

187

divided into a few principal foliage masses — these usually are fairly evident — we can render forms in light and shadow. The first caution here is the avoidance of too much contrast of light and dark colors and the consequent danger of losing the unity of the entire tree form. As a matter of fact the contrast is far less than is usually imagined by the inexperienced painter who is likely to achieve a spotty, unpleasant foliage pattern. Usually there are a few principal foliage masses that dominate the whole design.

In many trees there is no pronounced subdivision of the entire mass into smaller foliage groupings. Such trees are far less interesting. However, because of their color or the shape of their silhouette they may be wanted in the picture. In such an instance the painter through his familiarity with tree structure and his sense of design can tailor the foliage to suit the needs of the composition.

It should be obvious that trees in the near foreground can be more detailed in treatment than others farther away. Those in the far distance will be simple silhouettes. The tree in Jacob Getlar Smith's watercolor — there are really two trees — is right up in the foreground and is rendered with considerable detail. Strong light on some of the foliage masses results in pronounced modeling such as would be out of place in trees in the background or even the middle-distance.

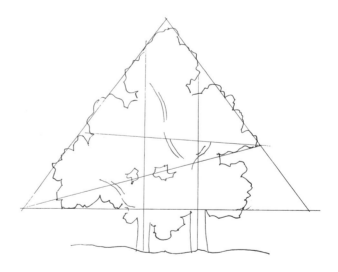

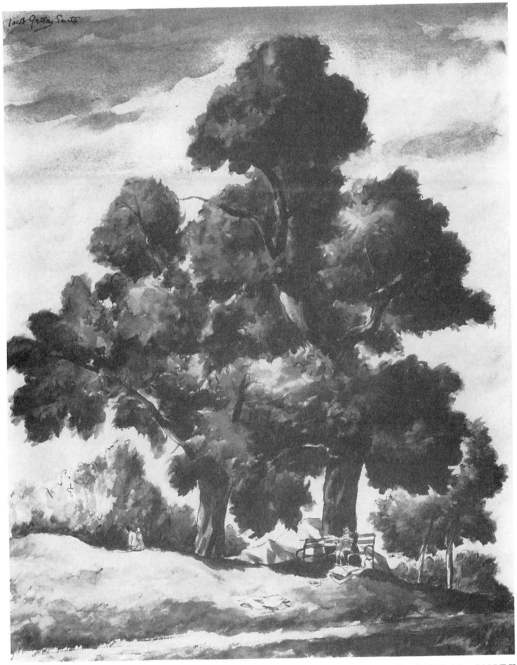

SUNDAY IN THE PARK WATERCOLOR 25 X 19 JACOB GETLAR SMITH

Collection Ernest W. Watson

AFTER THE BATH OIL 29 X 24 RAPHAELLE PEALE
Nelson Gallery—Atkins Museum (Nelson Fund), Kansas City, Missouri

190

Drapery

Drapery is an almost indispensable property for the still life painter. Indeed, a still life without drapery is something of a rarity. Therefore it is worthwhile making considerably more than a casual study of it. This will reveal surprising resourcefulness by painters in the use of drapery in composing their pictures. An old tablecloth, a shawl, a towel, window curtains or a worn smock hanging on a peg often serve as the dominant factor in unifying the design and in supplying an element of gracefulness to an otherwise stiff or awkward composition. Cézanne, who certainly is one of the greatest of still life painters, frequently used strikingly-figured and colorful fabrics to supply pattern interest. Sometimes he rendered his draperies realistically, sometimes in a rigidly controlled manner, as in his *Still Life* on page 193. We see an even more stiffly stylized treatment in Bentley Schaad's *Still Life* on page 49.

Some painters have a surprising preference for some old drapery that is used repeatedly in their pictures; it may be the color, the texture or its familiar clinging folds that particularly appeal to them. Other painters have a cabinet filled with a variety of fabrics: velvet and brocade, silk, rayon, linen and calico pieces, some richly colored and patterned, others in plain colors. I have watched painters "try on" one after the other of these *costumes* — they might appropriately be so called — considering which would best enhance the subject. It might be a filmy silk that offered a smoothly flowing, clinging line, or a heavy fabric that in the stiffness of its folds provided a supporting element according to the compositional needs of the particular subject.

In many canvases drapery is the unifying factor of the composition, as in Cézanne's *Still Life with Apples and Oranges* and in McFee's *Blue Table* on page 108. In these and many others the drapery can be said to be the "stage" upon which the performance takes place. In some pictures the drapes are arranged at the sides and serve in the manner of parted curtains.

191

A good way to study this drapery aspect of painting is to make diagrams or sketches, in the notebook, of every drapery device discovered in pictures seen in exhibitions or in printed reproductions. Such a record will be found very useful later in one's own compositions.

And, of course, the value of making drapery studies with brush or charcoal should not be overlooked. These should include the various kinds of fabrics. It would be profitable to paint these meticulously at times as did Raphaelle Peale in his *After the Bath*, searching the subject for subtleties that could be overlooked in a more casual or sketchy treatment.

As one studies drapery one becomes aware that it acts in accordance with laws — that there is an "anatomy" of folding construction. When strong lighting is used it sharpens light and shadow on the folds and accentuates the structural patterns.

The study of drapery in sculpture will contribute considerably to a more thorough realization of its possibilities in painting. Classical sculptors were wonderful drapery designers. Archaic sculptors are worth studying for the more simplified and stylistic effects which modern painters are more likely to prefer.

STILL LIFE WITH APPLES
CÉZANNE
Courtesy The Museum of Modern Art
Lillie P. Bliss Collection

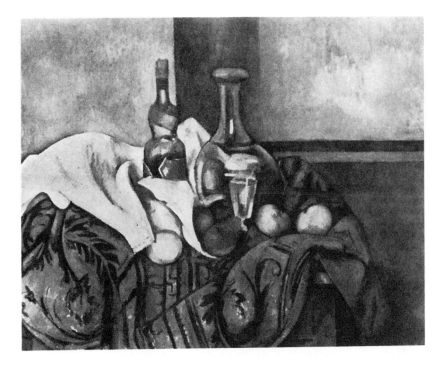

STILL LIFE OIL
CÉZANNE
*Courtesy National Gallery of Art
Chester Dale Collection*

The diagram calls attention to the way in which the drapery folds and the flowers lean inward to establish unity with the bowl of apples.

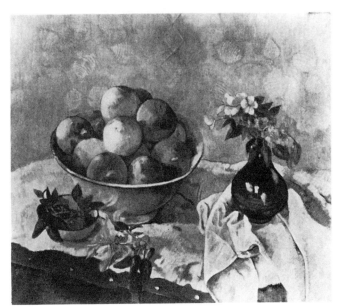

STILL LIFE WITH APPLES 26 X 30 GAUGUIN

193

I had not seen Gauguin's *Still Life with Apples* until it was exhibited in October 1958 at Wildenstein's New York Gallery, after it had brought $297,000 — a record post-impressionist price — at the sale of the Collection of the late Mrs. Margaret Biddle. (See p. 193)

The drapery here is artfully arranged not only for its intrinsic interest but as a structural factor in the action of the composition. Note how it thrusts inward and how it cooperates with the vase of flowers, the latter leaning toward the bowl of apples.

This is an extremely lovely canvas, but are not the apples considerably less interesting than they might be if these were more varied in shape and size? Cézanne would not be guilty of this strange monotony, nor would McFee, nor Brackman nor any other still life painter represented in this book. Gauguin's apples look as though they might have been "faked," that is, painted without benefit of models, and without great familiarity with this particular fruit. Still they appear to be worth $297,000 a dozen!

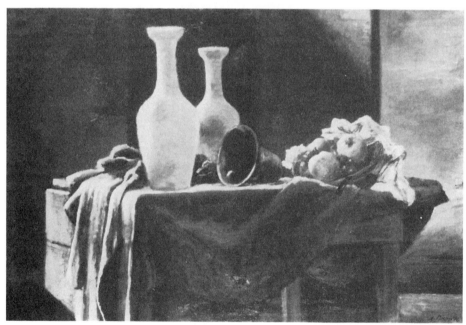

THE SENTINELS OIL 32 X 48 ALEXANDER BROOK
Collection Whitney Museum of American Art, New York

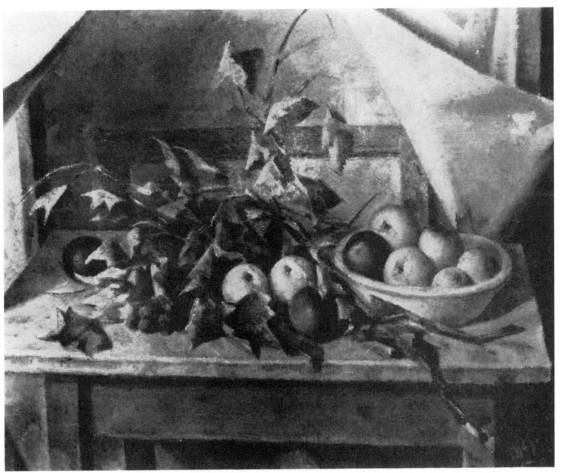

STILL LIFE, DEAD LEAVES OIL HENRY LEE McFEE

Courtesy Rehn Galleries

*Line analysis of McFee's still life
to emphasize its linear pattern*

195

Biographies

ADDISON, ROBERT W.—American, B. 1924, Boise, Idaho. Attended Boise Junior College, also graduated from Art Institute of Chicago. Now associated with Stevens Gross Studios, Chicago. Has recently started to exhibit widely, but for some years has been represented in private collections and won prizes, the latest being in the 1958 Chicago Navy Pier Show. Served for three years with U.S. Army. *AA Oct. 1958.

ANDREWS, SPERRY—American, B. 1917, New York. Studied: Nat'l Academy Design. Art Students League. Among important awards, 1st Hallgarten, Nat'l Academy, 1950; Hassam Fund Purchase for Amer. Academy Arts & Letters, 1953; Invitation exhibitions, Wadsworth Atheneum, Hartford and Slater Memorial, Norwich, Conn. Work in collections of Wadsworth Atheneum, New Britain (Conn.) Museum and Columbus (Ohio) Gallery of F. A. *AA Nov. 1952.

ANGELO, VALENTI—American, B. 1897, Massarosa, Italy. Author, painter, self-taught. Has had several exhibitions both in East and West Coast galleries. His work is in public and private collections, including Library of Congress and the New York Public Library. Has written and illustrated 14 books for children since 1937 and has illustrated 250 others since 1925. *AA 1944-1950-1954.

AVERY, MILTON—American, B. 1893, Altmar, N. Y. Mostly self-taught. Since 1932, 25 one-man shows in New York; exhibits major national shows, also abroad. Honored by Baltimore Museum & Inst. of Contemporary Arts, Boston, with 1952 Retrospective. Works in 35 museums, including Whitney, Metropolitan & Museum of Mod. Art, N. Y.; Honolulu & Tel-Aviv Museums. Prizes include Logan, Chicago Art Inst.; 1st prize, Baltimore Museum, 2nd at Boston Arts Festival.

BARBER, JOSEPH G.—American, B. 1915, Larchmont, N. Y. Studied: Grand Central Sch. Art; Art Students League; Taos Valley Art Sch.; Tiffany Scholarships and Grants. One-man shows in Grand Central Galleries, others. Childe Hassam Purchase Prize; Ranger Fund Purchase Prize; Salmagundi Prizes; others. Represented in various museums; mural commissions and paintings for industry. *AA Jan. 1948.

BATES, KENNETH—A.N.A. American, B. 1896, Haverhill, Mass. Studied at Art Students League and Pennsylvania Academy of the Fine Arts. Exhibited widely in national

exhibitions for many years, receiving a number of awards, including the Jennie Sesnan Gold Medal at the Penn. Academy. Represented in public and private collections. Has lectured and written on art. *AA May 1943.

BOUCHE, LOUIS—N.A. American, B. 1896, New York. Studied: Grande Chaumière, Ecole des Beaux-Arts, Paris; Art Students League. Exhibited in national shows since 1917, and in Europe. Represented in many museums, including Metropolitan; Whitney; American Academy of Arts & Letters, New York; U. S. State Dept. Coll.; Pennsylvania Academy of F. A. Murals in many public buildings, including Auditorium of New Interior Bldg., Washington, D. C. Guggenheim Fellowship in 1933. Many prizes from 1915 to Grand Prize of "Art U.S·A. 1958." *AA Apr. 1944.

BRACKMAN, ROBERT—N.A. American, B. 1898, Odessa, Russia. Pupil, George Bellows and Robert Henri. Represented in nearly 40 permanent collections, including the Metropolitan and Brooklyn Museums, New York. Portraits of many notables, among them, Mr. & Mrs. Charles Lindbergh, Mr. & Mrs. John D. Rockefeller, Jr.; Mr. Henry L. Stimson (Pentagon Building Coll.). Winner of many national prizes. For many years has taught at Art Students League, other schools and at his studio in Noank, Conn. *AA Nov. 1942.

BRANDT, REX (Rexford E.)—A.N.A. American, B. 1914, San Diego, Calif. With his painter wife Joan Irving lives on the edge of Newport Harbor at Corona del Mar, Calif. The summer school which he founded in 1945 with fellow painter Phil Dike is a west coast mecca for watercolor students. Books and films showing his procedures have made his work well known internationally. Grad. Univ. of Cal.; member of many art societies, including Nat'l Academy & Amer. Watercolor Soc.; work in 17 public collections, many magazines & books. *AA Feb. 1953.

BRAQUE, GEORGES—French B. 1882.

BROOK, ALEXANDER—N.A. American, B. 1898, Brooklyn, N. Y. Mem. Nat'l Academy & Nat'l Inst. of Arts & Letters. Many prizes, incl. Art Inst. of Chicago, 1929; Carnegie Internat'l, 1930-39; Gold Medal, Philadelphia Academy of F.A., 1948. Work: in more than 15 permanent collections, incl. Metropolitan, Whitney, Modern and Brooklyn Museums in N. Y.; Art Inst. of Chicago;

198

Boston & San Francisco Museums, and Carnegie Institute.

BROWNE, SYD—A.N.A. American, B. 1907, Brooklyn, N. Y. Studied: Art Students League & with Eric Pape & Frank DuMond. Many awards from national shows, incl. several from Salmagundi & Amer. Watercolor Soc. Work: many public & private collections, incl. Library of Congress; N. Y. Pub. Library; New Britain Institute; Staten Island Inst.; Prentice-Hall Coll.; Wm. Church Osborn Coll. *AA Dec. 1952.

BURCHFIELD, CHARLES E.—N.A. American, B. 1893, Ashtabula, O. Studied Cleveland School of Art. Exhibits nationally, incl. 40 yr. Retrospective at Whitney, 1956. Many prizes; also Hon. Degrees L.H.D. from Kenyon College & Valparaiso Univ.; Hon. Art D. from Harvard & Hamilton Univ. Work in Metropolitan, Whitney, Brooklyn Museums, N. Y.; Fogg Museum; Boston & Syracuse Museums; R. I. School of Design; Detroit Inst. of Art; Univ. of Nebraska; others *AA May 1942.

CADMUS, PAUL— American, B. 1904, New York. Studied: Nat'l Academy, Art Students League. Exhibited national shows: London, 1938; Carnegie Inst.; & Florence, Italy. Art Inst. of Chicago award, 1945. Work: Modern, Metropolitan, Whitney & Public Library, New York; Art Inst. Chicago; Library of Congress; Amer. Embassy, Ottawa, Can.; mural in Parcel Post Bldg., Richmond, Va. *AA Oct. 45.

CEZANNE, PAUL—French 1839-1906.

CHARDIN, JEAN BAPTISTE SIMEON— French 1699-1779.

COWLES, RUSSELL—American, B. 1887, Algona, Ia. Studied: Dartmouth Col., A.B.; Nat'l Acad.; Art Students League; Amer. Acad., Rome; Century Ass'n. Exhibits in major national shows and in many museums. Awards: Hon. Deg. D.H.L., Dartmouth, 1951; D.F.A., Grinnell Col., 1945; many prizes & honors for painting. Work: Metropolitan Museum of Art; Encyc. Britannica Coll.; Murdock Coll.; Univ. Wichita; Dartmouth; Addison Gal.; Va. Museum, Richmond; Des Moines Art Center; others. *AA Nov. 1945; Apr. 1949.

CRAWFORD, RALSTON—American, B. 1906. Painter, lithog., photog. Studied chiefly Penn. Acad. F.A.; Barnes Foundation. Internat. exhibitions; 36 one-man shows. Represented 50 public Colls. Teacher, drawing & painting many art sch. & universities. Intensive periods lithog. work, Paris. Vast series photog. studies Negro musical life, New Orleans. Photogs. pub. internationally. Bibliog.: *Ralston Crawford* by Richard B. Freeman, Univ. of Ala. 1953; *Ralston Crawford*, Milwaukee Art Center, 1958.

DASBURG, ANDREW M.—American, B. 1887, Paris. Studied abroad & Art Students League. Awards: Pan-American Exposition, 1925; Carnegie Inst., 1927, 1931; Guggenheim Fellowship, 1932. Represented in Metropolitan & Whitney Museums, New York; Denver Museum; Los Angeles Museum; Calif. Palace of Legion of Honor; Dallas & Cincinnati Museums.

DE MARTINI, JOSEPH—N.A. American, B. 1896, Mobile, Ala. Represented Metropolitan Museum, Whitney, Mus. Modern Art, City Art Museum, St. Louis, Boston Museum, Fine Arts Gal., San Diego, and 15 other museums and university collections. Guggenheim Fellowship, 1951. Artist-in-Residence Univ. of Georgia, 53-54. Several awards Nat'l Academy, Penn. Academy, Univ. of Illinois. Exhibited widely. Ten one-man shows. *AA Feb. 1951.

DERAIN, ANDRE—French 1880-1954.

DESGOFFE, BLAISE ALEXANDER— French 1830-1901.

DIKE, PHIL—N.A. American, B. 1906, Redlands, Calif. Studied: Chouinard Art Inst.; Art Students League; Amer. Academy, Fontainebleau, France, and with Clarence Hinkle, George Luks. Has exhibited in many national & international shows. Represented in many public & private coll., incl. Metropolitan Museum, Library of Congress, Santa Barbara, Los Angeles County Museum & Pasadena Art Inst. Over 50 awards, incl. Nat'l Academy, Penna. Acad. Member, Nat'l Academy of Design. *AA

DODD, LAMAR—N.A. American, B. 1909, Fairburn, Ga. Studied: Georgia Inst. Tech.; Art Students League, with Boardman Robinson, George Bridgeman, others. Mem. College Art Ass'n of Amer., Member of the Nat'l Acad. of Design. Many awards, incl. Southern States Art League, Art Inst. of Chicago, Pepsi-Cola. Work in various museums, incl. Atlanta Art Inst., Art Inst. of Chicago, Museum Mod. Art. Contributor to many pub. Regents Prof. Art, Hd. Dept. of Art, Univ. Georgia. *AA Feb. 1946; Feb. 1952; Feb. 1956.

DOUGHTY, THOMAS—American, 1793-1856. Member of Hudson River School.

EILSHEMIUS, L. M.—American, 1864-1941.

ETNIER, STEPHEN MORGAN—N.A. American, B. 1903, York, Pa. Studied: Yale School of Fine Arts, Pennsylvania Academy of Fine Arts. Awards from Butler Art Inst. and gold medal, Nat'l Academy Design. Mem. Nat'l Academy. Represented in many museums, including Metropolitan, Boston Museum of F. A., Vassar College, Phillips Collection, Washington, D. C. Murals in U. S. Post Office in Everett, Mass., and Spring Valley, N.Y. Has exhibited nationally. *AA June 1956.

FEININGER, LYONEL C.—American 1871-1956. Studied in Berlin and Paris. Has won several awards, including prizes from Los Angeles Museum of Art and the Worcester Museum of Art. His work appears in many museums — incl. Metropolitan Museum of Modern Art, Whitney, and in university as well as private collections. His murals have been exhibited at the 1939 N. Y. World's Fair, Carnegie Institute, Tate Gallery, and Musee du Jeu de Paume in Paris.

FREDENTHAL, DAVID—American 1914-1958. Studied Cranbrook Academy, Colorado Springs Fine Arts Academy. Guggenheim Fellowship. Several painting prizes. Frescoes Detroit Naval Armory. Post Office murals. Paintings and drawings *Life*, *Fortune*, Abbott Lab. Coll. War artist and correspondent for *Life*. Book illustrations. Teacher Columbia U., Indianapolis Art Ass'n, Norton Gallery. Exhibited widely.

GAERTNER, CARL—A.N.A. American 1898-1952.

GAUGUIN, PAUL—French 1848-1903.

GIOTTO—Florentine 1266-1337.

EL GRECO (Domenikos Theotocopoulos)—Spanish 1541-1614.

HARNETT, WILLIAM M.—American 1848-1892.

HARTLEY, MARSDEN—American 1877-1943. Studied in New York. Exhibited internationally. Took part in "Blaue Reiter" show in Munich and in first German Salon d'Automne, Berlin, 1913.

HASSAM, CHILDE—N.A. American Impressionist 1859-1935.

HILTON, ROY—American, B. 1891, Boston, Mass. Studied: Eric Pape School, Boston; Fenway School, Boston; Charles Woodbury School, Ogunquit; Art Students League. Taught 29 years at Carnegie Tech., Pittsburgh. Now teaching Carnegie Museum. Exhibited in many national exhibitions from Denver to New York. Also in several internationals and Painting in the U. S. exhibitions. Post Office murals in Westfield, N.J., and Rockymount, Va.

INNESS, GEORGE—N.A. American 1825-1894.

ISENBURGER, ERIC—N.A. American, B. 1902, Germany. Studied in Frankfurt, Berlin, Barcelona, Vienna. Exhibited: Berlin, France, London, Stockholm. U. S. Citizen, 1949. Works: Colls., Museum Modern Art, Penn. Acad., Corcoran, de Young, Colorado Springs, Springfield, Mass., Baltimore Museum, others; 8 one-man shows N. Y. 9 in other cities. Awards: 3 at Nat'l Academy; Carnegie Inst., Corcoran; Pepsi-Cola; others. *AA Jan. 1949.

JACOBSSON, EDWARD GUSTAVE—American, B. 1907, New York. Studied: Nat'l. Academy of Design, Art Students League, Art Institute of Chicago. His work appeared in the Pennsylvania Academy of F.A., Mint Museum, Springfield Museum of F. A., Berkshire Museum, and others. He is the founder and director of the Berkshire Art Center, Canaan, N. Y.

KENT, NORMAN—N.A. American, B. 1903, Pittsburgh, Pa. Graduate, Rochester Institute of Technology; Scholarship, Art Students League; study in Italy. Numerous one-man shows and included in national exhibitions; represented in over forty museums, here and abroad; several prizes and awards. Mem. Philadelphia Water Color Club, American Watercolor Society, Nat'l Academy, others. Former teacher and art director. Author of books and articles. Watercolorist, xylographer, designer. Presently, Editor, *American Artist*.

KINGMAN, DONG—N.A. American, B. 1911, San Francisco, Calif. Studied in China. Many awards, incl. gold medal, Audubon A., Guggenheim Fellow. His work is in Metropolitan, Museum of Modern Art, Whitney and others. Exhibited nationally. Illustrated "China's Story," "The Bamboo Gate"; covers for *Fortune* and other publications. Instruc-

tor in watercolor painting, Columbia Univ., N. Y., and at Famous Artists Sch., Westport, Conn. *AA Feb. 1943; June 1958.

KNATHS, KARL—American, B. 1891, Eau Claire, Wis. Studied Chicago Art Institute. Lives in Provincetown. Exhibited in major U.S.A. shows. Represented in many museums, private collections. Fully represented at Phillips Gallery, Washington, D. C. First prize, Carnegie 1946. Metropolitan 1950. Hon. Degree of Doctor of Fine Arts, Chicago Art Institute. Docufilm — "Karl Knaths' Cape Cod," a motion picture. Monograph — Karl Knaths, by Paul Moczanyi. Mem. Nat'l Inst. of Arts and Letters.

KOSA, EMIL J. JR.—N.A. American, B. 1927, Paris, France. Studied California Art Institute; in Prague with Prof. Bukovac; in Paris under Pierre Laurens, also with Prof. Kupka. Has exhibited throughout the U. S. and abroad and is represented in many museums, including Los Angeles, San Diego, Boston, Toledo, Springfield, has over 100 awards, including 5 from the Nat'l Academy of Design and 4 from the American Watercolor Society. *AA Oct. 1940; Feb. 1947; Mar. 1950.

KROLL, LEON—N.A. American, B. 1884, New York. Studied: Art Students League, Nat'l Academy of Design, Julian Academy, Paris. Mem. Nat'l Academy, American Academy of Arts & Letters., Nat'l Inst. of Arts & Letters. Many national prizes. Works in many museums, including Metropolitan, Whitney, Art Inst. of Chicago, Museum of Modern Art. Has executed several mural and war memorials. President of the American Committee, Int'l. Assoc. Plastic Arts. *AA June 1942.

LEVI, JULIAN—American, B. 1900, New York. Studied at Pennsylvania Academy of F. A. and in Paris. Was a Fellow at Penns. Academy of F. A. and won prizes from Art Inst. of Chicago, Nat'l Academy of Design, others. Work appears in 16 museums including Metropolitan, Museum of Modern Art, Whitney. Has exhibited nationally and internationally and has contributed to the Magazine of Art. He is an instructor at the Art Students League and at the New School. *AA Mar. 1947.

LORAN, ERLE—American, B. 1905, Minneapolis, Minn. Ed.: Univ. of Minn.; Minn. School of Art; traveled and painted in Europe 4 years. Exhibited 15 museums and shows by invitation; 9 one-man shows; awards: Paris: $6,000, Chaloner; Purchases,

Calif. Water Color, 1947; San Francisco M. of A., 1956; 26 other awards. Work in private colls. & museums, universities. Treas. Dept. commissions. Author, *Cézanne's Composition*, 6th printing. Prof. of Art & former Chairman of Art Dept., Univ. of Calif. at Berkeley. *AA Mar. 1950.

MARSHALL, MAY—American, B. Mangum, Okla. Studied Cornish School of Allied Arts. Fashion artist and commercial artist on Seattle newspapers several years; taught art 8 years at Edison Technical School; member of several art societies; one-man shows, Seattle Art Museum and Frye Museum. *AA May 1953.

MARTINO, ANTONIO P.—N.A. American, B. 1902, Philadelphia, Pa. Studied: Penn. Museum Sch. Ind. Arts, Spring Garden Art Inst., Philadelphia Sketch Club, La France Inst.; mem. several art societies; represented many museum collections; awards and prizes in oil and watercolor, Nat'l Academy of Design; Amer. Watercolor Society, Audubon Artists, others. Exhibited widely, in U. S. *AA June 1953.

MASON, ROY M.—N.A. American, B. 1886, Gilbert Mills, N. Y. Studied under his father, a steel engraver, and with Chauncy Ryder. Has exhibited both oil and watercolor, winning his first award in Buffalo, N. Y., 1929. Represented in 15 museums, including Metropolitan Museum and has won 28 awards. Present output confined chiefly to watercolors. Lives in New York State summers and Calif. winters. *AA Apr. 1946.

MAXWELL, JOHN—American, B. 1909, Rochester, N. Y. Received art education at Rochester Institute of Technology and Univ. of Rochester. Engaged in private study under the tutelage of Alling M. Clements, Carl W. Peters, Antonio Martino and Jonas Lie. Mem. Philadelphia Water Color Club, A.W.S. Exhibits nationally, including Penns. Academy of F. A., Art Inst. of Chicago, Nat'l Academy, N. Y. Represented in many private and public collections incl. Lehigh Univ. and Butler Inst. of American Art. Many important prizes and awards. *AA Nov. 1952.

MCFEE, HENRY LEE—N.A. American 1886-1953. Studied at the Art Students League. Mem. Nat'l Institute of Arts & Letters. Has won awards from the Paris Salon, Penns. Academy of F. A., etc. His work has been exhibited nationally and is represented in many museums, including the Metropolitan,

Corcoran Gallery, Penns. Academy of F. A. *AA Feb. 1948.

MENKES, SIGMUND—American, B. 1896, Lwow, Poland. Studied: Inst. of Art & Indus., Lwow, and at Academy of Fine Arts, Cracov, Poland. Worked in Paris, France, 20 years, in U. S. A. since 1935. Exhibits in major nat'l shows; several one-man shows. Awarded several prizes. Work is in 10 museums, incl. Metropolitan, Whitney, Brooklyn, New York; Penn. Acad.; Cranbrook Acad.; Walker Art Center. He also exhibits widely in Europe. *AA Oct. 1956.

MESS, GEORGE JO—American, B. 1898, Cincinnati, O. Studied: Columbia Univ.; School of Mod. Design, Chicago; Wayman Adams; John Herron Art School; and in Europe. Fellowship, Tiffany Foundation. Exhibited in many nat'l & internat'l shows, incl. Metropolitan, Carnegie Inst., Art Inst. of Chicago, Penn. Acad., Art Expositions of Paris, Rome & Stockholm. Over 40 prizes for paintings & prints. In permanent colls. of the Metropolitan, Cleveland, Dayton Art Museums and Library of Congress. *AA June 1945.

MILLET, JEAN FRANCOIS — French-1814-1875.

MONDRIAN, PIET—Dutch 1872-1944

MONET, CLAUDE—French 1840-1926.

MURCH, WALTER—American, B. 1907, Toronto. Studied: Ontario Col. Art, Art Students League; work in many museums, incl. Brooklyn Museum of Modern Art, Whitney, Toledo, Univ. of Illinois, Carnegie Inst. Private collections. Exhibited widely in U. S., England & Canada. Paintings for *Fortune, Scientific American.* Paintings for industry — Nat'l City Bank, others. *AA Oct. 1955.

PALMER, WILLIAM—American, B. 1906, Des Moines, Ia. Studied: Art Students League under Boardman Robinson & Kenneth H. Miller and at Fountainebleau, France. Supervisor, 1939, Mural Dept. N. Y. City W. P. A. Fine Arts Project. Work: many museums & private collections, incl. Metropolitan & Whitney Museums. Murals. Organizer & Dir. Munson-Williams-Proctor Inst. School of Art; Artist-in-Residence, Hamilton College. *AA Apr. 1958; Apr. 1948.

PARSHALL, DOUGLAS—A.N.A. American, B. 1899, Studied under his father DeWitt Parshall; Art Students League, N. Y.; Santa Barbara School of the Arts, California. Represented in many museum collections including Syracuse Museum; Detroit Museum; Kansas City Museum; deYoung Museum, San Francisco; Santa Barbara Museum of Art; San Diego Fine Arts Gallery. Exhibited widely. Many prizes and awards. Member Calif. Watercolor Society; Santa Barbara Art Ass'n; Soc. Western Artists; Los Angeles Art Ass'n.

PEALE, JAMES—American 1749-1831.

PEALE, RAPHAELLE—American 1774-1825.

PICKNELL, WILLIAM LAMB—A. N. A. American 1853-1897.

PIERCE, DONALD—American, B. 1916, Toms River, N. J. Studied: Pratt Inst., Grand Central Art School. Mem. American Watercolor Soc., N. J. Watercolor Soc. Has exhibited at Corcoran Gallery, Penns. Academy of F. A., Nat'l Academy of Design; has won numerous awards: from Montclair Art Museum & N. J. Watercolor Soc. Has lectured and demonstrated at the Art Students League and conducts painting classes at the Taubes-Pierce School of Art and at the Port Arthur Art Ass'n. *AA May 1954.

PITZ, HENRY C.—A.N.A. American, B. 1895, Philadelphia, Pa. Received his art education at the Philadelphia Museum College of Art, where he is now director of the illustration Dept. His illustrations have appeared in many magazines and over 150 books. His paintings have been widely exhibited and are in many public and private collections. Has received about 25 prizes and awards. Associate of the Nat'l Academy, Author of 6 art books. *AA June 1958.

PLEISSNER, OGDEN M.—N.A. American, B. 1905, Brooklyn, N. Y. Studied at Art Students League. Mem. Nat'l Academy and American Watercolor Society. Represented in over 40 museums and public collections, incl. Metropolitan, Philadelphia, Brooklyn, Minneapolis, Toledo and Cincinnati Museums. Official artist for Air Forces in W. W. II. Over 35 awards, incl. those from Chicago Art Inst., Phila. Water Color Club, Century Ass'n., Audubon Artists and Gold Medal & $1000 at American Watercolor Soc. 1956. *AA Mar. 1942.

REINDEL, EDNA — American, B. 1900, Detroit, Mich. Studied at Pratt Inst. Several awards, incl. Art Director's Club Medal.

Work represented in many publications and private collections. In museum collection of Metropolitan, Whitney, Canajoharie, others. Has executed murals for Fairfield Court in Stamford, Conn., and other public buildings. Paintings for industry. *AA May 1944.

RIBA, PAUL—American, B. 1912, Cleveland, O. Studied: Penn. Academy of Fine Arts; graduated from Cleveland Inst. of Art; now an instructor there. Career began as mural painter; later became an illustrator. Most of his time now spent on easel paintings which have been classified as magic realist. This style has won him recognition by leading American museums and exhibitions. He also illustrates, and designs wallpaper and fabrics. *AA Nov. 1953.

ROBINSON, THEODORE—American 1852-1896. Early exponent of the Impressionist School in America.

ROGERS, ROBERT STOCKTON — American, B. 1896, Burrton, Kansas. Grad. Art Inst. of Chicago; studied at American Academy of Art, Chicago. Teaches Atlanta Art Inst. Exhibits widely in Southeast, nat'l shows, leading museums; several one-man shows. Work: in several public & private colls. Specializes watercolor; lectures & painting demonstrations for civic & club groups. Several painting prizes; 2 Carnegie Grants to paint in Mexico & N. Mexico. *AA Jan. 1951.

RYDER, ALBERT PINKHAM—N.A. American 1847-1917.

SCARLETT, ROLPH—American, B. 1881. One of the first abstract painters in American purely nonobjective field. Large representation in Guggenheim Museum & private colls. Exhibited: Whitney & Metropolitan Museums; others, incl. Ann. Contemporary Amer. Painting at Univ. of Ill.; Neu Réalité, Paris. One-man shows, several cities. Also teacher, lecturer, industrial designer; and designs for the theater.

SCHAAD, BENTLEY—American, B. 1925, California. Rec'd art education in schools on West Coast. Exhibits widely here & abroad; work in many public & private colls., including Orlando (Fla.) and Pasadena Museums of Art. Many important prizes and awards. Served 3 yrs. with U. S. Navy in South Pacific. Now teaches in The Los Angeles County Art Inst. *AA Feb. 1955.

SCHRECKENGOST, VIKTOR—American, B.

1906, Sebring, O. Graduate of Cleveland Art Inst.; graduate work in Vienna. Work in watercolor, sculpture and ceramics exhibited widely in all major American museums and many European galleries. Work in permanent colls. of 15 museums and many private colls. More than 70 prizes and awards, incl. Fine Arts Medal, A. I. A., for sculpture 1958. Fellow, International Inst. of Arts & Letters; Commander, USNR; Mem. faculty, Cleveland Inst. of Art. *AA May '49

SHEELER, CHARLES—American, B. 1883, Philadelphia, Pa. Studied: Philadelphia Museum School of Industrial Art, Penns. Academy of Fine Arts. Work in many museums, incl. Metropolitan, Boston Museum of Fine Arts, Baltimore Museum of Art, Museum of Modern Art. Exhibited nationally. Was Artist-in-Residence, Phillips Academy, Andover, Mass. *AA Jan. 1959.

SMITH, JACOB GETLAR—American 1898-1958. Studied U.S. and abroad. Exhibited Carnegie Internat'l; Penn. Acad.; Corcoran Biennial; Whitney; Nat'l Gal.; Canada; World's Fairs, N. Y. & San Francisco. Represented: Whitney; Corpus Christi Museum; Butler Art Inst.; U. S. Dept. Labor; Several private colls. Awards: Guggenheim Fellowship; Frank Logan Prize, Art Inst. Chicago. U. S. Post Office murals. Writer, teacher, formerly Contributing Editor to *American Artist*. *AA May 1956, Apr. 1943.

SPENCER, NILES—American 1893 -1952. Studied at Rhode Island School of Design and Art Students League and under George Bellows and Robert Henri. One-man exhibitions as well as permanent representation in Metropolitan Museum of Art, Museum of Modern Art. *AA Oct. 1944.

TANGUY, YVES—American, B. Paris. 1900-1955.

TAUBES, FREDERIC—American, B. 1900, Lwow, Poland. Studied: Vienna Art Acad., Munich Art Acad. and Bauhaus, Weimar. Fellow, Royal Soc. of Art, London. Paintings owned by 26 museums and public colls., incl. Metropolitan and San Francisco Museums of Art. Author 20 books on art. Contributing Editor to *American Artist* and onetime Contributing Editor to Encyclopaedia Britannica Yearbooks. Visiting professor at many univs. here & abroad. Formulator of Taubes Varnishes and Copal Painting Media.

TAYLOR, WILL S.—American, B. 1882. Studied: Mass. State Art Sch. Boston; Art Students League. Research, study, Alaska, Europe. Mexico. Work: 15 murals, Amer.

Museum Nat. Hist., N. Y., culture of Northwest Indians; Late Stone Age; Bronze & Iron Ages. Mural, Fireman's Mutual Ins. Co. Providence, R. I. Instructor, paint. & illus., Pratt Inst. Art Sch., N. Y., 10 years. Chairman Art Dept. Brown Univ., 28 years. *AA Oct. 1952.

THON, WILLIAM—A.N.A. American, B. 1906, New York. Represented in permanent collections of the Metropolitan Museum, Whitney, Brooklyn, several others. Winner of Nat'l Acad. prizes — First Altman, Palmer Memorial Award, Watercolor prize; awards at Phila. Acad. and Penn. Acad.; grant from Acad. Arts & Letters; Amer. Acad. in Rome Fellowship; Artist-in-Residence at Amer. Acad. in Rome in 1956. *AA Feb. 1953.

VICKREY, ROBERT—American, B. 1926, New York. Studied: Wesleyan U., Yale U., Art Students League. Represented in many museums, incl. Whitney, Museum of Modern Art in Rio de Janeiro. Exhibited widely. Has won numerous painting prizes. *AA June 1957.

VON SCHLEGELL, WILLIAM C.—American, 1877-1950.

WARREN, FERDINAND—N.A. American, B. 1899, Independence, Mo. Work: many museum colls., incl. Metropolitan and Brooklyn, N. Y.; Univ. of Ga. Exhibits widely; 16 one-man shows; 12 awards & prizes. In World War II, did many posters, U. S. Treas. Dept.; Resident Artist, U. of Ga.; 1950-1; Head, Art Dept., Agnes Scott Col., Decatur, 1956-7; U. of Ga. grant research in encaustic painting. *AA Feb. 1952.

WATSON, ERNEST W.—American, B. 1884, Conway, Mass. Graduate, Mass. Art School; special study Pratt Inst.; sketching & research summer 1926 Europe & England, summer 1936 Mexico. Monthly adv. drawing for 12 yrs. Teacher, admin. Pratt Inst. many yrs; co-founder 1915 Berkshire Summer School of Art; co-founder 1937 (with Arthur L. Guptill, Ralph Reinhold) Watson-Guptill Pubs., and Amer. Artist; its Editor & interviews with artists 18 yrs; now, Editor Emeritus. Author 14 art books; color woodcuts in Colls. Smithsonian Inst.; Library of Congress; N. Y. Pub. Library; Brooklyn and Baltimore Museums; Albert H. Wiggin Coll. Boston Pub. Library; many private colls.

WATSON, ROBERT J. JR.—American, B. 1923, Martinez, Calif. Studied: Univ. of Illinois and Univ. of Wisconsin with Frederic Taubes. Has exhibited nationally and has work in several permanent collections including Toledo Museum of Art, Mills College. *AA Dec. 1953.

WILSON, SOL—American, B. 1896, Vilno, Poland. Studied Cooper Union; Nat'l Acad. of Design & with George Bellows & Robert Henri. Exhibited in most nat'l shows; many abroad. Represented in over 20 museums & public colls., among them: Whitney, Brooklyn & Metropolitan Museums; Library of Congress. Over 15 prizes for painting, incl., Corcoran Gal., Carnegie Inst., Acad. of Arts & Letters. *AA Apr. 1950.

WYETH, ANDREW N.—N.A. American, B. 1917, Chadds Ford, Pa. Studied with father N. C. Wyeth. Exhibited in major nat'l shows, incl. one man at Art Inst. of Chicago, trav. ex. in England. Has rec'd many prizes & awards; also Hon. degree, D. F. A. Harvard, 1955, Colby Col., 1955. Work: Boston Museum, Metropolitan, Museum of Mod. Art, Art Inst. of Chicago & many others. Murals for Delaware Trust Bank, Wilmington. *AA Sept. 1942; Nov. 1958.

Index

206

207